THE SISTINE CHAPEL

T0366509

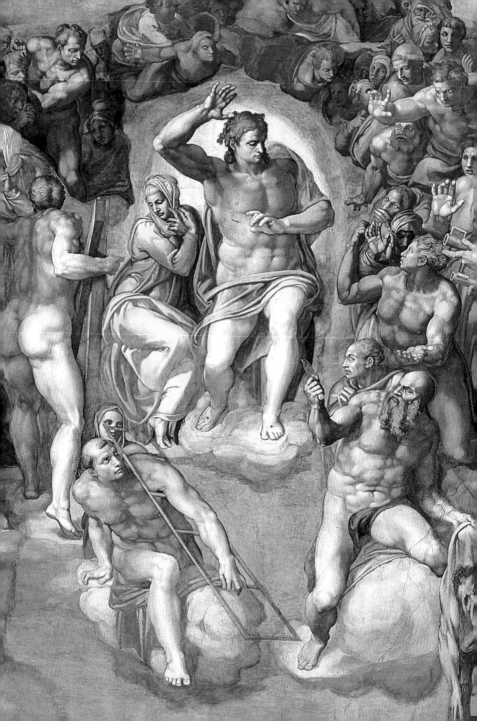

THE Sistine Chapel
PARADISE IN ROME

Ulrich Pfisterer

Translated by David Dollenmayer

THE GETTY RESEARCH INSTITUTE LOS ANGELES

The Getty Research Institute Publications Program
Thomas W. Gaehtgens, *Director, Getty Research Institute*
Gail Feigenbaum, *Associate Director*

Originally published in German as *Die Sixtinische Kapelle*, by Ulrich Pfisterer
© Verlag C.H. Beck oHG, Munich 2013

English translation © 2018 J. Paul Getty Trust

Published by the Getty Research Institute, Los Angeles
Getty Publications
1200 Getty Center Drive, Suite 500
Los Angeles, California 90049-1682
www.getty.edu/publications

Laura Santiago, *Manuscript Editor*
Kurt Hauser, *Designer*
Victoria Gallina, *Production Coordinator*

Distributed in the United States and Canada by the University of Chicago Press
Distributed outside the United States and Canada by Yale University Press, London

Printed in China

Library of Congress Cataloging-in-Publication Data

Names: Pfisterer, Ulrich, 1968– author. | Dollenmayer, David B., translator.
 | Getty Research Institute, issuing body.
Title: The Sistine Chapel : paradise in Rome / Ulrich Pfisterer ; translated
 by David Dollenmayer.
Other titles: Sixtinische Kapelle. English
Description: Los Angeles : Getty Research Institute, [2018] | "Originally
 published in German as Die Sixtinische Kapelle, by Ulrich
 Pfisterer."—ECIP galley. | Includes bibliographical references and index.
Identifiers: LCCN 2017056250 | ISBN 9781606065532
Subjects: LCSH: Cappella Sistina (Vatican Palace, Vatican City) |
 Michelangelo Buonarroti, 1475–1564—Criticism and interpretation. | Mural
 painting and decoration, Italian—Vatican City. | Mural painting and
 decoration, Renaissance—Vatican City.
Classification: LCC N2950 .P4913 2018 | DDC 759.5—dc23
LC record available at https://lccn.loc.gov/2017056250

p. i: Federico Zuccaro (Italian, ca. 1541–1609). Detail of *Taddeo in the Sistine Chapel Drawing Michelangelo's "Last Judgment,"* ca. 1595. See fig. 26.
Frontispiece and pp. xiv, 38, 108, 126, 144: Michelangelo (Italian, 1475–1564). Details of *The Last Judgment*, 1536–41. See pl. 23.
pp. iv–v: Étienne Dupérac (French, ca. 1525–1604). Detail of *Mass of the Papal Chapel in the Sistine Chapel*, 1578. See fig. 3.

CONTENTS

PREFACE TO THE ENGLISH EDITION

Francisco de Hollanda's panegyric to Michelangelo's
frescoes in *Diálogos em Roma* (1548) suggests the challenges the Sistine Chapel
and its interior decor have posed to viewers both then and now. He notes
that the "fountain-head" of all "celebrated painting" is "the frescoes of a great
barrel-vaulted ceiling with its arches and façade, whereon Michael Angelo has
divinely pictured how God first made the world, divided into subjects, with
many images of sibyls and figures of consummate art and beauty. And it is very
notable that this vault . . . in itself contains the work of twenty painters in one."[1]

From its construction in 1477 until at least 1600, the Sistine Chapel was the
most described and probably the most reproduced work of art in Europe since
classical antiquity. In the centuries that followed, the flood of texts about and
images of the Sistine made it one of the best-known artworks in the world. To
Francisco de Hollanda and countless others, the Sistine's creator is Michelangelo,
a genius who seems to exceed normal human categories. As much as scholars of
recent decades have worked to deconstruct this myth, a convincingly balanced
assessment of Michelangelo's contributions to the Sistine Chapel remains diffi-
cult. Indeed, today many remain under the impression that the Sistine consists
mainly of Michelangelo's frescoes. The earlier paintings and Raphael's tapestries
appear to be of secondary significance.

Another crucial element to take into account is the restoration of the chapel
from 1979 to 1999. That restoration resulted in a flood of new reproductions and
analyses, and it produced technical discoveries that have not yet been incorpo-
rated into a comprehensive interpretation.

With this in mind, the present book makes two basic assumptions. First,
an interpretation of the artistic elements of the Sistine Chapel can proceed only
in the context of the decorations already existing at each stage of the chapel's
development. Michelangelo's conception for the ceiling, for instance, had its

roots in Piermatteo d'Amelia's original ceiling painting and the fifteenth-century picture fields along the walls. Raphael's tapestries supplemented the quattrocento frescoes and Michelangelo's ceiling. And in painting the *Last Judgment,* Michelangelo had to confront his own paintings of two decades earlier. The narrative content of each successive decorative project must be interpreted, but beyond that, we must consider how each new work visually and semantically combines with and recontextualizes the works already present. Ultimately, I investigate a "chronotopic" Renaissance for art history.[2] A central thesis of this book is that from this chronotopic perspective, all phases of the Sistine's decoration relate to the theological and ecclesio-political conception of it as a liminal space between the world and the hereafter of the heavenly Jerusalem and paradise.

The second assumption is that to be convincing, an interpretation of the chapel's interior must keep in mind the restoration's technical discoveries, the practical details of how the works were fashioned, and—to the extent one can reconstruct them—the circumstances under which they were commissioned, designed, and perceived by contemporaries. As a result of these considerations, this book will suggest a new chronology for the quattrocento frescoes and a revised disposition of Raphael's tapestries. To delimit the perceptual and interpretive horizon—the "period eye"[3]—of Michelangelo's frescoes, the book also includes for comparison several heretofore neglected works, especially the surviving conceit of Piermatteo d'Amelia's original and highly complex starry ceiling.

The first attempt at a comprehensive presentation of the chapel, Ernst Steinmann's *Die Sixtinische Kapelle,* ran to 1,550 pages.[4] That was not an option for this book, the length of whose German original was limited by the series in which it appeared. Despite sacrificing some details, I hope that the concentrated format helps to provide insights into the chapel's history and interpretation.

NOTES

1. Francisco de Hollanda, *Diálogos em Roma (1538): Conversations on Art with Michelangelo Buonarroti,* ed. Grazia Dolores Folliero-Metz (Heidelberg: Winter, 1998), 89.

2. This develops on Mikhail Bakhtin's ideas; M. M. Bakhtin, "Forms of Time and of the Chronotope in the Novel: Notes toward a Historical Poetics," in idem, *The Dialogic Imagination: Four Essays,* ed. Michael Holquist, trans. Caryl Emerson and Michael Holquist (Austin: University of Texas Press, 1981), 84–258.
3. See Michael Baxandall, *Painting and Experience in Fifteenth-Century Italy,* 2nd ed. (Oxford: Oxford University Press, 1988).
4. Ernst Steinmann, *Die Sixtinische Kapelle,* 2 vols. (Munich: Bruckmann, 1901–5).

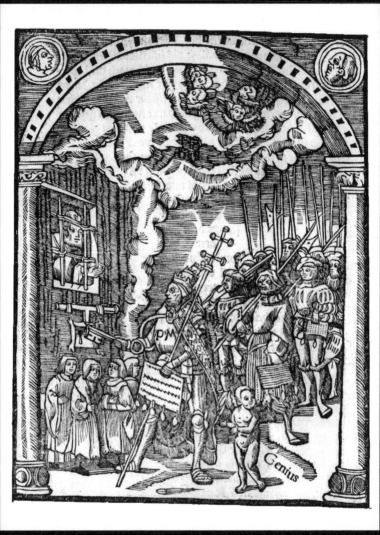

Fig. 1. *Pope Julius II at the Locked Door of Heaven.*
Woodcut from *Von den Gewalt und Haupt der Kirchen ein Gesprech . . .* (Speyer, ca. 1521).
Munich, Bayerische Staatsbibliothek.

PROLOGUE AT THE DOOR OF HEAVEN

"What mishap is this? The door won't open at all!" Pope Julius II had not quite four months to enjoy Michelangelo's spectacular new frescoes for the ceiling of the Sistine Chapel. The finished work was unveiled for the pope on 31 October 1512 and for the entire world on the following day. Then, during the night of 21 February 1513, Julius died supposedly of fever. When the soul of Christ's representative on earth reached the door of heaven, however, the key he had brought with him did not fit the lock. The doorkeeper, Saint Peter himself, refused him entry into the kingdom of heaven. The silver "key of power" with which the imperious Julius thought to control everything seemed to the Prince of the Apostles a different object entirely from the two keys Christ himself had entrusted to him as the sign of his papal office so long ago.

At least, that was the story hawked in an anonymous lampoon written soon after the pope's death and probably first printed in 1517.[1] The lampoon has been variously ascribed to Erasmus of Rotterdam, Ulrich von Hutten, Publio Fausto Andrelini, and others—although Erasmus is by far the most likely author. A woodcut accompanying the first German translation shows the scene: the Warrior Pope Julius, clad in the most ornate papal regalia and also in a full suit of armor ("PM" on the breastplate identifies him as Pontifex Maximus), arrives at the door of heaven at the head of his army and accompanied by his genius as well as some choirboys (fig. 1). From behind a barred window, Saint Peter turns the new arrival away. The ensuing dialogue begins with Julius's astonished exclamation quoted above, goes on to reveal the pope's (supposed) misdeeds, and culminates in Peter's advice to "build yourself a new paradise somewhere."

The pamphlet, often reprinted and translated in the following decades, encapsulates the abuses of the church hierarchy in the image of the false and useless key, thereby satirizing the central symbol of papal power. As the

successor to Peter, the pontiff actually exercises the double power to "bind" and to "loose" (Matthew 16:19); that is, to judge and to smooth the path to the kingdom of heaven through the forgiveness of sins, symbolized by a key of silver and a key of gold.[2] In the decades around 1300, the popes had adopted the keys of the kingdom of heaven as their own attribute. During the crises of the papacy from the fourteenth to the sixteenth century—schisms, exile in Avignon, the difficult return to and reassertion of power in Rome, and then the catastrophe of the Reformation—the keys became indispensable symbols of papal authority.

The pope's power of the keys, established by Christ, is also a frequent theme in the Sistine Chapel (see pls. 1, 2). It is closely related to the notion that the history of salvation will be consummated by the return of the kingdom of God, the heavenly Jerusalem, to which the golden key will grant admission. In the final analysis, this idea legitimized the popes and the entire Catholic Church. That final goal of faith and the absolute authority of the pope are the leitmotifs threaded through the four main campaigns to decorate the Sistine Chapel between 1481 and 1541. With each new addition to the decor, these motifs were modified, expanded, and made more precise. The present book intends to illuminate their interconnections, which coalesce only when the entire history of the Sistine Chapel's decorations is taken into account.

Thus, I will not postulate a program of images in the modern sense of a plan that has been decided upon once and for all and then consistently carried out in detail. Instead, I will argue that there were fundamental ideas that found increasingly concrete expression as the number of images in the chapel grew. At the same time, the satire of Julius at heaven's door reminds us that such ideas and the possibilities for their visual realization were in constant dialogue with the shifting politics of the day. Papal self-image and sovereign legitimacy could change with each new officeholder. Moreover, each addition to the interior of the Sistine Chapel had a retroactive influence on how the already existing images were perceived and interpreted. Finally, in addition to the theological and political aspects of the decor and the wishes of the commissioning authority, the intentions of the artists themselves played a decisive role—especially

when painters such as Sandro Botticelli, Michelangelo Buonarroti, and Raphael were involved. Thus, gradually, over space and time, a complex fabric of thematic, chronologic, and artistic references took shape in the Sistine Chapel.

To investigate this fabric requires the most precise possible grasp of the developmental history of the chapel's images and the original intentions for their disposition. In the last two decades of the twentieth century, campaigns to restore the chapel were especially important in providing new insights into its history. Up to now, however, there has been no summary of how those insights modify our understanding of the chapel. This book therefore aims not just to present a new, comprehensive interpretation of the Sistine Chapel but also to revise several current notions about the chronology and reconstruction of its decorations.

In any case, as the papal master of ceremonies Paris de Grassis declared in 1518, in view of the grandeur of its interior, the Sistine Chapel was regarded as the "foremost chapel in the world."[3] Here, at the heart of Christianity and in the residence of the representative of Christ on earth, one could divine a reflection of the city of God. With Michelangelo's *Last Judgment* completing the decor in 1541, the chapel had been transformed into a monument of hope and triumph in the history of salvation, the vestibule and future door to paradise, where Christ would appear at the End of Days to open the way into the eternal kingdom of heaven for the "only true church," led by the pope.

NOTES

The aims of this book are to put forward my current understanding of the Sistine Chapel, in all its complexity, for a general educated audience.

1. For the most recent edition, see Erasmus of Rotterdam, *Giulio: Testo latino a fronte,* ed. Silvana Seidel Menchi (Turin: Einaudi, 2014), 4–5.
2. Throughout this volume, quotations from the Bible are from the King James translation. On the symbolism of keys, see Agostino Paravicini Bagliani, *Le chiavi e la tiara: Immagini e simboli del papato medievale* (Rome: Viella, 2005).
3. Paris de Grassis, *Diarium,* 5 April 1518, Add. Ms. 8444, fol. 91r, British Library, London: "Ista cappella tam in maestate quam in structura . . . prima mundi." Quoted in John Shearman, "La storia della Cappella Sistina," in *Michelangelo e la Sistina: La tecnica, il restauro, il mito,* ed. Fabrizio Mancinelli, exh. cat. (Rome: Palombi, 1990), 27n6.

PARADISE IN CONTENTION: THE "FOREMOST CHAPEL IN THE WORLD" AND SIXTUS IV

If a sojourner in Rome in the mid-fifteenth century, within sight of Saint Peter's Basilica and the Vatican Palace, had asked after the way to paradise, he could expect to receive at least three different answers. One answer—but by no means the most obvious—would have interpreted the question metaphorically and recommended a life of pious virtue in the hope of salvation at the Last Judgment. Frances of Rome, recently deceased in 1440 and already venerated as a saint, had shown the Romans what such an ascent into heaven could look like, for she had often described it in her visions.[1] A second response would have quite simply pointed the way into the forecourt of Old Saint Peter's. At the time, the atrium of the Constantinian basilica, and of some other European churches, was called "paradise." Of course, the central fountain in front of Saint Peter's, with its two ancient bronze peacocks and the bronze pinecone dispensing water, made the symbolic identification especially palpable. A third response would have referenced a garden tucked between Saint Peter's Basilica and the papal palace and also described as "paradise." In Giannozzo Manetti's 1455 biography of Pope Nicholas V, we read of this Vatican garden: "In this gorgeous paradise stand three extremely well-proportioned and outstanding buildings."[2] Manetti, however, was not describing what actually existed but envisioning the magnificent buildings planned by Nicholas. At least one of those buildings, the "great palace chapel" erected in the thirteenth century, had apparently become so dilapidated in the course of time that not many years later it had to undergo a thorough renovation. Sixtus IV was responsible for the work, and thus, beginning in the 1520s, it became customary to call the structure the Sistine Chapel after that papal builder.

The Building, Its Commissioner, and the Chronology of the First Set of Paintings

In 1420, Martin V, the first pope after the Great Schism, resumed permanent residence in Rome and chose to live not in the Lateran Palace, the old residence southeast of the city, but in the Vatican Palace, next to Saint Peter's on the west bank of the Tiber. After years of neglect, this edifice cannot have been in much better shape than the Lateran, but Martin chose it to mark a decisive new beginning.

The Vatican Palace's *capella magna* (or *capella major palatii*) was located on the second floor (fig. 2). The main access was through the adjoining reception room, the Sala Regia (or *aula magna*). Diagonally across from the entrance to the *capella magna* was the door to the *capella parva* (small chapel) or Cappella di San Nicola, built under Pope Nicholas III (r. 1277–80). This chapel served as a site for less important masses, as a waiting room during consistories in the Sala Regia, and, after the return of the popes from their exile in Avignon, as the polling room during conclaves. (From the fifteenth century onward, cells where the cardinals could get some sleep during the election proceedings were erected in the Sistine Chapel itself.) By the second decade of the sixteenth century, the Cappella di San Nicola seems to have become too crowded and probably also too dilapidated for the growing number of members of the papal chapel. Around 1540, Paul III had it torn down and replaced by the Cappella Paolina, which contains Michelangelo's last cycle of frescoes, on the life of the apostle Paul.[3] About a century earlier, from 1447 to 1450, in another chapel located on the third floor and at the opposite corner of the palace complex, Fra Angelico had completely covered the walls with frescoes on the orders of Pope Nicholas V (r. 1447–55). It served as the private chapel for the daily devotions of the Renaissance popes.

The *capella magna,* an oblong brick structure of several stories and free-standing on three sides, may have been first built under Innocent III (r. 1198–1216). The interior had a flat wooden ceiling and a wooden floor. A miniature from the 1470s, produced shortly before the *capella magna*'s renovation into the Sistine Chapel we know today, gives us an impression of how the original chapel

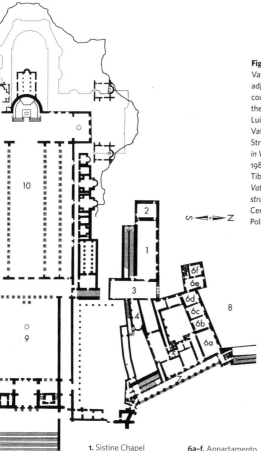

Fig. 2. Reconstruction of the Vatican Palace in 1521 with the adjacent Saint Peter's and its fore-court on the left (section of the second floor, after Christoph Luitpold Frommel, "Il Palazzo Vaticano sotto Giulio II e Leone X: Strutture e funzioni," in *Raffaello in Vaticano*, exh. cat. [Milan: Electa, 1984], 133; supplemented by Tiberio Alfarano, *De basilicae Vaticanae antiquissima et nova structura* [1590], ed. Michele Cerrati [Rome: Tipografia Poliglotta Vaticana, 1914]).

1. Sistine Chapel (*capella magna*)
2. Sacristy (expanded, probably starting in 1482, by Sixtus IV and Innocent VIII)
3. Sala Regia
4. Cappella di San Nicola (*capella parva*)
5. Stanzetta di Innocenzo III (on the third floor: Cappella di Niccolò V)

6a-f. Appartamento Borgia, private rooms for Alexander VI (on the ground floor: 6a-d, libraries of Sixtus IV; on the third floor: 6a, Sala di Costantino; 6b, Stanza d'Eliodoro; 6c, Stanza della Segnatura; 6d, Stanza dell'Incendio)
7. First loggia (on the fourth floor: Raphael's loggias)

8. Cortile del Belvedere
9. Forecourt to Old Saint Peter's with a fountain ("paradise")
10. Old Saint Peter's (thick black lines); Nicholas V's project (thin dotted line); new construction (thin black line)

looked. It shows a Mass attended by the pope in a whitewashed room with large windows (see pl. 3). In light of the chapel's future redecoration, it is important to note that at this point, the altarpiece already depicted the Assumption of Mary and the walls were hung with flower tapestries. The functional requirements for the chapel are also clear from this miniature. The calendar of the papal court included about forty occasions when the entire papal chapel was required to be in attendance. In the era of Sixtus, this involved perhaps two hundred persons (a number that would grow substantially over the course of the sixteenth century): the college of cardinals with their attendants, other important clergy who happened to be present, officials of the Curia, and lay members of the papal court, as well as a series of guests. In addition, there were the celebrants of the Mass and the choir (since, in 1471, Sixtus IV had regulated the chapel's liturgical music, this choir also bore the name Cappella Sistina). On average, only eight occasions per year required the papal chapel's attendance in Saint Peter's Basilica. The remaining thirty-two were celebrated in the *capella magna,* most frequently during Lent and Holy Week. In the late fifteenth century, the pope himself celebrated a public Mass only three times a year: at Christmas, Easter, and the feast day of the Prince of the Apostles, Saint Peter. Julius II did so only on Easter and the Feast of Saints Peter and Paul.

In the miniature, we can also see the U-shaped configuration of seats around the altar, with the pope's seat distinguished by a canopy and with inferior persons relegated to sitting on the floor in the center. It is likely that this arrangement was already the practice of the chapel during its exile in Avignon, and it would determine the interior structure of the renovated Sistine Chapel. Moreover, fencing off some of the chapel's interior allowed more of the secular world to attend services.[4] Access to the chapel, however, was regulated. It was probably under Leo X (r. 1513–21) that on exceptional occasions, women were first allowed to attend Mass there. A copper engraving by Étienne Dupérac from 1578 shows that the basic arrangement was still being followed a century later, although Dupérac's figures are depicted in too small a scale, giving the impression of more space than actually existed (fig. 3).

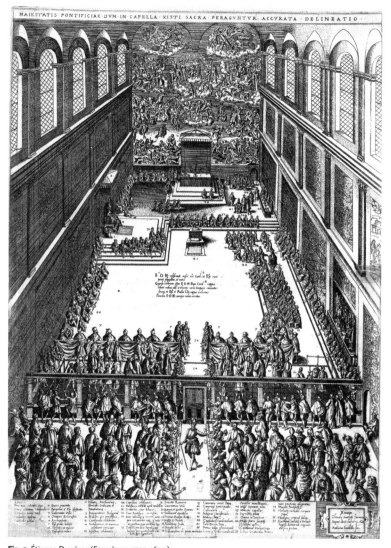

Fig. 3. Étienne Dupérac (French, ca. 1525–1604).
Mass of the Papal Chapel in the Sistine Chapel ("Maiestatis Pontificiae dum in Capella Xisti Sacra Peragantur Accurata Delineatio"), 1578, copper engraving.

Most important, this arrangement reminds us of the symbolic dimension of the papal chapel. Its gatherings represented the *maiestas pontificia,* the pope's brilliant splendor and majesty, as one can read on the engraving. In the Middle Ages, there was already a notion that the monks gathered in the pews of a monastery would join the heavenly hosts as a tenth choir.[5] How much more powerfully, then, did this apply to the papal chapel. In the orderly circle of his court, the clergy, and the laity, Christ's deputy on earth represented the earthly church and anticipated its fulfillment in the heavenly *ecclesia triumphans* (triumphant church) to come. The glory of the *maiestas pontificia* gave a foretaste of the radiance of the heavenly hosts and the Church at the End of Days. Julius II and his master of ceremonies Paris de Grassis would explicitly articulate this parallel. It alone justified—and as much as demanded—the greatest possible display of grandeur and the employment of the best artists. So the great palace chapel already shone in renewed glory in Nicholas V's vision of a thoroughly renovated Rome as recorded by his biographer Manetti.

However, construction on the chapel did not actually begin until Sixtus IV. Francesco della Rovere, born near Savona in Liguria in 1414, had been chosen as the successor to Paul II on 9 August 1471. As a young man, Della Rovere had joined the Franciscan order and made a name for himself as one of the most outstanding theologians of the fifteenth century. Among other things, all his life he advocated making the Immaculate Conception of Mary dogma, and in 1483, he promulgated it with all the weight of his papal authority in the bull *Grave nimis.* In 1464 he became the superior general of his order and was named cardinal in 1467. Great hopes that he would advance systematic church reform were tied to his election as pope, given that until then he had been such an exemplary person. These hopes, however, were to be thoroughly dashed. Under Sixtus, nepotism and secular, military conflict between the Vatican and other powers in Italy reached a new high point.[6]

To be sure, Sixtus completed a large-scale program of construction projects in Rome, from the improvement of roads to the building of a hospital and the renovation of churches. With a donation of antique statues on the

Capitoline Hill, he founded the first "public museum."[7] In the Vatican Palace, he expanded the library on the ground floor, thus founding the later Biblioteca Vaticana. He sought to ensure his own personal salvation by constructing a new choir chapel for the chapter of Saint Peter's, dedicated to the Immaculate Conception of Mary and the two most important Franciscan saints: Saint Francis and Saint Anthony of Padua. Pietro Vannucci, called Perugino, painted the ceiling of the apse with a *sacra conversazione* that included the kneeling donor Sixtus being presented to the Madonna by Saint Peter and Saint Francis. Sixtus wanted to be buried in the middle of the chapel, surrounded by the stalls for the canons—an optimal site to ensure his liturgical memory. The dedication of the choir chapel to the Immaculate Conception and of the Sistine to the Assumption of Mary makes it probable that this chapel for the canons and for Sixtus's grave belonged together with the Sistine Chapel—begun shortly thereafter—in the pope's plans.

The panegyrics to Sixtus declare that he renovated the Sistine Chapel from the ground up (fig. 4). By contrast, investigations during the most recent restoration work prove that the foundations and even the walls of the previous, medieval chapel were preserved up to a considerable height, although the walls were reinforced and unified by an outer layer of brick. Thus the rectangular, slightly uneven foundation plan was a given, with its exterior dimensions of about 40.5 meters in length and 13.78 meters (east wall) and 13.11 meters (west wall) in width. When contemporaries spoke of Sixtus enlarging the chapel, they could have been referring to its greater height that now reached approximately 20.73 meters, and to the shallow barrel vaulting with vaulting cells above the windows. In addition, the rooms on the ground floor for the masters of ceremonies and their assistants were transformed from dark substructures into bright spaces. The former "hell" of this "prison" had thus become a "paradise" regained for heaven, as people joked at the time.[8] From then on, these rooms were called *paradiso* even in official documents—the name of the garden was probably transferred to the building within it. One could claim that the Sistine Chapel was built not just in but on top of paradise.

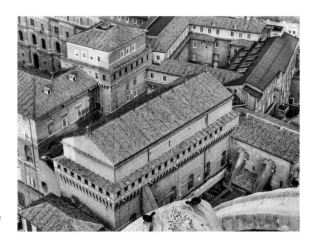

Fig. 4. The Sistine Chapel viewed from the southwest.

On the basis of the few known sources, we can merely surmise the details of how construction progressed. Perhaps the Holy Year 1475 made the urgent need for a renovation particularly obvious. It was in the old *capella magna,* following Mass on 2 February 1477, that Giuliano della Rovere, later Pope Julius II, was elevated to archbishop of Avignon by his uncle Sixtus IV.[9] Later in 1477, construction on the renovation was in full swing. We have evidence that construction work was still under way in early 1481, and that the painting of the interior began in the second half of that same year. Two years later, on 15 August 1483—Assumption Day and the patronal feast of the chapel—the first Mass was celebrated. But by mid-May 1482 at the latest, Andreas Trapezuntius, one of the pope's two private secretaries, described the chapel as if it were already complete. This would suggest that the space was essentially ready to be consecrated a year before its actual consecration took place. On 15 August 1482, however, Rome was being threatened by the "greatest terror."[10] The army of the king of Naples stood before its walls. No one expected that six days later, on 21 August, the pope would celebrate his most important military victory in the Battle of Campo Morto. That may be why the opening of the new chapel was postponed for a year. Smaller tasks related to construction, such as gilding the

latticework and painting the glass, continued for quite some time, probably right up to the death of the pope on 12 August 1484.

It is not easy to reconcile the two surviving documents concerning the interior paintings—a contract from 1481 and a report from 1482—with this compressed time frame. All that is certain is that between 1481 and 1483, an extensive cycle of frescoes was created and the ceiling was painted most likely with a starry sky (fig. 5). Above the main cornice and between the windows, portraits of the first thirty, canonized popes circled the room, beginning on the altar wall with Christ and Peter. Below the popes, two series of eight large picture spaces faced each other, containing scenes from the life of Christ and the life of Moses. The dado was painted with trompe l'oeil draperies, except for the surface behind the altar, which contained a fresco of the Assumption of Mary.[11]

On 27 October 1481, the painters Cosimo Rosselli, Sandro Botticelli, Domenico Ghirlandaio, and Perugino signed a joint contract to produce ten frescoes in the Sistine Chapel, to be ready by 15 March 1482, with a promise—given "voluntarily," as explicitly mentioned in the contract—to pay a considerable contractual penalty if the deadline was not met. The contract speaks of "ten pictures of events from the Old Testament and New Testament with painted curtains below" that were to be painted with "as much care and fidelity" as each master and his assistants could muster, "as has been begun." (The portraits of popes above are not mentioned, because they had already been completed, as we shall see!)[12] As was often the case in the fifteenth century, final payment would not be determined until a committee of experts had examined the finished frescoes. However, a central interpretive problem is posed by the fact that there were actually sixteen, not ten, large surfaces to be painted, two on each of the shorter walls and six on each of the longitudinal walls. The second document, from 17 January 1482, does not solve the problem. It is the expert committee's report on the "first four pictures of events in the Great Chapel."

Earlier scholarship tried to solve the problem by calling the two frescoes on the altar wall, to be painted by Perugino alone, a special case and excluding them from the reckoning. The pictures the contract seems to mention as

Fig. 5. Floor plan of the Sistine Chapel and layout of the frescoes of 1481–82.

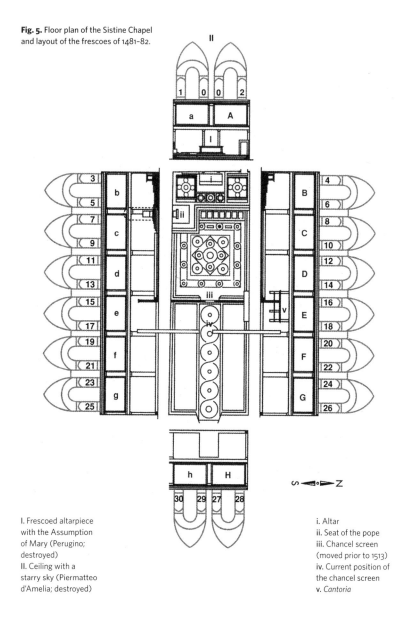

I. Frescoed altarpiece with the Assumption of Mary (Perugino; destroyed)
II. Ceiling with a starry sky (Piermatteo d'Amelia; destroyed)

i. Altar
ii. Seat of the pope
iii. Chancel screen (moved prior to 1513)
iv. Current position of the chancel screen
v. *Cantoria*

Moses Cycle
(See p. 151 for the inscriptions.)

a. Moses in the Bulrushes (Perugino; destroyed)
b. Moses Leaving for Egypt (Perugino; 42 *giornate*)
c. The Trials of Moses (Botticelli; 45 *giornate*)
d. The Crossing of the Red Sea (Biagio d'Antonio; 63 *giornate*)
e. Descent from Mount Sinai (Rosselli; 35 *giornate*)
f. Punishment of Korah, Dathan, and Abiram (Botticelli; 55 *giornate*)
g. Testament and Death of Moses (Signorelli/Bartolomeo della Gatta; 54 *giornate*)
h. Disputation over Moses's Body (according to Vasari: Signorelli; destroyed; replaced between 1559 and 1565 or in 1571–72 by Matteo da Lecce)

Christ Cycle
(See p. 151 for the inscriptions.)

A. Birth of Christ (Perugino; destroyed)
B. Baptism of Christ (Perugino; 46 *giornate*)
C. Temptation of Christ (Botticelli; 63 *giornate*)
D. Vocation of the Apostles (Ghirlandaio; 51 *giornate*)
E. The Sermon on the Mount (Rosselli; 46 *giornate*)
F. The Delivery of the Keys (Perugino; 51 *giornate*)
G. The Last Supper (Rosselli; 43 *giornate*)
H. Resurrection of Christ (according to Vasari: here favoring Rosselli; Ghirlandaio; destroyed; replaced between 1559 and 1565 or in 1571–72 by Hendrick van den Broeck)

Popes
(Numbered according to their chronological order; attributions possible only in some cases.)

0–0. Christ and Peter or Peter and Paul (destroyed)
1. Linus (destroyed)
2. Clement I (destroyed)
3. Cletus (Ghirlandaio)
4. Anacletus (Ghirlandaio)
5. Evaristus (Botticelli)
6. Alexander I
7. Sixtus I
8. Telesphorus (Botticelli)
9. Hyginus (Ghirlandaio)
10. Pius I (Ghirlandaio)
11. Anicetus (Botticelli)
12. Soter (Botticelli)
13. Eleuterus
14. Victor I (Ghirlandaio)
15. Zephyrinus
16. Calixtus I (Rosselli)
17. Urban I
18. Pontian
19. Anterus (Perugino)
20. Fabian (Perugino)
21. Cornelius (Botticelli)
22. Lucius (Botticelli)
23. Stephan (Botticelli)
24. Sixtus II (Botticelli)
25. Dionysius (Rosselli)
26. Felix I
27. Eutychian
28. Caius (Ghirlandaio)
29. Marcellinus (Botticelli)
30. Marcellinus I (Botticelli)

"begun" were taken to be the first four scenes from the life of Christ on the lon-gitudinal wall, the only place in the chapel where works of all four painters are in a row next to one another. It would have been these that were examined by the committee in January. Adding the ten picture spaces mentioned in the contract and painted after it was signed at the end of October, all sixteen spaces would be accounted for. But there are at least two difficulties with this theory. If the first four scenes from the life of Christ had already existed when the contract was signed, the contract's description "beginning at the altar" would not be true, at least for that side of the chapel. And why would the committee have waited two and a half months to examine these pictures?

Arnold Nesselrath has developed an alternative theory—hinted at by earlier scholars—that the contract indeed marks the beginning of the painted scenes. The ten picture spaces are the two on the altar wall and four more on each of the longitudinal walls. The area thus accounted for corresponds to the original space behind the choir screen down to the *cantoria,* or singing gallery. In a second campaign that followed immediately, and for which there was no contract, the remaining six fields were painted. Nesselrath's theory avoids the problems mentioned above and also supplies an explanation for the discovery during restoration that some fields of this second campaign had obviously been painted under changed conditions, with more participation by members of the painters' studios. However, the greatest challenges to this theory are posed by the number of *giornate* (workdays) each fresco required—something also docu-mented for the first time during the most recent restorations—and by the pre-cise attribution of the pictures.[13] Although theoretically, scaffolding could have filled the entire interior and although the painters with their numerous studio associates could have been working on several picture fields at the same time, apparently the opposite was the case. Each painter finished only one fresco at a time, and in sequential order—at least that is the situation suggested by the few pieces of evidence. But in this scenario, it is difficult to see how, mathematically, the considerable contribution of Perugino could have been completed between October and mid-May at the latest (even if we assume that sometimes two

teams would be working simultaneously on two parts of a fresco). It also remains an open question why the work during the conjectural first campaign was so unequally distributed. Why would a "contract among equals" for the first ten picture fields make Perugino alone responsible for four, but Ghirlandaio—at least in what was in fact completed—responsible for only one?

The new chronology laid out below brings together the insights of both previous theories and the newly discovered expenditure of time for individual scenes. About mid-1481, when construction work on the chapel was largely complete, Piermatteo d'Amelia painted the ceiling as a blue sky spangled with golden constellations, perhaps using some of the extensive scaffolding left from work on the vaulting (see pl. 6). At the same time, Perugino must have begun to paint onto the altar wall the beginning of the series of popes and, below it, the first scenes from the lives of Moses and Christ. Since these pictures were later chiseled off and replaced by Michelangelo's *Last Judgment,* we do not know how they looked or how many days were required to complete them. However, using the average time of forty to forty-one days for the other frescoes, Perugino would certainly have worked on them for more than three months and thus would have started in July 1481 at the latest. Then, in September, Botticelli, Rosselli, and Ghirlandaio could have joined the project; we have evidence that the latter, at least, did not arrive in Rome until that month. First, the three of them finished the portraits of canonized popes along the longitudinal walls and above the entrance. Perugino and his studio assistants, fully occupied with the altar wall, worked on very few of these portraits (fig. 6). After the popes' portraits were done, the tall scaffolding was disassembled, for only lower platforms were needed for the picture fields. The division of labor on the part of the wall devoted to the popes thus has no strict relationship to the picture fields below.

The contract of 27 October 1481 would then in fact mark the beginning of work on the frescoes of the walls running *a capite altaris* (down from the altar side). The Latin formulation *a capite altaris* has had widely different interpretations in the scholarship. We know at least that Johannes Burchard, the papal master of ceremonies from 1484 to 1503, employed it for the Sistine

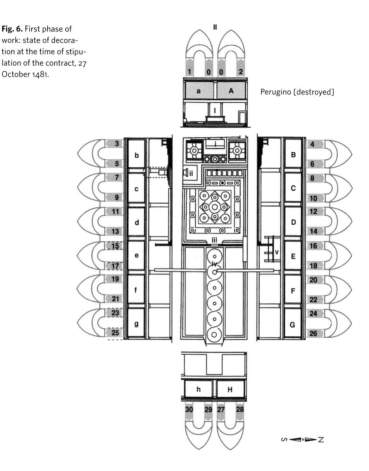

Fig. 6. First phase of work: state of decoration at the time of stipulation of the contract, 27 October 1481.

Perugino [destroyed]

Chapel in the sense of "altar side" or "altar wall." When the contract goes on to stipulate that the painters should proceed "as has been begun," that refers to the example of Perugino's frescoes on the altar wall. Botticelli, the slowest worker, required sixty-three days for his first picture field, including the framing pilasters. If we count up the Sundays and feast days—on which presumably no work was performed—as well as a few days for the preparation of the wall's surface, Botticelli would have been the last of the four painters to finish his first

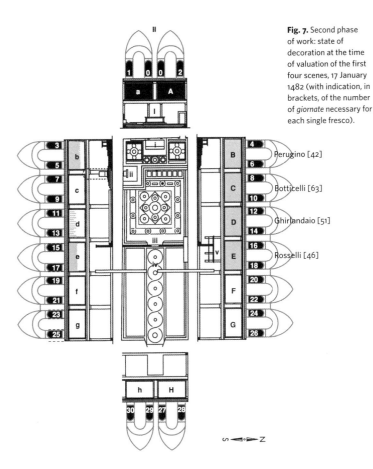

Fig. 7. Second phase of work: state of decoration at the time of valuation of the first four scenes, 17 January 1482 (with indication, in brackets, of the number of *giornate* necessary for each single fresco).

Perugino [42]

Botticelli [63]

Ghirlandaio [51]

Rosselli [46]

fresco, just a few days before the examination by the committee of experts on 17 January. Thus, instead of delaying for months, the committee would indeed have scheduled its examination as soon as at least one work by each artist was completely finished (fig. 7).

By that day in January, Perugino and Rosselli would have been at work for two weeks on their second scene—both of them probably on the Moses pictures directly across from their completed frescoes from the life of Christ on the

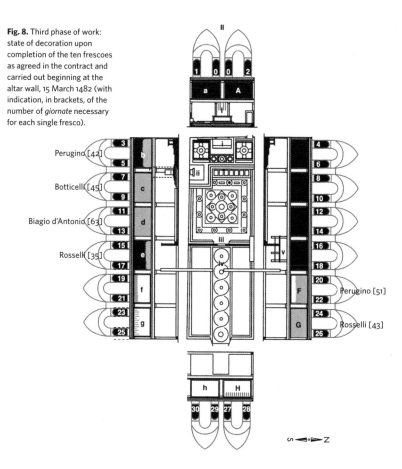

Fig. 8. Third phase of work: state of decoration upon completion of the ten frescoes as agreed in the contract and carried out beginning at the altar wall, 15 March 1482 (with indication, in brackets, of the number of *giornate* necessary for each single fresco).

Perugino [42]

Botticelli [45]

Biagio d'Antonio [63]

Rosselli [35]

Perugino [51]

Rosselli [43]

north wall. When Botticelli then also moved to the other side, he worked furiously to make up for lost time and succeeded in completing his second fresco in forty-five *giornate,* the average time for his colleagues. Meanwhile, Perugino and Rosselli had been at work for barely two weeks on their third picture fields, *The Delivery of the Keys* (see pl. 4) and *The Last Supper,* respectively. For his part, Botticelli set to work on *The Punishment of Korah, Dathan, and Abiram* (see pl. 5) and probably finished it by the end of April 1482.

If this reconstruction is correct, the mutually agreed distribution of the ten picture fields named in the contract among the painters would have been that each of them was responsible for one pair of frescoes facing each other; that would be the easiest way to assure complementarity of style and subject matter. As the most famous of the four, Perugino and Botticelli would each have been granted a third scene. Rosselli's *Last Supper* does not belong to the ten contractual frescoes, but his work continued immediately and without a new contract on the remaining picture fields. The fact that Rosselli was given this important subject, and the first of the remaining four frescoes, owed to his spectacular speed. He completed *Descent from Mount Sinai* (see pl. 9) in a mere thirty-five *giornate* and *The Sermon on the Mount* in only forty-six (and perhaps the future assignment of the fields not covered by the contract was from the beginning held out as an incentive to work quickly). In sum, the contract would have been more or less fulfilled and the collective contractual penalty avoided. By the end of March 1482, with two weeks' delay, Rosselli's *Last Supper* was already finished as fresco number eleven, even though probably only nine of the ten frescoes in the contract were complete; Botticelli had about half the *giornate* for his *Punishment of Korah, Dathan, and Abiram* still ahead of him (fig. 8).

From this sequence of events, it seems probable that Domenico Ghirlandaio and his studio left the team after they finished their first fresco, *The Vocation of the Apostles,* at the end of 1481 or at the latest in mid-January 1482, when the evaluation committee made its inspection. It was Biagio d'Antonio who was called in at this point to paint the corresponding scene from the life of Moses, *The Crossing of the Red Sea.* He had probably already been working as an associate of Rosselli's. The large number of *giornate*—two and a half months of work—shows that Biagio devoted all his energy to the challenge and the dramatic subject matter. (It is arguable that he worked from a design of Ghirlandaio's.)

Increasing time pressure may also have led Perugino to turn over demanding parts of *The Delivery of the Keys* to collaborators, especially Luca Signorelli and Bartolomeo della Gatta. Perugino himself must have been working at the same time on the fresco for the Sistine's high altar, another highpoint of the

entire interior decor. Also at about this time, Signorelli and Bartolomeo were given responsibility for the last two frescoes of the life of Moses. The one on the entrance wall has been destroyed, but the surviving one, *Testament and Death of Moses,* was completed in fifty-six *giornate.* As an exception to the rule, Signorelli and Bartolomeo and their team could have worked on both frescoes concurrently since they stood kitty-corner to each other, which would help to explain the finding that many hands worked on the surviving fresco and would also have made it possible to finish these two picture fields by the end of April at the latest.

A difficulty remains with the last fresco of the life of Christ cycle, located on the entrance wall. The lintel of the chapel's main portal collapsed suddenly on Christmas Eve 1522. The falling debris killed a Swiss guard and missed Pope Adrian VI by a hair. The frescoes above the portal were badly damaged. Surprisingly, unlike the lintel, which was repaired immediately, the frescoes were not replaced by those we see today until 1559–65 or 1571–72. The only evidence for attributing the last fresco, the *Resurrection of Christ,* to Ghirlandaio is in Giorgio Vasari's biography of him, which did not appear until 1550 (with a second edition in 1568). If Vasari's attribution is correct, then we would have to explain why Ghirlandaio was the only painter to switch to the entrance wall before completion of the ten frescoes specified in the contract. Moreover, in the three other corners of the room, the two frescoes meeting at the corner were assigned to the same studio, possibly to save time and money by allowing both picture fields to be worked on from the same scaffold. All of this would suggest that it was not Ghirlandaio but Rosselli who was assigned the *Resurrection of Christ* on the entrance wall next to the *Last Supper,* especially because in the fresco's heavily damaged condition, Vasari may very well have mistaken Rosselli's style for Ghirlandaio's. Rosselli could easily have finished this last contribution by the end of April, given that he again called on his associate Biagio d'Antonio to paint the three small scenes from the Passion in the background of the *Last Supper* fresco, thus gaining more working time for himself. In addition, we have strong evidence that Domenico Ghirlandaio was at least temporarily back in Florence in May 1482—several weeks earlier than his colleagues.[14] Among the four frescoes from

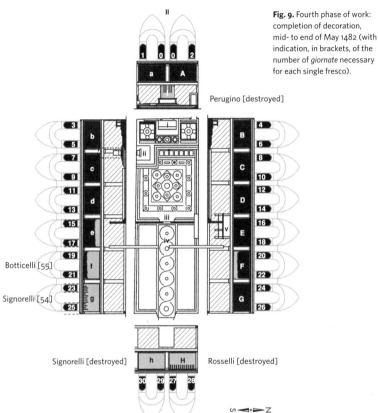

Fig. 9. Fourth phase of work: completion of decoration, mid- to end of May 1482 (with indication, in brackets, of the number of *giornate* necessary for each single fresco).

Perugino [destroyed]

Botticelli [55]

Signorelli [54]

Signorelli [destroyed] Rosselli [destroyed]

the longitudinal wall evaluated in January, Ghirlandaio's was probably the least convincing, and as a result he could have left to work on a different commission.

In any case, the remaining painters in the Sistine Chapel still had the rest of April and the first half of May to see to final details on the frescoes and their frames and to have their associates paint the draperies below them. The report of the evaluation committee of 17 January 1482 explicitly states that the still-incomplete draperies remain to be examined, so this element of the decor was not continued until enough workers were available (fig. 9).

Given the chronology outlined above, Andreas Trapezuntius's declaration—written in mid-May 1482 at the latest—that the chapel was "completed" does not seem to be too great an exaggeration.[15] The mosaic floor and the most important remaining details of decor were probably also nearly finished, although beginning in mid-April, the approach of the Neapolitan army and the postponement of the chapel's consecration until the following year may have caused further delays in the process. The "extraordinary speed" with which the Sistine Chapel was constructed and decorated, so admired by Trapezuntius, was a demonstration of the pope's "omnipotence," but surely it was also due to his age, for he was staring death in the face. Both factors contributed to the "foremost chapel" of Christianity being decorated with one of the greatest fresco cycles of the fifteenth century in Italy in the record time of about a year.

The history of the fresco cycle's creation, sketched out above, underscores the importance of the juxtaposition of picture fields in a dialogue of images from the history of salvation and also suggests what problems could have arisen between artists who were both cooperating and competing with one another. These issues are discussed at length in the sections that follow.

The History of Salvation as a Dialogue of Images

A central element in medieval and early modern biblical exegesis is the notion of a series of conspicuous parallels between the Old and New Testaments that was not merely accidental. On the basis of God's comprehensive plan of salvation, the events of the Old Testament were thought to have occurred as prefigurations of the life of Christ. The temporal succession of cause and effect as it appears to men seemed to be repealed and turned on its head from God's perspective. This typological principle, as it was called, could be divined in many places in the Bible. However, typology was often also—and principally—visually based and could be developed especially well in images. Thus, for example, any cross-like shape—however far removed from an instrument of torture—could function typologically merely on the basis of formal similarity. Sixtus IV himself analyzed the symbolic openness of typology

in his *Tractatus de sanguine Christi* (Treatise on the blood of Christ), written while he was still a cardinal and printed in 1471, using the example of the death and blood of Christ prefigured in the image of the sacrificial lamb and various other sacrifices in the Old Testament: "A configuration in the New Testament and its Old Testament prefiguration [Sixtus uses the words *figura* and *figuratum*] do not have to correspond in every aspect. . . . Nor do they have to proceed at the same pace," but sometimes converge only at one point.[16] Within this theological and art-theoretical context, the paintings in the Sistine Chapel reveal their message as a dialogue of images among themselves and beyond the visual space itself, between the pictures and the texts to which they refer.

The series of popes—in all likelihood beginning with the now destroyed images of Christ and Peter on the altar wall (although perhaps Paul was also there, or only Peter and Paul)—followed the papal chronicle that the humanist and first librarian of the Vatican library, Bartolomeo Platina, composed and had printed in 1479. Inscribed names identify the otherwise indistinguishable first successors to Peter. Before the backdrop of this legitimizing series of predecessors, Sixtus IV had himself presented on the altarpiece, kneeling before the Madonna in heaven, with Peter entrusting him to the Mother of God and laying his hand and the keys on Sixtus's shoulder. As early as 1477, a poetic encomium had compared Sixtus's demeanor with that of the first four popes, from Peter to Cletus.[17]

It would seem that at least in part, the primary source for the sixteen large picture fields of the lives of Christ and Moses, all showing several events occurring simultaneously, was the widely circulated *Historia scholastica* of Petrus Comestor rather than the Bible itself—except for the cases where the depicted events were so well known that the frescoes could have been planned without needing to consult a text.[18] Above every picture field there is a title in large letters briefly communicating the significance of the scene (see appendix, p. 151). In each case, the diction of this title is coordinated with that of the corresponding fresco on the opposite wall. These titles, not rediscovered until the late 1960s, make clear what one could surmise from the pictures' juxtaposition: the scenes from the lives of Moses and Christ are typologically parallel. The

pictures from each life are not meant to be simply read off one after another from the altar wall to the entrance wall; instead, each fresco refers to its mate on the opposite wall. In God's plan of salvation, each event from the life of the Old Testament leader of the Chosen People, the recipient of the Ten Commandments and thus of time *sub lege* (under the law), points forward to an event in the life of Christ, the Redeemer and recipient of the New Testament law of love and thus of time *sub gratia* (under grace). The roles of both as priests, teachers, and sovereigns are emphasized. The typological potential of the images thereby leads us to Sixtus and the present moment in the history of salvation. In this same vein, for instance, the encomium of 1477 mentioned above compares the pope to Moses, who led his people through the Red Sea, away from their enemies and into the promised land.

However, the pictures do more than just illustrate their titles; some of them even shift their supplementary visual messages into the foreground. One example will have to suffice here: *The Delivery of the Keys* and *The Punishment of Korah, Dathan, and Abiram* are connected to each other by their inscriptions' mention of the "turmoil of the soul."[19] It is clear what that means in the case of Moses and the rebellious Korah, but Christ is handing over the keys quite calmly, and the same goes for the secondary scene in the background on the left, the handing over of the tribute money (Matthew 17:24–27). The "turmoil" refers to the background event on the right, where the Jews try to stone Christ for his assertion that he is the Messiah (John 8:59 and 10:31). On the visual level, the two frescoes correspond mainly by virtue of their triumphal arches. The crumbling one from the Moses cycle stands for the fall of all apostate, heretical movements. It serves to underscore the shining authority of the building flanked by two intact triumphal arches on the facing fresco of *The Delivery of the Keys.* Handing over the keys lays the foundation for the future church triumphant, and the donor inscriptions on the triumphal arches relate it to Sixtus IV in their praise of him. The Dominican cardinal Juan de Torquemada had summarized how the image of giving the keys should be interpreted—even without a typological correspondence—in his 1467 instructions for meditation on a cycle

of frescoes in the cloister of Santa Maria sopra Minerva in Rome: Christ in his benevolence had conferred on the popes "a wonderful power" through which they could "free man from sin and open heaven's door to the faithful."[20]

The basic typological conception also shows that the pictures are—at least primarily—not meant as commentary on contemporary events, as has been conjectured especially for *The Punishment of Korah, Dathan, and Abiram*. The inscription on the crumbling triumphal arch is identical with a formulation from the bull *Grave gerimus,* in which Sixtus IV excommunicated Andreas Jamometić, the schismatic archbishop of Krajina (parts of which are in today's Montenegro) in Albania, on 16 July 1482. Earlier scholarship therefore dated the fresco accordingly and connected the choice of scene to this contemporary event alone. However, the new chronology and the title that has been discovered in the meantime show that *The Punishment of Korah* stands much more generally for the dangers of schism and of questioning papal authority. The Old Testament event was already cited in this sense by Gratian, the most important canon lawyer of the High Middle Ages, and after him by numerous fifteenth-century authors. But if the sequence is the other way around and the bull apparently adopted the succinct phrases from the fresco, then it could be evidence that the actual author of the bull, the pope's privy secretary Leonardo Grifo, had been involved in the conception of the visual program for the Sistine Chapel and used his own words a second time. In any event, Sixtus IV's power of the keys was repeatedly invoked in the text of the bull as well; the corresponding fresco, *The Delivery of the Keys,* gained added significance on this level: "The pope carries the keys to eternal life; he is the doorkeeper [of heaven] through the power of the keys."[21]

With such typological correspondences, the Sistine appeals to principles that were already being applied to the early Christian frescoes in the basilicas of Saint Peter and Saint Paul and that continued to be used in medieval ecclesiastical painting in Rome and its surroundings. The same is true of the series of popes, the elaborate marble floor mosaics in the tradition of Roman Cosmati work, and the conjunction of the rood screen with the singing gallery,

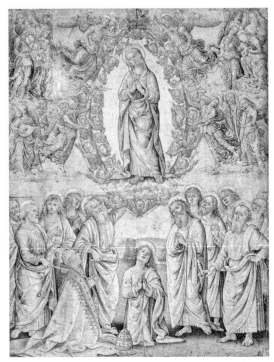

Fig. 10. Studio of Perugino or Jacopo Falconetto. Copy (?) of a drawing of the fresco on the high altar of the Sistine Chapel with the Assumption of the Virgin Mary, 1490s (?), silverpoint, pen, wash, 27.2 x 21 cm. Vienna, Albertina.

which is reminiscent of the early Christian *cantoriae* with an ambo. All of these old-fashioned elements in the chapel's interior have less to do with an "early Christian revival" and more to do with a connection to the long, legitimizing tradition of the Church and its popes.[22]

In this interplay between the Old and New Testaments, Moses and Christ, and Peter and the popes, the Virgin Mary occupies a key position as the typological symbol of the Church. The chapel was under the patronage of the Assumption of the Virgin, which was to be seen on Perugino's altar fresco (fig. 10).[23] The physical Assumption was theologically possible only through the Immaculate Conception of Mary (an event celebrated by its patronage of Sixtus IV's funeral chapel in Saint Peter's). The Assumption of the Mother of God had

also proved to humanity for the first time that Christ's work of redemption had indeed overcome original sin and made possible a future acceptance into God's kingdom. In addition to Perugino's altar fresco, the most important reference to Mary was Piermatteo d'Amelia's ceiling, both the largest and chronologically the first contribution to the chapel's visual program. Until now, however, its importance for a comprehensive interpretation has been all but ignored.

This is owing not just to the fact that the work was forced to make way for Michelangelo's frescoes in 1508 or to the fact that we know its appearance only from a single drawing. An inaccurate reconstruction of how the chapel's interior looked at the time of Sixtus IV's death, prepared in 1899 by Gustavo Tognetti for Ernst Steinmann's influential monograph on the Sistine, also had serious consequences (fig. 11). Ever since its publication, Tognetti's reconstruction has

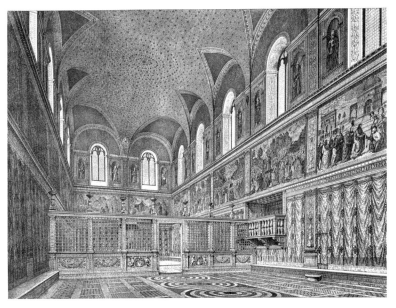

Fig. 11. Gustavo Tognetti (Italian, active ca. 1899).
Reconstruction of the Sistine Chapel at the end of the quattrocento, 1899.
From Ernst Steinmann, *Die Sixtinische Kapelle* (Munich: Bruckmann, 1901), 1: pl. VII.

often been copied and has had a decisive influence on all subsequent ideas of the chapel's original appearance. Tognetti shows the ceiling as a nocturnal vault of heaven with a purely ornamental pattern of stars. If this had been correct, we would have to admit that the ceiling decoration simply adopted the same late medieval conventions to be found, for example, in Giotto's Arena Chapel in Padua. Tognetti's reconstruction also corresponds to the long-standing scholarly assessment of Piermatteo d'Amelia; namely, that he was more an artisan painter than a real artist. Yet why would Sixtus, who commissioned the work and was assiduous in choosing renowned artists, have been satisfied with a third-rate painter for the ceiling? Most important, however, is that in reality, the ceiling looked nothing at all like Tognetti's reconstruction!

The surviving drawing is extremely precise, although its blue pigment has been much altered by the passage of time, thereby affecting its legibility (see pl. 6). It may be the final design on whose basis the contract for Piermatteo's ceiling was agreed upon. This drawing was preserved in the Vatican, and that seems the most likely explanation for the fact that the architect Antonio da Sangallo the Younger (Michelangelo's predecessor as *capomastro* [master builder] of Saint Peter's) noted on the reverse side of the drawing that Michelangelo had conceived of the ceiling in a different way (see pl. 7).[24] What the drawing shows is by no means a traditional, ornamental starry heaven. Instead, it is a portion of the zodiac stretching across the sky. Yet the constellations are presented not as mythological figures but simply as groups of gilded stars, each one a larger or smaller dot according to its luminosity. Thus, not just in sheer size but also in its abandonment of symbolism, the Sistine's "heaven" exceeded, for example, the innovative constellation that was painted above the altar of the Old Sacristy of San Lorenzo in Florence after 1442. (The nearest thing to Piermatteo's ceiling are the dazzling stars of various sizes used in an ephemeral decoration for a famous princely wedding in Pesaro in 1475.)[25] In any event, it seems that Piermatteo's drawing shows the August sky above Rome. This would correspond brilliantly with the patronage of the chapel, the celebration of the Assumption of Mary on 15 August, and the election and coronation of Sixtus IV in August 1471. We can

therefore conclude that the ceiling of the Sistine Chapel acquired a spectacular starlit sky that accorded with the most up-to-date scientific knowledge and method of presentation, as befitted a pope who took pains to reform the calendar and who had a special interest in astronomy.[26] The fact that mythological trappings were dispensed with is most easily explained by the location itself: in the center of Christianity there should be no sight of gods or other figures from classical antiquity.

This dark blue vault of heaven, with its gilded stars twinkling in the candlelight of the liturgy, completed the Sistine's visual program, for with her Assumption into heaven, the Virgin Mary became both *porta coeli* and *regina coeli,* the "door to the heavenly kingdom" and the "queen of heaven," her attribute a blue, starry cloak. In Dante Alighieri's depiction of paradise in *The Divine Comedy,* Mary the triumphant queen of heaven appears in the sky among the fixed stars (*Paradiso* 23.91–139). Here the divine plan for the world is most clearly revealed: the procession of the stars and the divine order they embody directs the fate of the world and of humanity. At the same time, the starry sky serves as a warning to men (*Purgatorio* 14.148–50): "The heavens call you and wheel about you, showing you their eternal beauties, and your eyes gaze only on the earth."[27] And finally, the sky of fixed stars marks the boundary of the created world. Above it begins the eternal empyrean, the place of the angels and the elect, above whom there is only the Trinity.

If at first the walls of the Sistine Chapel—with Moses, Christ, the Virgin Mary, and the canonized popes beginning with Peter—refer the viewer to the past, then the gaze into the (painted) sky reveals God's transcendent and future plan of salvation. This border of the created world could be overcome only thanks to a God-given vision (such as Dante's) or at the End of Days, upon the return of the lord of the world that would end all earthly categories of space and time. Mary was the first human to tread the path into heaven. The rest of humankind hoped for God's mercy and the intercession of Christ, Mary, and the saints at the Last Judgment. Thus the starry sky above the Sistine connected the past history of salvation with the hope for a future kingdom of heaven.

Artists in Competition | In the encomiums written in the fifteenth century in praise of papal construction projects and art commissions, no one is named except the relevant pope. The decisive initiative, the only one worth mentioning, was ascribed to him as commissioner of the work. The names of the artists involved play no role in these texts, although in other contexts the artists might be highly regarded. This state of affairs began to change with the first modern guide to Rome by Francesco Albertini, published in 1510. In his enumeration of "some churches and chapels" of the "new Rome," Albertini, himself a priest and a painter, briefly mentions the major themes of the Sistine Chapel and names—accurately for the most part— the artists who painted the frescoes: "The very beautiful chapel of Sixtus IV in the Apostolic Palace, in which there are pictures from the Old and New Testaments as well as the canonized popes," by the hand of Perugino, Botticelli, Ghirlandaio, Rosselli, and "Philippus Florentinus" (he probably meant Filippino Lippi, whom he confuses with Signorelli). But Albertini says not a word about the architect of the building, so that even today there is debate about whether it was Giovannino di Pietro da Dolci or Baccio Pontelli. Most important, however, Albertini hints for the first time at a motive for the painters' cooperation, a hint that Vasari would later elaborate on: he writes that there was "competition among the most outstanding painters."[28]

We shall see below that such a competition of artists and paintings was central to the decoration of the Sistine in the sixteenth century. For the quattrocento frescoes, however, this was until recently thought not to be the case. After all, Rosselli, Botticelli, Ghirlandaio, and Perugino signed the contract of October 1481 together. And Sixtus IV's main concern seems to have been to engage a competent team of the greatest talents—some of whom he knew from earlier commissions—who would be able to decorate the enormous stretches of wall in record time. Time pressure also explains why another of the pope's "court painters," Melozzo da Forlì, was not entrusted with any part of the commission. In the first half of 1481, Melozzo (along with his Roman colleague Antoniazzo Romano) was still receiving funds for paintings in the pope's private library in

the Vatican. After that, however, Melozzo seems to have been so busy with the frescoes in the sacristy of Saint Mark's in Loreto—probably also commissioned by the pope—and possibly with the now lost frescoes in the apse of Santi Apostoli in Rome, that he was not considered for the Sistine Chapel.

The selection of the four painters finally chosen likely had an additional motivation as well. In his praise of the Sistine Chapel, Andreas Trapezuntius explicitly mentions the fact that astonishingly enough, the enormous building was completed during the great armed conflict with Florence. Trouble had flared up when the Medici accused the pope of supporting the Pazzi conspiracy to which Giuliano de' Medici fell victim in 1478. Peace between Florence and Rome was not concluded until 3 December 1480, after Giuliano's brother Lorenzo, who was only wounded during the attack, made a personal visit to Rome. Against this background, the exclusive engagement of four painters who worked in Florence—and who, moreover, were grouped together precisely under this topographical rubric around 1485 in Giovanni Santi's poem in celebration of painting—can hardly be understood as anything but a political statement. The pope was honoring the cultural—and in particular the artistic—blossoming of Florence, which in its turn was contributing to the decoration of the papal palace and thus paying homage to the head of the Church.[29]

It is certain that as they began their work, the four painters were given thematic specifications and then decided on particular formal guidelines among themselves. It is also certain that no individual fresco was supposed to stand out from the ensemble by emphasizing personal elements of style and invention. And in the end, the enormous pressure to complete the assignment on time required increasing collaboration. Even under these conditions, however, the painters apparently competed to prove their virtuosity—something Sixtus probably expected to happen. At least since the beginning of the fifteenth century, the principle of increasing quality through competition was official policy. For example, three of the statues of seated angels on the facade of the Duomo in Florence were assigned to three different sculptors with the promise that the best one would then get the commission for the remaining fourth angel. Here,

too, precise specifications for the statues had obviously ensured that despite the competition, in its primary features the ensemble formed a coherent whole.

This background allows us to understand especially the conspicuously virtuosic figures of Perugino, which directly face their most important viewer, the pope himself on his throne (it is also here that we find the most portraits of contemporaries). Perugino already derived great advantages from his theme, the Baptism of Christ. In addition to his depiction of landscape and groups of figures, with the ideally beautiful nude figure of God's son and the seated figure next to him—who is waiting to be baptized and removing his tights in a complexly foreshortened pose—Perugino was able to demonstrate his complete mastery of human anatomy and his engagement with ancient art (in this case, the *Spinario*).[30] That this is the only fresco to be signed also confirms that in the end, Perugino was granted a leading role among the four painters.[31]

By contrast, Botticelli's first assignment seemed to present great difficulties. In the theme of the Temptation of Christ, which included a purification ritual, nude figures—a principal way for an artist to exhibit his mastery—had no place. The dedication Botticelli nevertheless brought to the task is evident in the sixty-three *giornate* the fresco required. No other surviving picture from the fifteenth century in the Sistine took so long to complete. Among other things, Botticelli's brilliant conception includes a young woman carrying a bundle of oak firewood and a little boy clutching a bunch of oversize grapes and being frightened by a snake emerging from them (see pl. 8). These two figures are clearly set off from the background of contemporaries surrounding them by their idealized forms, active poses, and the woman's rippling drapery and streaming hair. Since they do not belong to the essential personnel of the Old Testament purification ritual, a late fifteenth-century viewer would have recognized them as a sort of decorative commentary. The fact that these figures were subsequently reproduced as a separate, independent panel by Botticelli's studio at least suggests such an isolating, abstract, allegorical intention. The young woman belongs to the category of antique "nymphs" (the name given them by Aby Warburg around 1900, using the example of precisely this figure),

especially cultivated and very popular in Florence.[32] The boy, on the other hand, requires of the viewer antiquarian knowledge of another order. Botticelli combined in him two clearly recognizable ancient statues that by this time were probably already in the Vatican collections: a girl starting back from a snake and a boy with grapes. At the same time, the figure allowed the learned to display their knowledge of Pliny the Elder's *Naturalis Historia* (*Natural History*), which had been printed in Latin for the first time in 1469 and in Italian translation in 1473. Pliny reported that the ancient Greek painter Zeuxis had painted a boy with grapes so authentic-looking that birds gathered to pick at the fruit (book 35, ch. 36, §65–66).[33] Zeuxis had painted a similar picture in competition with the painter Parrhasius. In the text just before this passage, Pliny praises another painting of Zeuxis that showed the young Hercules strangling the serpents and depicted the terror of his mother, Hecuba, in a particularly impressive way. Thus Botticelli's boy is not just a synthesis of the two ancient statues; he is also related to several works of Zeuxis surviving in Pliny's descriptions. How current such ideas were is shown in poems by Ugolino Verino from the same time that compare Botticelli to Zeuxis and his grapes: "Sandro is a painter the equal of Zeuxis, who had the gift of fooling birds with painted grapes."[34]

The greatest challenge for Botticelli was to put his artistic figures into a meaningful relationship with the painting's other contents, the purification ritual and the temptations of Christ. Wine and serpent could refer not merely to the sacrificial blood of Christ and to sin; the oversize grapes could also be interpreted as a reference to the spies with the grapes from the promised land (Numbers 13:16–27). Just as the fresco as a whole brings together Christ and the Old Testament, the boy with the grapes connects Jesus and Moses. And the woman with the bundle of sprouting oak branches (the oak was in the coat of arms of the Della Roveres, the pope's family) seems to show that all dangers present and future will be overcome by the pope's efforts.

Rosselli obviously built similar self-reflective theoretical commentary into his pictures. On the marble frame of the fresco *Descent from Mount Sinai,* an illusionistic paint pot and brush have been painted as if left behind by the painter.

Obliquely behind them stands the idol of the golden calf with a monkey sitting on the ground before it (see pl. 9). Here, Rosselli's intention must have been to do more than merely condemn art as an idol and mere aping. The forgotten paintbrush was probably meant as witty self-praise, for this fresco was by far the most quickly completed in the Sistine Chapel. The message would be something along the lines of: "This work was painted with such speed that we even overlooked some of our tools"—and yet the trompe l'oeil is perfectly executed. We may hear an echo of Rosselli's phenomenal speed in Vasari's report that Sixtus IV considered Rosselli's frescoes the best in the chapel (if only, allegedly, because of their extensive gilding and not their virtuoso execution).

Although the fifteenth-century hymns of praise for the papal commissions still do not name the artists, simply having the best artists of the time compete with one another contributed decisively to the glory of their patron Sixtus (and at least the self-portrait of Perugino is recognizable in *The Delivery of the Keys*). Frescoes in this number and of this quality were to be found nowhere else in Italy at that time. In all the contemporary criteria for outstanding painting, they set new standards: in relation to ancient art, in perspective, in the depiction of the human body, in portraiture, in convincing action and affect, in landscape, and so on. The precisely contemporary encomium of Andreas Trapezuntius confirms this reputation. He wrote that the chapel's frescoes distinguished themselves not just in their "beauty," "softness" of color, apparent "lifelikeness," "variety," and mastery of the human figure. One also found oneself in the presence of "complete and absolute art" that surpassed even the painting of the ancient Greeks.

Sixtus IV, the *renovator urbis* (renovator of the city), did not want his construction projects and beautification campaigns in Rome to be regarded primarily as monuments to his glory and brilliant statements of papal omnipotence, as was the case with his predecessor Nicholas V. According to the Englishman Robert Flemmyng, writing in 1477, Sixtus was guided by "usefulness, fear of God, and honesty," which explains why he mainly invested in the urban infrastructure.[35] In the final analysis, what was crucial to the Franciscan monk and spiritual leader

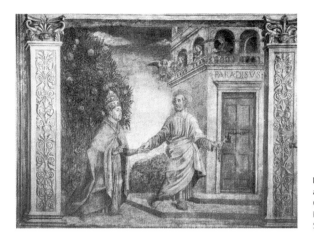

Fig. 12. Pope Sixtus IV
at the door of heaven.
Ca. 1484, fresco.
Rome, Ospedale di
Santo Spirito in Sassia.

of Christianity was the love of God and one's fellow man as well as salvation. In any event, that was the message of the painted life of Pope Sixtus in the hospital of Santo Spirito in Sassia, a mere few hundred yards from the Vatican Palace. This work was begun in 1475 and included at least thirty-four scenes, the last two possibly not completed until just after the pope's death in 1484. One of these final two shows Sixtus kneeling as angels present his buildings as good works to God the Father. The last picture then suggests his reward: Sixtus is spared the fate of ordinary men, who when they die must serve a period of expiation in purgatory. Sixtus's progenitor Saint Peter opens the door directly into heaven, labeled "PARADISVS" (fig. 12). In stark contrast to what would befall his nephew a mere three decades later in an anonymous satire (see fig. 1), the Prince of the Apostles even takes Sixtus by the hand. In death, Sixtus IV finds his place among the canonized popes he had ordered to be painted between the windows of his chapel. Just as his great palace chapel was erected symbolically in an earthly garden of paradise and served during Sixtus's lifetime as the outstanding location of papal majesty, so the towering architecture of the heavenly city honors him after his death.

NOTES

1. On Frances of Rome's visions of the hereafter, see Giorgio Carpaneto, *Il dialetto romanesco del Quattrocento: Il manoscritto quattrocentesco di G. Mattiotti narra i tempi, i personaggio, le "visioni" di Danta Francesca Romana, compatrona di Roma* (Rome: Nuova Editrice Spada, 1995), 13–14, 40–41, and 319. On their graphic depictions, see Kristin Böse, *Gemalte Heiligkeit: Bilderzählungen neuer Heiliger in der italienischen Kunst des 14. und 15. Jahrhunderts* (Petersberg: Imhof, 2008); and Alessandra Bartolomei Romagnoli, ed., *Francesca Romana: La santa, il monastero, e la città alla fine del Medioevo* (Florence: Ed. del Galluzzo, 2009).

2. Iannotius Manetti, *De vita ac gestis Nicolai Quinti Summi Pontificis,* ed. Anna Modigliani (Rome: Storico Italiano per il Medio Evo, 2005), 84. See Carroll W. Westfall, *In This Most Perfect Paradise: Alberti, Nicolas V, and the Invention of Conscious Urban Planning in Rome, 1447–55* (University Park: Pennsylvania State University Press, 1974); and Christine Smith and Joseph F. O'Connor, *Building the Kingdom: Giannozzo Manetti on the Material and Spiritual Edifice* (Tempe: Arizona Center for Medieval and Renaissance Studies, 2006), esp. 168–84 and 394–97. Moreover, in the fifteenth century at the latest, two inns on today's Piazza del Paradiso had the names Il Paradiso Grande and Il Paradiso Miccinello (or Piccolo). See Umberto Gnoli, *Alberghi ed osterie di Roma nella Rinascenza* (Rome: P.

Maglione, 1942), 119.

3. For comprehensive information on the construction history, see Alessandro Monicatti, *Il Palazzo Vaticano nel Medioevo* (Florence: Olschki, 2005).

4. On the liturgical use of the chapel, see John Shearman, "La costruzione della cappella e la prima decorazione al tempo di Sisto IV," in *La Cappella Sistina: I primi restauri; La scoperta del colore,* ed. Marcella Boroli (Novara: Istituto Geografico De Agostini, 1986), 22–87; and Bernhard Schimmelpfennig, "Die Funktion der Cappella Sistina im Zeremoniell der Renaissancepäpste," in *Collectanea II: Studien zur Geschichte der päpstlichen Kapelle,* ed. Bernhard Janz (Vatican City: Biblioteca Apostolica Vaticana, 1994), 123–74.

5. On music and its symbolic importance, see Reinhold Hammerstein, *Die Musik der Engel: Untersuchungen zur Musikanschauung des Mittelalters* (Bern: Francke, 1990). On music in the Sistine Chapel in particular, see Klaus Pietschmann, *Kirchenmusik zwischen Tradition und Reform: Die päpstliche Kapelle und ihr Repertoire unter Papst Paul III (1534–1549)* (Vatican City: Biblioteca Apostolica Vaticana, 2007).

6. On the life of Sixtus IV, see Egmont Lee, *Sixtus IV and Men of Letters* (Rome: Edizioni Storia & Letteratura, 1978); Rona Goffen, "Friar Sixtus IV and the Sistine Chapel," *Renaissance Quarterly* 39 (1986): 218–62; and Isidoro Gatti, "'Singularis eius inaudita doctrina': La formazione intellettuale e francescana di Sisto IV e suoi rapporti

con gli ambienti culturali," in *Sisto IV: Le arti a Roma nel Primo Rinascimento,* ed. Fabio Benzi (Rome: Edizioni dell'Associazione Culturale Shakespeare, 2000), 21–32.

7. On the endowment of statues on the Capitoline, see Tilmann Buddensieg, "Die Statuenstiftung Sixtus' IV. im Jahre 1471: Von den heidnischen Götzenbildern am Lateran zu den Ruhmeszeichen des römischen Volkes auf dem Kapitol," *Römisches Jahrbuch für Kunstgeschichte* 20 (1983): 33–73; on the burial chapel in Saint Peter's, see Maria G. Aurigemma, "Osservazioni sulla Cappella dell'Immacolata Concezione in S. Pietro," in Benzi, *Sisto IV: Le arti,* 458–94.

8. The first floor of the Sistine Chapel is described in a Latin poem by Aurelio Brandolini, *De loco qui Paradisus dicitur, a Sisto aedificato* (On the place called Paradise, erected by Sixtus), printed in Eugène Müntz, *Les arts à la cour des Papes pendant le XVe et le XVIe siècle* (Paris: E. Thorin, 1878–82), 3:135–36.

9. On Giuliano della Rovere, see a marginal notation to the *Taxae cancellariae apostolicae,* MS. Lat. 4192A, fol. 71, Bibliothèque nationale de France, Paris, published by John Shearman in *Die Sixtinische Kapelle* (Zurich: Benziger, 1986), 27.

10. Giacomo Gherardi, *Il diario romano di Jacopo Gherardi da Volterra,* ed. Enrico Carusi (Città di Castello: S. Lapi, 1904), 109 (lines 5–6).

11. John Monfasani, "A Description of the Sistine Chapel under Pope Sixtus IV," *Artibus et Historiae* 7

(1983): 9–18.

12. Contract of 1481 and report of 1482, transcribed in Arnold Nesselrath, "The Painters of Lorenzo the Magnificent in the Chapel of Pope Sixtus IV in Rome," in *The Fifteenth Century Frescoes in the Sistine Chapel,* Francesco Buranelli and Allen Duston (Vatican City: Musei Vaticani, 2003), 70–71. However, the fact that Sixtus IV was a very dilatory client who took decades to pay the painters' invoices is shown by Leopold Ettlinger, *The Sistine Ceiling before Michelangelo: Religious Imagery and Papal Primacy* (Oxford: Clarendon, 1965), 30; and Dario Covi, "Botticelli and Pope Sixtus IV," *Burlington Magazine* 111 (1969): 616–17.

13. See Maurizio De Luca, "Technique and Restoration Method," in Buranelli and Duston, *Fifteenth Century Frescoes,* 87–93 and 239–49, with analytic diagrams of all frescoes.

14. Unlike his colleagues Perugino and Botticelli, whose return to Florence is not documented until the fall of 1482, Ghirlandaio must have been back on the Arno by May 1482, since a son—Ridolfo—was born to him nine months later, in the very first days of February 1483. See Ronald G. Kecks, *Domenico Ghirlandaio und die Malerei der Florentiner Renaissance* (Munich: Deutscher Kunstverlag, 2000), 227; and Jean K. Cadogan, *Domenico Ghirlandaio: Artist and Artisan* (New Haven: Yale University Press, 2000), 224–25.

15. Monfasani, "A Description of the Sistine Chapel," 9–18.

16. Sixtus IV, *Tractatus de sanguine Christi* (Nuremberg: Friedrich Creussner, 1473), [fols. 54r–56v]; see Franz Xaver Kraus, *Geschichte der christlichen Kunst*, vol. 2.2, *Italienische Renaissance*, ed. Joseph Sauer (Freiburg im Breisgau: Herder, 1908), 342.
17. Robert Flemmyng, *Lucubranciunculae Tiburtinae*, published by Vincenzo Pacifici, *Un carme biografico di Sisto IV del 1477* (Tivoli: Società Tiburtina di Storia e d'Arte, 1922), 18, 62–63 (on Sixtus and Moses). This edition is not entirely reliable; see Jozef IJsewijn, "Robert Flemming and Bartolomeo Platina, or the Need of Critical Editions," *Humanistica Lovaniensia* 34A (1985): 76–82.
18. See the evidence gathered by Ettlinger, *The Sistine Ceiling*, 59, 64, 66, 77–78. On the dissemination of the text, see James H. Morey, "Peter Comestor, Biblical Paraphrase, and the Medieval Popular Bible," *Speculum* 68, no. 1 (1993), 6–35.
19. The titles (*tituli*) were first published by Deoclecio Redig de Campos, "I *tituli* degli affreschi del quattrocento nella Cappella Sistina," *Pontificia Accademia Romana di Archeologia: Rendiconti* 42 (1969/70): 299–314. Visual reminders of the lost first scenes of the lives of Jesus and Moses destroyed for Michelangelo's *Last Judgment* can be found in panel paintings by Perugino and the Master of Apollo and Daphne (Berea College, Berea, Kentucky), as noted by Alexander Linke, *Typologie in der Frühen Neuzeit: Genese und Semantik heilsgeschichtlicher Bildprogramme von der*

Cappella Sistina (1480) bis San Giovanni in Laterano (1650) (Berlin: Reimer, 2014), 96 and n312.
20. Johannes de Turrecremata, *Meditationes*, ed. Heinz Zirnbauer (Wiesbaden: O. Harassowitz, 1968).
21. For the text of the bull, see Jürgen Petersohn, "Kirchenrecht und Primatstheologie bei der Verurteilung des Konzilsinitiators Andreas Jamometić durch Papst Sixtus IV: Die Bulle 'Grave gerimus' vom 16 Juli 1482 und Botticellis Fresko 'Bestrafung der Rotte Korah' (mit Edition des Quellentextes)," in *Proceedings of the Twelfth International Congress of Medieval Canon Law*, ed. Uta-Renate Blumenthal, Kenneth Pennington, and Atria A. Larson (Vatican City: Biblioteca Apostolica Vaticana, 2008), 667–98. For Antonio Gratiadei's statement on the pope's power of the keys, see Steinmann, *Die Sixtinische Kapelle*, 1:272. Peter Howard analyzes the frescoes as a "sermon for the eye" and suggests that Marco Maroldi, the new Master of the Sacred Palace (*Magister Sacri Palatii Apostolici / Pontificalis Domus Doctor Theologus*), was an adviser for the program; see Peter Howard, "Painters and the Visual Art of Preaching: The *Exemplum* of the Fifteenth-Century Frescoes in the Sistine Chapel," *I Tatti Studies: Essays in the Renaissance* 13 (2010): 33–77.
22. On the tradition of graphic images in Rome since the early Christian era, see Herbert L. Kessler, *Old St. Peter's and Church Decoration in Medieval*

Italy (Spoleto: Centro Italiano di Studi sull'Alto Medioevo, 2002).
23. The most recent discussion of the drawing is by Hans-Joachim Eberhardt, "Falconetto kopiert Perugino in der Sixtinischen Kapelle," in *Kunst und Humanismus: Festschrift für Gosbert Schüßler zum 60. Geburtstag*, ed. Wolfgang Augustyn and Gosbert Schüssler (Passau: Klinger, 2007), 87–103.
24. Inv. 711°, Gabinetto dei Disegni e delle Stampe, Galleria degli Uffizi, Florence; the inscription on the back has been variously deciphered. In Steinmann, *Die Sixtinische Kapelle*, 1:191; and Charles de Tolnay, *Michelangelo II: The Sistine Ceiling* (Princeton: Princeton University Press, 1945), 13, we read: "Per la capella di Sisto di mano di Piermatteo di mano di Piermatteo d'Amelia; non si fece così. La fatta Michelangelo poi a fiure come si vede in opera" (For the chapel of Sisto by the hand of Piermatteo d'Amelia; but not realized like this. Michelangelo made it then with . . . as one sees it in the work [today]). More recently, Monica Castrichini has suggested: "P[er] lacapella di Sisto di maniera dipiermatteo damelia non si fece così / lafatta Michelangelo poi afine / comesi[o]ne di Papa" (For the chapel of Sisto in the manner of Piermatteo d'Amelia; but not realized like this. Michelangelo finished it then [as] a commission of the pope); see Monica Castrichini, "Catalogo opera," in *Piermatteo d'Amelia: Pittura in Umbria meridionale fra '300 e '500*, ed. Francesca Baldelli et

al. (Todi: Ediart, 1997), 199–200; and Vittoria Garibaldi and Francesco F. Mancini, eds., *Piermatteo d'Amelia e il rinascimento nell'Umbria meridionale*, exh. cat. (Cinisello Balsamo: Silvana, 2009), 134, cat. no. 18 (Monica Castrichini). My suggestion is a combination of the two: "P[er] lacapella di sisto di mann[i?]era di piermat[teo] damelia no[n] si fece così / Lafatta michelagnolo poi a fi[g]ure come si vede i[n] op[er]a" (For the chapel of Sisto in the manner of Piermatteo d'Amelia; but not realized like this. Michelangelo made it then with figures as one sees it in the work [today]).
Some assume that the drawing was not made until 1504 by Piermatteo d'Amelia, then circa sixty years old, in conjunction with discussions about restoring the ceiling; see most recently Volker Herzner, *Die Sixtinische Decke: Warum Michelangelo malen durfte, was er wollte* (Hildesheim: Olms, 2015), 21–23. Others have interpreted this note to mean that Piermatteo's project of 1481 was not realized and that there was no ceiling decoration at all in the Sistine Chapel before Michelangelo, also pointing out a casual remark in Vasari's 1550 edition of the *Lives* (2:962: "sendo la volta della cappella di Sisto non dipinta"), which, however, can simply mean that the ceiling was not painted with figures; for the modern edition, see Giorgio Vasari, *Le vite de' più eccellenti pittori, scultori e architettori nelle redazioni del 1550 e 1568*, ed. Rosanna Bettarini and

Paola Barocchi (Florence: Sansoni, 1987), 6:33. The claim that Piermatteo's project was never realized is unlikely to be correct. Brandolini's poem *De loco qui Paradisus dicitur, a Sisto aedificato*, written shortly after the completion of the chapel, alludes to the heavens ("coelumque reduxit"), 3:135–36; and the eyewitness Andreas Trapezuntius described the chapel as "completed in all parts" (absolutum omni ex parte). See Trapezuntius, cited in Monfasani, "A Description of the Sistine Chapel," 11–12. Moreover, it would not make much sense that Paris de Grassis would report in his *Diarium* on 10 June 1508 about the noise and dust raised by the destruction of the old ceiling (just an uncolored layer of white plaster?). The thesis that there was an original ceiling fresco but the surviving drawing was not made until 1504 leaves open the question of why such a detailed drawing was needed for a restoration but not for the original job, for in that case, the drawing would probably not have to supply a completely new design for the ceiling—it would only supplement what was already there. Sangallo's cryptic note, which in any case was written on the back years later, seems to me to refer to the basic form of the ceiling and the altered configuration of its architectural frame; for this connection, see Shearman, "La costruzione della cappella," 42–45. On Sangallo's collection of drawings and his practice of often not inscribing the sheets until years later,

see Christoph L. Frommel, "Introduction: The Drawings of Antonio da Sangallo the Younger; History, Evolution, Method, Function," in Frommel, ed., *The Architectural Drawings of Antonio da Sangallo the Younger and His Circle* (New York: Architectural History Foundation, 1994), 3–5.

On the question of why Piermatteo was awarded this prestigious commission in 1481, see Nathaniel Silver, *Close Up: Piermatteo d'Amelia's Annunciation* (Carlisle, MA: Benna, 2016), 45–47. Silver notices that in 1476—immediately before the start of the chapel's renovation—Sixtus IV left Rome to flee the plague and spent three months in Piermatteo's hometown of Amelia.

25. On the starry sky of San Lorenzo painted by Giuliano d'Arrigo, known as Il Pesello, see Isabella Lapi Ballerini, "Il 'cielo' di San Lorenzo," in *La linea del sole: Le grandi meridiane fiorentine*, ed. Filippo Camerota (Florence: Edizioni della Meridiana, 2007), 29–39. On Pesaro, see Jane Bridgeman and Alan Griffiths, *A Renaissance Wedding: The Celebrations at Pesaro for the Marriage of Costanzo Sforza & Camilla Marzano d'Aragona, 26–30 May 1475* (London: Miller, 2013), 57–58. Thanks to Gerhard Hartl from the Deutsches Museum, Munich, for the identification of the astronomical constellation, and to Philippe Morel for alerting me to the wedding in Pesaro.

26. See Dieter Blume, "Picturing the Stars: Astrological Imagery in the Latin West, 1100–1550,"

in *A Companion to Astrology in the Renaissance*, ed. Brendan Dooley (Leiden: Brill, 2014), 333–98. On Sixtus IV, who began preparations for a calendar reform and invited the astronomer and mathematician Johannes Müller (Regiomontanus), see Karin Reich, "Problems of Calendar Reform from Regiomontanus to the Present," in *Regiomontanus: His Life and Work*, ed. Ernst Zinner, trans. E. Brown (Amsterdam: Elsevier, 1990), 345–62.

27. Dante Alighieri, *The Divine Comedy of Dante Alighieri*, vol. 2, *Purgatorio*, trans. John D. Sinclair (New York: Oxford University Press, 1961), 189–91.

28. Francesco Albertini, *Opusculum de mirabilibus novae & veteris urbis Romae* (Rome: Iacobum Mazochium, 1510), [fol. X iii°]–[X iv°] and [fol. Y°], reprinted in Peter Murray, ed., *Five Early Guides to Rome and Florence* (Farnborough: Gregg, 1972).

29. On this political dimension of the choice of artists—a conjecture already made by Steinmann (*Die Sixtinische Kapelle*, 1:110) and by Herbert P. Horne, *Alessandro Filipepi, Commonly Called Sandro Botticelli, Painter of Florence* (London: George Bell and Sons, 1909), 74–75—see, most recently, Tobias Daniels, *La congiura dei Pazzi: I documenti del conflitto fra Lorenzo de' Medici e Sisto IV; Le bolle di scomunica, la "Florentina Synodus," e la "Dissentio" insorta tra la santità del Papa e i Fiorentini* (Florence: Edifir, 2013). Giovanni Santi, *La vita e le gesta di Federico di Montefeltro, duca d'Urbino*, ed. Luigi Michelini (Vatican

City: Biblioteca Apostolica Vaticana, 1985), 2:668–77 (XXII/xci, vv. 364–79): "Ma in Italia, in questa età presente / vi fu [. . .] / dui giovin par d'etate e par d'amori, / Leonardo da Vinci e 'l Perusino / Pier della Pieve, ch'è un divin pictore, / el Ghirlandaia, el giovin Philippino, / Sandro di Botticello, e 'l Cortonese / Luca, de ingegno e spirto pelegrino. / Hor, lassando di Etruria el bel paese, / [. . .]" (But in Italy at the present time / there were [. . .] / two youths of the same age and same loves, / Leonardo da Vinci and the Perugian / Pier della Pieve, who is a divine painter, / Ghirlandaio, the young Filippino, / Sandro Botticelli, and the Cortonese / Luca, of singular skill and spirit. / Now, leaving Etruria the beautiful country, / [. . .]). Translation from the Italian by Sabine Eiche. That at the time of the decoration of the Sistine Chapel, Perugino was by no means seen as the representative of an "alternative school of painting," as has recently been argued (Stefano Pierguidi, "'Quasi ella sia stata il centro di tutte': La 'concorrenza' dei pittori forestieri nella Roma di Sisto IV e Giulio II," *Commentari d'Arte* 15/44 [2009]: 21–35), is also demonstrated by the poem written between 1480 and 1487 by Ugolino Verino, which presents Perugino, along with Ghirlandaio, Botticelli, and others, as an ornament to the city of Florence: "At contra celeri pingendi gloria dextra / Reddidit insignes Ghirlando nomine fratres. / Nec Zeuxi inferior pictura Sander habetur, / Ille licet volucres pictis

deluserit uvis. / [. . .]
/ Tu quoque Apelleos
nosti Perusine colores /
Fingere, & in tabulis viuos
ostendere vultus" (And on
the other hand, the skillful
glory of the swift strokes
/ Made the Ghirlandaio
brothers famous. / Nor is
Botticelli's art of painting
inferior to that of Zeuxis,
/ Although the latter
deluded the birds with
painted grapes. [. . .] /
And you, Perugino, knew
how to re-create the col-
ors of / Apelles, and how
to exhibit living faces in
panels). Translation from
the Latin by Ivana Bičak.
See Ugolino Verino, *De
illustratione urbis Florentiae
libri tres* (Lyon: Apud
M. Patissonium, 1583),
fol. 17r–v (II, vv. 443–86).
30. The antique *Spinario*
sculpture served as a
reference for the seated
figure next to Christ pull-
ing off his stockings.
31. For the special role
of Perugino, see also the
sources from the early
sixteenth century quoted
by Ettlinger, *The Sistine
Ceiling*, 31.
32. See the two-part study
by Barbara Baert: *Nymph:
Motif, Phantom, Affect; A
Contribution to the Study of
Aby Warburg (1866–1929)*
(Leuven: Peeters, 2014);
and *Nymph: Motif,
Phantom, Affect. Part II:
Aby Warburg's (1866–1929)
Butterflies as Art Histor-
ical Paradigms* (Leuven:
Peeters, 2016).
33. Pliny, *Natural History*,
vol. 9, *Books 33–35*,
trans. H. Rackman, Loeb
Classical Library 394
(Cambridge, MA: Harvard
University Press, 1952).
34. Verino, *De illustratione
urbis Florentiae*, fol. 17r–v
(II, vv. 443–86). To be
sure, Verino is inconsis-
tent in his comparisons. In

*De pictoribus et sculptoribus
florentinis qui priscis graecis
equiperaro possunt,*
Botticelli is compared to
Apelles and Leonardo
da Vinci to Zeuxis; see
Ugolino Verino, *Epigrammi*,
ed. Francesco Bausi (Mes-
sina: Sicania, 1998), 328
(III, 23). In the epic poem
Carlias, the "wondrous his-
tory paintings in the royal
palace of Buthrotum" are
ascribed to Botticelli ("the
Tuscan Alexander, succes-
sor of the Coan Apelles"
[tuscus Alexander, Choi
successor Apellis]) and
Filippino Lippi; see Ugolino
Verino, *Carlias: Ein Epos
des 15. Jahrhunderts*, ed.
Nikolaus Thurn (Munich:
Fink, 1995), 150–51 (I, vv.
319–34). Translation from
the Italian by Sabine Eiche.
35. See Fabio Benzi,
*Sisto IV, Renovator Vrbis:
Architettura a Roma,
1471–1484* (Roma: Officina,
1990); Benzi, *Sisto IV: Le
arti;* Eunice D. Howe, *Art
and Culture at the Sistine
Court: Platina's "Life of
Sixtus IV" and the Frescoes
of the Hospital of Santo
Spirito* (Vatican City:
Biblioteca Apostolica Vat-
icana, 2005); and Philine
Helas, "Ospedale di Santo
Spirito in Sassia," in *Rom:
Meisterwerke der Baukunst
von der Antike bis heute*,
ed. Christina Strunck
(Petersberg: Imhof, 2007),
183–87. Flemmyng, *Lucu-
branciunculae Tiburtinae*,
30, vv. 716–20 ("verum
sanctorum templis
pulchrisque sacellis /
atque monasteriis, et
[ut uno plurima verbo /
comprendam] innumeris
praestantibus aedibus, iis
quas / utilitas, pietas vel
honestas denique poscit,
/ non pompa aut fas-
tus. . . ."); also see 26 and
66, where the hospital of
Santo Spirito is described.

TRIUMPHAL GATE AND ENTRANCE HALL TO THE CITY OF GOD: MICHELANGELO'S CEILING FRESCOES AND JULIUS II

Even tearing down paradise could open up a new path into it. Work on the foundations of the choir of Old Saint Peter's in preparation for a significantly expanded structure had begun in the mid-fifteenth century under Pope Nicholas V, but decades later not much progress had been made. So Pope Julius II supposedly gave the architect Donato Bramante carte blanche for an even more ambitious project. Bramante demolished the choir of the early Christian basilica, and in 1506, the cornerstone was laid for a monumental new structure of his design. Even if the old nave and the sanctuary were preserved for the time being and were screened from the construction site by a temporary wall, services in Saint Peter's were so disrupted that the pope transferred feast days and other scheduled events to the nearby Sistine Chapel with increasing frequency. And once the chapel had been decorated with new ceiling paintings by Michelangelo between 1508 and 1512 on the orders of Julius, it was even more justified to call it the "foremost chapel in the world." The successive destruction of Saint Peter's elevated the Sistine de facto to the center of Christianity.

Once again, these changes at the door of heaven were controversial. In 1517, a little book by Andrea Guarna titled *Simia* ("ape" or "copycat") was published in Milan.[1] Guarna, who was probably a priest and had been in Rome since 1510 or 1511, wrote it there in 1516. His text, a satire on conditions at the Curia under Julius II, describes a procession of recently departed souls toward heaven and their discussions with the doorkeeper, Saint Peter, about whether they are worthy of admission. First, Guarna praises in the highest terms both the new pope, Leo X, incumbent since 1513, and his predecessor Julius II. While the latter had

been denied entry in the satire *Pope Julius II at the Locked Door of Heaven* (see fig. 1), Guarna—in what is certainly a conscious intertextual reference—reverses the situation by assigning Julius a place of honor among the popes in paradise. Then he depicts the destruction of Old Saint Peter's as the result of Bramante's deception of the pope. And so Peter does not let the architect into heaven, for "it was you who tore down my temple in Rome!" When Bramante assures him that Leo will certainly finish the new building quickly, Peter responds cautiously that until then, Bramante can wait at heaven's door. The architect displays his hubris in particular with his vision of radically demolishing all of paradise and rebuilding it from the ground up, making it even more comfortable and magnificent than before. He would begin with the road leading to heaven's door, which would no longer be steep and difficult but have generously wide curves and be passable even on horseback, an obvious reference to the spiral staircase Bramante in fact built in the Vatican Palace.[2]

Guarna's satire, which conceives of paradise in earthly terms, functioned well because Rome as a whole, and especially the Vatican Hill with Saint Peter's and the papal palace, was widely regarded by contemporaries as similar to or as an anticipation of paradise and the Civitas Dei. That is how the visionary transition from Rome to the heavenly city is visualized on the opening pages of several illuminated manuscript editions of Augustine's *Civitas Dei* (*City of God*) made for Nicholas V, in which the Vatican is prominent in the foreground.[3] Should Saint Peter be inclined not to accept Bramante's conditions in heaven, Guarna's text threatens that the architect will be transferred to hell, where after millennia of destructive fire his renovation plans will certainly be welcome.

Yet the commission to repaint the Sistine Chapel ceiling should not be seen merely in connection with the gigantic construction site of Saint Peter's and the substantial renovations and expansion of the Vatican Palace that also began in these years. When Michelangelo received the commission, he was already in the service of the pope as a sculptor. Since 1505, he had been working on the gargantuan project of a tomb for Julius in the main choir chapel (Cappella Iulia) of the new Saint Peter's. With Michelangelo's switch to the Sistine's ceiling,

work on the tomb experienced its first lengthy interruption and would reach a makeshift conclusion—laborious decades later—only with Julius's tomb in San Pietro in Vincoli. But the Sistine Chapel profited from both the demolition of Old Saint Peter's and the "tragedy of the tomb." The project of new ceiling frescoes for the chapel depended on a readiness to destroy what existed comparable to that of Julius II and Bramante in the case of Old Saint Peter's. It is true that in the spring of 1504, a large settling crack had opened up in Piermatteo d'Amelia's vault of nocturnal sky, but this damage was patched with bricks, probably in the course of the same year, and could have been easily repainted. In any case, the crack cannot have been the real motivation for a new conception and radical alteration of the heavenly vault, given that the vault was almost six hundred square meters in area, painted with costly blue and gold pigment, and, even at the beginning of the sixteenth century, still unique in its precise detail.

Difficulties and Rewards of the Work The earliest surviving documentary evidence of the idea to offer Michelangelo the job of painting the Sistine ceiling makes clear the difficulties that confronted contemporary interpreters and continue to confront us today. On 10 May 1506, the minor architect and sculptor Piero Rosselli wrote from Rome to his friend Michelangelo in Florence, reporting a conversation between himself, Bramante, and Pope Julius II:

> On Saturday evening—the pope was at table—Bramante and I showed him some drawings for his assessment. When the pope had eaten and I had showed them to him, he sent for Bramante and told him, "[Giuliano da] Sangallo is going to Florence early tomorrow morning and will bring Michelangelo back with him." Bramante replied, saying, "Holy Father, that will come to nothing—I have already tried several times and Michelangelo told me again and again that he did not want to work on the chapel" and that you [Michelangelo] wanted to turn this task over to him [Bramante]; and that thus, you wanted to work on nothing except

the tomb, not on any paintings. And he continued: "Holy Father, I think
Michelangelo doesn't have the courage for the task, since he hasn't yet
made too many figures and especially since the figures are very high up
and must be shown in foreshortening, and that's another thing entirely
from painting on the ground." Whereupon the pope answered and said,
"If he doesn't come, he will do me wrong, so I believe that in any case he
will come back!" At this moment, I intervened and scolded him [Bra-
mante] roundly.[4]

Thus, in April 1506 at the latest, a complete repainting of the Sistine ceiling
was under consideration, as was commissioning the thirty-one-year-old Michel-
angelo to carry it out. Thirteen months earlier, Michelangelo had broken off
work on his large fresco *Battle of Cascina* in the Palazzo Vecchio in Florence—
hardly having finished the cartoon—in order to accept the commission for
Julius II's gigantic tomb in Rome. The artist's sketches and drafts for the tomb
call for approximately forty monumental marble figures. But even after one year
of Michelangelo working on this commission, all the marble had not yet reached
Rome. In the face of repeated demands for money from Michelangelo, Julius
seems to have lost patience for a brief time, refusing several payments to the
sculptor. Possibly on the day the cornerstone of the new Saint Peter's was laid
(18 April 1506) or the day thereafter, Michelangelo fled to Florence. The pope,
however, was not really put out. As Rosselli's letter proves, the pope hoped that
Michelangelo's friend, the Florentine architect Giuliano da Sangallo, would talk
some sense into the artist and bring him back to Rome as quickly as possible.
For even before their falling-out, the serious delays in the tomb project had made
it painfully clear to the sixty-five-year-old pope that in view of his age, he must
look for a faster alternative to enter his name in the history books with an artistic
project of the very highest order. What was more obvious than to present himself
to the world in what was at this time the most important room in Christianity?

In the end, Julius's desire to be remembered may have been the catalyst for
the idea of repainting the Sistine ceiling. At the same time, Julius was making

a seamless connection to the family tradition of his uncle Sixtus, who not only urgently pursued the speedy renovation of the chapel but also shortly before had built himself a funeral chapel in Saint Peter's. Both the large number of workers who were supposed to assist Michelangelo when work actually got under way in 1508 and the—for Michelangelo—surprisingly rapid completion of the ceiling in just four years also suggest that, as was the case under Sixtus IV, the artist was working against the clock to finish before his patron's impending death, a race he came to within a few weeks of losing. Officially, work on Julius's tomb continued in parallel. In this context, the frescoes in the Sistine were thought of as an interim commission, at least initially. The removal of the existing ceiling was justified as an improved decoration of the chapel with greater art, thereby enhancing its religious effect and majesty.

This removal also leads to a look at the costs, although such numbers are to be read with some skepticism. For the construction of the Cappella Iulia in 1513, estimated expenses were about 20,000 ducats, with 10,500 more for the tomb in its center. By comparison, for the entire Sistine ceiling, 3,000 ducats were contractually agreed upon in 1508, and by 1512, about 3,200 had probably been paid out. To be sure, this seemingly modest amount compared with the tomb's cost was still almost three times the usual fee for similarly extensive frescoes in the fifteenth century (for example, Domenico and Davide Ghirlandaio's frescoes in the high chapel of Santa Maria Novella in Florence). Michelangelo's position as an exceptional artist is evident in the exceptional fee. That fee, along with his frugal style of life, put him in a position to save about 2,000 ducats of the Sistine fee. Thus the commissions of Julius II laid the cornerstone for the considerable wealth Michelangelo accumulated during his life.[5]

The majority of scholars read Rosselli's letter of 1506 primarily as evidence of enmity between Michelangelo and Bramante and of their competition for papal commissions. And the biographies by Vasari (1550, 1568) and Ascanio Condivi (1553) seem to confirm this view. They both pass along the story, with variations, that with the commission for the ceiling fresco, the considerably older architect and painter Bramante had wanted to distract Michelangelo

from his rightful discipline of sculpture and had hoped that the inexperienced parvenu would botch the job and embarrass himself. There is no question that the relationship between Bramante and the prickly Michelangelo was strained.[6] In the course of further work in the Vatican, it even led to an open conflict. Besides, the situation of Vatican artists in general promoted competition between them. However, Vasari and Condivi, writing the artists' biographies decades later, inaccurately reshaped the events of earlier in the century. Their assertion, for example, that Michelangelo himself had suggested Raphael replace him for the commission has no basis in fact: at the time, Raphael had not even arrived in Rome. In addition, the late Michelangelo worked very hard to present his younger self as an unprecedented, exceptional genius, which meant denying that Bramante had ever served as a model.

Yet in 1506, Bramante would have been a perfectly obvious choice as the ideal candidate to repaint the ceiling. After all, he was considered a master of complicated perspectival compositions. Of the frescoes painted around 1500, Bramante's *Argus* fresco in Milan (see pl. 10)—which survives only in fragmentary form—with its combination of fictive architectural elements, bronze tondi, and an apparently living figure, displays the most similarities to Michelangelo's later conception of the Sistine ceiling. And no less a source than Benvenuto Cellini reports (although not until the 1560s) that it was indeed Bramante who was supposed to have repainted the ceiling.[7] It may or may not be so. But it is unlikely that the sixty-four-year-old master, recently busy with the Vatican's three great construction projects—Saint Peter's, the papal palace, and the Belvedere—would have been seriously considered for the project.

There were surely several reasons why in the end the choice fell on Michelangelo. He had been trained in fresco painting in Florence and had recently won one of the most prestigious commissions of the time, the *Battle of Cascina,* which was supposed to rival and complement Leonardo da Vinci's *Battle of Anghiari.* Moreover, he was already working in Rome as a sculptor for the pope, who was obviously very pleased with oversize projects and Michelangelo's new, heroic style. On the other hand, Bramante had rightly remarked that

Michelangelo "hasn't yet made too many figures," especially ones that "are very high up and must be shown in foreshortening." It could be that, without being in the least hostile, Bramante was naming with fair precision Michelangelo's real misgivings in taking on the task.

If one rereads Rosselli's letter against this background, with Bramante's declaration that Michelangelo lacked the courage for the new project, then the letter can be understood less as an expression of deep hostility between the two artists than as a precisely calculated provocation—more or less a supplement to the encouragement of Michelangelo's friend Giuliano da Sangallo—to win Michelangelo for the project after all. The latter had shortly before (in 1501–4) made a name for himself with the marble *David* in Florence, a sculptural tour de force whose daring Michelangelo himself emphasized at various times. Thus there was actually nothing left for Michelangelo to do but reply to Bramante's provocation by proving the opposite. It even seems possible that the letter writer, Michelangelo's *charisimo fratello* Rosselli, was privy to the plan, for shortly thereafter, he profited from the commission himself by helping to construct the scaffolding and prepare the surfaces of the Sistine ceiling. And if, as some scholars have argued, Michelangelo in fact gave the features of Bramante to the prophet Joel in the first bay he painted (and the similarity to Bramante's portrait in Vasari's *Lives* is at least worth considering), then that would argue for Michelangelo's great respect for Bramante as a colleague, at least until 1510.

At any rate, the desired result was achieved. In 1507, Michelangelo was working for Julius II again—for the time being on the triumphal bronze statue that was erected to the pope in Bologna after its reconquest for the papal state. Immediately after the statue's completion, Michelangelo hoped to be able to return briefly to Florence to work on the tomb commission. But he was back in Rome by 23 April 1508, and by 10 May he wrote in his diary that he had begun "to work [on the ceiling] today" (certainly not on the fresco yet, only on preparations).[8] In the following four years, it would demand his entire attention.

To begin the discussion of Michelangelo's work on the ceiling, we need to address two practical questions that illuminate both the chronology of the

ceiling frescoes and Michelangelo's self-image: who were his assistants and what kind of scaffolding did he work from? The biographies by Vasari and Condivi give different reports of Michelangelo's helpers. According to Condivi, Michelangelo completed all the painting basically alone. We can recognize this as Condivi's attempt, promoted by Michelangelo himself, to portray him as a solitary, peerless artist-hero. According to Vasari, however, Michelangelo was aided by five assistants from Florence (that they were Florentines comports well with Vasari's local patriotism). Of course, Michelangelo hired specialists to build the scaffolding and prepare the ceiling's surface; even for such seemingly minor tasks, he sought people he knew well, some of them brought to Rome from Florence. For the entire time, he certainly had the help of several (perhaps four?) workshop boys who ground pigments, held the cartoons against the ceiling to be traced, clambered up and down the scaffold to run errands, and so on. It is also well documented that by the end of April 1508, Michelangelo had five additional painters come from Florence, very probably at the urgent wish of the pope, who was anxious for the work to be done as quickly as possible. Francesco Granacci, Michelangelo's friend from their days as apprentices to Ghirlandaio, seems to have helped out with the hiring in Florence and then acted as a kind of project manager in Rome. The painters who were hired on were Bastiano da Sangallo, Giuliano Bugiardini, Jacopo di Sandro, Jacopo "L'Indaco" Torni, and Agnolo di Domenico di Donnino. Whether these were the only painters who helped remains an open question.

It is hardly surprising that discoveries made during the most recent renovations reveal that the ceiling's trompe l'oeil architectural elements, its ornaments and inscriptions, and a series of secondary figures were not all painted by Michelangelo himself. Of the picture fields along the central axis, it is especially *The Flood,* the first to be painted, that seems to have been created with help from other painters. However, while critics have been able to distinguish various stylistic hands in the fresco, no one has yet convincingly attached specific names to any of them. The other remaining difficulty is that Michelangelo's account statements from this time show no regular debits for the cost of wages;

could it be that the pope himself undertook to pay the painter's helpers directly? Overall, however, despite the differences in the details of their narratives, the two biographies agree that in the end, Michelangelo lost patience with his colleagues and sent them away. This is likely true to the extent that as work on the ceiling continued and Michelangelo's experience increased, he needed less and less help. In any case, even when we concede that other hands participated, the sheer amount of work Michelangelo achieved on the ceiling remains enormous.

Both biographies use the construction of the scaffolding as anecdotal support for animosity between Bramante and Michelangelo. Bramante, who supposedly was given the job of building a platform for work on the ceiling, is said by Vasari and Condivi to have consciously proposed an impractical design that would have suspended the platform from ropes. Leaving aside this late and unverifiable artistic legend, the primary challenges confronting a scaffold of such great height were to avoid damaging the existing frescoes from the fifteenth century and to let through to the ceiling enough air and at least some light from the windows below. Despite the putlog holes in the wall uncovered during the most recent restorations as well as a sketch of the scaffolding by Michelangelo also discovered a few years ago, there is still controversy about its exact construction.[9] The carrying beams were set above the cornice that encircles the chapel at the bottom edge of the lunettes and were reinforced by oblique beams resting on the main cornice. Upon the base of this open structure of beams probably rested catwalks and the actual work platform that rose in steps to follow the curve of the ceiling and was fairly easy to move to a new location. Michelangelo drew a caricature of himself on the margin of a poem he wrote, showing the miserable working conditions that forced him to work with his back constantly arched, his head tilted back, and paint dripping onto his face (fig. 13).

In addition, the web of beams seems to have been screened off from below with a sort of barrier, likely meant primarily to preserve the dignity of the chapel below and intercept falling mortar, tools, and the like, but also to prevent people from seeing Michelangelo's frescoes too soon. One can imagine such a (suspended?) pseudo-ceiling in the central part of the scaffolding so that air and

Fig. 13. Michelangelo (Italian, 1475–1564).
Self-caricature while painting the ceiling, 1512 (?), drawing next to a poem.
Florence, Archivio Buonarroti.

light could still reach the ceiling area from the sides. Nevertheless, Michelangelo needed additional illumination from lamps for his work. His figures probably owe the brilliant intensity of their colors partly to these lighting conditions. It is often repeated that Michelangelo at first built scaffolding beneath only half the ceiling, from the entrance to the midpoint, and then moved this scaffolding to the other half; however, the scaffolding must have spanned the entire chapel, because to chip off the starry sky and prepare the surface for painting, every corner of the ceiling had to be accessible. When work on the frescoes then began, the first task was to place the basic frame of trompe l'oeil architecture onto the irregular surface of the ceiling by fitting it within a network of lines and markers. This, too, required access to the entire ceiling. Moreover, the master of ceremonies Paris de Grassis reported with relief on 31 October 1512 that the "three or four years" during which the chapel's ceiling (and not just part of it) "was always covered up" were now concluded.[10]

Michelangelo's self-supporting scaffolding enabled the chapel to remain usable: as possible, services continued in the Sistine during the entire period of work on the ceiling. That some interference was unavoidable, however, is shown by a complaint of the cardinals on 10 June 1508 that the dust and noise that day had been intolerable. It is very likely that at that point, the workers were chiseling off the original ceiling fresco above the area of the altar and converting the two abutting spandrels in each of the eastern corners of the chapel into two large, continuous, sail-shaped surfaces. All this preparatory work was finished on 27 July, leaving the ceiling ready to be frescoed. Probably since the beginning of April, while the preparatory work was still going on, Michelangelo had been working through several drafts toward the final complete plan for the ceiling.

The frescoes were begun at the entrance end of the chapel, in reverse order from the way they were intended eventually to be read, probably to limit disruption of services at the other end of the space (see pls. 11a, 11b). By August 1510, some of the ceiling frescoes seem to have been largely complete. Michelangelo suggested as much in letters and asserted it again in retrospect in 1523.[11] Moreover, at this point he received partial payment for a "completed part" and for the

construction of more scaffolding. However, since just at this time the pope was leaving Rome to reconquer Bologna for the papal state and did not return until June 1511, he did not see the "new paintings that were recently unveiled" until the eve of 14 August 1511, the vigil for Assumption Day, the Sistine's patronal feast.[12] During Julius's absence, a quarrel arose about the payments for what had been done and, despite two visits by Michelangelo to the pope in Bologna, it could not be resolved. And so from September 1510 until at least February or June—and more likely even until September—1511, Michelangelo did no work in protest and in his own words "lost all this time."[13] Not until the pope had settled the matter, possibly during an audience he granted Michelangelo on 30 September, did the artist get back to what remained to be done. Finally, on 1 October 1512, Michelangelo was able to write to his father, "I have finished the chapel I was painting. The pope continues to be very pleased with it. But the other matters are not succeeding as I had expected. The times are to blame, which are very adverse for our art."[14] The final touches and the disassembly of the scaffolding once more forced the chapel to close completely for a few days. Then on 31 October, Paris de Grassis reports, "Today our chapel was opened for the first time since the paintings were completed." On the following day, 1 November 1512, the Feast of All Saints, the frescoes were presented in a solemn mass.

While the beginning and ending of the fresco production are well documented, differences of opinion remain as to what constitutes the first and second part of the work. The older theory is that Michelangelo painted the actual vaulted ceiling first and then, in a second step, the lunettes, vaulting cells, and pendentives. An alternative theory put forward by Johannes Wilde identifies a stylistic shift in the Genesis scenes in the central fields of the ceiling after *The Creation of Eve*.[15] The change is attributed to Michelangelo being able to get his first good look at the finished half of the ceiling from the chapel floor in 1510 and seeing that the scale of his figures was too small. According to Wilde's theory, once the scaffolding for the second half of the ceiling was in place, Michelangelo then, in a rush, finished the job to the altar wall from 1511 to 1512. Wilde hypothesizes that the picture fields along the edge were painted more or less

at the same time as the central fields, although a stylistic difference is not so clearly evident in the former. Still after the most recent restorations, this second theory of how the work progressed seems to have become the majority opinion.

However, those restorations revealed for the first time the precise number of *giornate* required for the ceiling. The problem of how the work progressed certainly cannot be solved by numbers alone. But it is clear that the Genesis scenes with their accompanying tondi; the groups of prophets, sibyls, and *ignudi;* and the lunettes, vaulting cells, and pendentives each required about 190 *giornate.* For the putative first phase of two years up to *The Creation of Eve,* a scant 300 *giornate* would have been invested. In the remaining second phase, lasting slightly more than a year, another 270 *giornate* would have been required. And one must add in more than seventy Sundays and holidays per year when no work was done, as well as the time Michelangelo needed for sketches and cartoons (by comparison, the work of the Curia was suspended on more than 140 days a year). If it is true that Michelangelo resumed work in earnest only after his audience with the pope at the end of September 1511, it hardly seems possible—purely mathematically—that he and his helpers finished the second half of the ceiling in the short time remaining. On the other hand, if he painted the actual ceiling surfaces in the first two years and in the second phase painted the border, then the *giornate* would be divided in the exact proportion of two-thirds to one-third. (The analysis of the types of plaster used and their distribution on the ceiling also suggests this model for how the work was carried out.)[16]

This is the situation that Francesco Albertini's guide to Rome—dated 4 February 1510 (about six months before the end of the first phase of work) and dedicated to Julius II—seems to describe quite precisely if one takes seriously his phrasing that Michelangelo "has decorated the upper, arched part [of the Sistine, but not the 'lower' arched part] with very beautiful pictures and with gold [the tondi?]." It also seems to agree with Michelangelo's own recollection, written in 1523, of how the work progressed. Condivi's later declaration that the ceiling was painted "in twenty months" thus also proves to be largely correct. If we add Condivi's further report that the pope ordered the ceiling unveiled

after Michelangelo had painted half of it, then it would mean that after a year of work, in 1509, Michelangelo presented the impatient Julius with what he had achieved up to that point: a good half of the ceiling surface without the sur-rounding lunettes, vaulting cells, and pendentives, in around 200 *giornate*. After that, he modified his style and accelerated his pace. The term *unveiling* in this case would not mean disassembling the entire scaffolding but merely removing the protective covering.

On the other hand, when Michelangelo tells his father on 5–7 September 1510 that the pope owes him five hundred ducats, needed to continue the "other part of my work" and "make the scaffolding,"[17] this easily comports with his making initial plans for the second phase: the lower picture fields and the work platforms that would need to be positioned at the juncture of walls and ceiling. It is also important to note that the restorers discovered it was not just in the central picture fields that the working method changed; a similar acceleration was to be found in the fields around the margins (but not in the two elaborately worked pendentives above the altar), as was a change in the technique used to trace the cartoons. (The lunettes, however, were largely laid out freehand.) Some of the ornamental details were also changed, although there are irregularities in them. According to the theory of the second work phase described here, it is not necessary for the margins of the ceiling to have been painted bay by bay from the entrance to the altar. Instead, it is possible that entire half-sections of wall were prepared and painted together. Time pressure may also have increased toward the end of the second phase so that the changes in the fields along the margin may have another explanation than just the pause between the two work phases. A final piece of evidence that the ceiling and the lunettes were not carried out in parallel but that the central vault was painted first, with the margins following, is the distribution of the different kinds of plaster that Michelangelo used over the years, as documented by the latest restoration (see pl. 12). While this distribution cannot be unambiguously interpreted, it seems to fit most easily with the interpretation of the chronology presented here.

Without being able to definitively clear up these questions of inner chronology, we can say that despite Michelangelo's laments to his father about the times being "adverse for our art," by 1512 his frescoes had fulfilled the pope's wildest dreams of leaving behind a monument to his outstanding patronage of the arts. For with them, Michelangelo, "called by Julius II, with the promise of rich recompense" (as Paolo Giovio wrote in 1527 in the earliest biography of Michelangelo), gave " testimony to his perfect art"—equal to that of antiquity— by having "completed in the Vatican, in a short time, an immense work."[18]

"Evidence of the Perfection of His Art" | The ceiling's formal and thematic designs present us with at least as many complications as its physical completion. Michelangelo himself wrote in 1523 that

> Pope Julius did not want me to continue work on the tomb, but to paint the ceiling of the Sistine instead; and we agreed on three thousand ducats for the work. The first drawing [i.e., the first design] of the work showed twelve Apostles in the lunettes and the rest with a certain distribution filled with ornaments, as was usual. Then, when I had begun the work in question, I thought it was turning out to be a paltry business, and I told the pope that—if I only painted the Apostles—it would be a paltry business. He asked me why. I replied, "For they too were poor folk." As a result, he gave me a new assignment that I was to do what I wanted and what would satisfy me, and that I should paint all the way down to the paintings of events below.[19]

Four surviving drawings by Michelangelo confirm that the design we see today was reached only after several stages of drafts and some radical changes.[20] When he commissioned the work, Julius II at first had in mind a combination of twelve Apostle figures and an ornamental segmentation of the rest of the vault. In and of themselves, those two elements—single figures and antique ornaments—constituted the elevated standard for religious decoration

Figs. 14, 15. Two phases of Michelangelo's design for the Sistine Chapel ceiling, 1508.
Reconstruction and realization by Christoph Luitpold Frommel, Hermann Schlimme, and Johanna Kraus.

in the decades around 1500. This is amply obvious from a look at the ceiling of the Cappella Brizio in Orvieto by Fra Angelico and Luca Signorelli, the Florentine ceilings of Ghirlandaio, and Bernardino Pinturicchio's ceilings in the Vatican itself and in the Libreria Piccolomini of the Siena Cathedral. Michelangelo's thought process began with figures seated on thrones, five along each of the longitudinal walls and one each on the short walls. He combined the thrones with a cornice and filled the interstices with lozenge-shaped and circular compartments. The next version improved the integration of the thrones into the structures surrounding them and lent rhythm to the ceiling sections by alternating wider and narrower bays. Modern attempts to reconstruct the process,

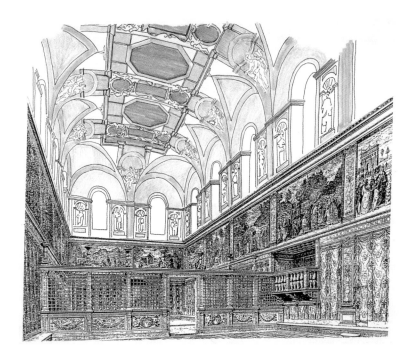

based on Michelangelo's hasty sketches, raise three fundamental problems
(figs. 14, 15). The ornamental segments grew larger and larger, dominated the
Apostle figures, and actually demanded to be filled with substantial images
(if they had been designed to be smaller, they would hardly have been readable
in such a large space). In both drafts, the seated figures do not appear suffi-
ciently monumental and are too "paltry"—while a sketch on the reverse side
of the second drawing makes it seem likely that at this stage, Michelangelo
was already thinking about sibyls and prophets. Most important, he realized
that it was not the figures but the fictive architecture that would ensure the
ceiling's unity.[21]

When Michelangelo claimed that he had been given a free hand to do what he wanted in the final design, he used exactly the same formulation Lorenzo Ghiberti had used scarcely one hundred years earlier to describe how the design for the *Gates of Paradise* in the Florentine baptistery came to be. In that case, however, we know for certain that there were specific guidelines for how the Old Testament scenes were to be depicted. Ghiberti's changes were made mainly to the form and number of picture fields. In the case of Michelangelo, it also seems most likely that being given a free hand did not involve the choice of themes but rather their formal presentation and possibly their distribution. Michelangelo's claims that the Apostles had been planned for the lunettes and that he was supposed to repaint the walls down to the scenes of biblical events were probably careless mistakes on his part.

The final design emerges out of an innovative fictive architecture that gives the illusion of expanding and reinterpreting the ceiling. Melozzo da Forlì's and Andrea Mantegna's tendencies in this direction were significantly amplified and modified by Michelangelo on the Sistine ceiling. The point at which the barrel vaulting commences is negated and an apparent attic story circles the room above the lunettes. At this height, the armrests of the thrones occupied by alternating monumental figures of prophets and sibyls serve simultaneously as pedestals for the transverse arches of the rhythmic ceiling vaulting. Everywhere a transverse arch begins, there are *ignudi* sitting at its base: brilliantly dynamic nude young men, some of whom hold oak-leaf garlands in the fictive space while others hold ribbons to which bronze medallions are fastened. The four larger and five smaller picture fields that alternate down the center of the ceiling seem suspended from their bays, devoid of any frames of their own, with the smaller ones flanked on both sides by the bronze medallions. And finally, at both the entrance wall and the altar wall, this painted vault leaves a narrow band open that seems to afford a view out to blue sky above.

Overall, the perspective of the ceiling is not oriented to any particular viewing location. Instead, its effect evolves successively as one moves from place to place down one side of the chapel while viewing the section of the ceiling

on the opposite side. Both in the scenes from Genesis and in the depictions of the prophets and sibyls, one can clearly see the stylistic development and enlargement of the figures in the course of the work, an enlargement of scale that runs counter to the direction in which the ceiling is to be read. The smallest narrative scale is found in the first picture field to be completed, *The Flood.* On the entrance wall, *Zachariah,* the first completed prophet, still sits strictly parallel to the surface of the wall. By contrast, the prophet Jonah on the altar wall is designed as a figure of maximum artistic virtuosity and the greatest level of difficulty and was much praised by Michelangelo's contemporaries. Despite the fact that the ceiling at that point actually curves forward, Jonah seems to be leaning backward and stretching his legs into the real space of the chapel.

In detail, beginning at the altar wall, the nine picture fields show Genesis from the *Separation of Light from Darkness* to *Noah's Drunkenness* after *The Flood* (fig. 16). The accompanying fictive bronze medallions continue the story from Abraham to the Books of the Maccabees from the Apocrypha. The latter subject was chosen because the feast day of Julius's titular church when he was a cardinal was the same as that of those warrior-priests from the Old Testament. Moreover, the Temple in Jerusalem plays a central role in the medallions' scenes. This part of the history of salvation in the Old Testament is completed by the four scenes of the rescue of the Chosen People in the pendentives as well as the frescoes of the life of Moses painted onto the lower walls by Michelangelo's predecessors. The figures of the prophets who follow the second Book of the Maccabees chronologically in the Bible and the figures of sibyls popular around 1500 continue the series and emphasize its links to pagan history. Finally, in the lunettes, the forebears of Christ according to the first chapter of Matthew are depicted. The uninterrupted genealogical succession from the altar to the entrance apparently has such importance that figures who already occur in other ceiling scenes—Abraham and David, for example—are repeated. The sequence constantly springs back and forth across the chapel space, and this arrangement formally connects the forebears of Christ with the line of popes beneath them. It remains to be explained, however, why the women in the

Fig. 16. Michelangelo's frescoes on the ceiling of the Sistine Chapel.

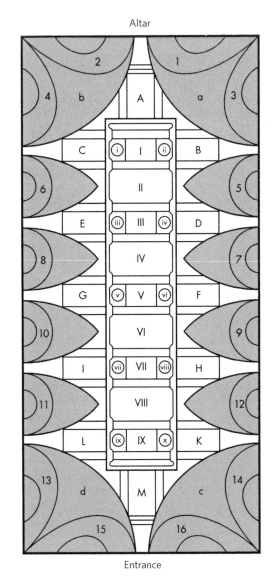

First Phase, August 1508–August 1510

Scenes from Genesis
I. Separation of Light from Darkness
II. Creation of the Sun, Moon, and Planets
III. Dividing Water from Heaven
IV. The Creation of Adam
V. The Creation of Eve
VI. The Fall of Man and Banishment from
the Garden
VII. The Sacrifice of Noah
VIII. The Flood
IX. Noah's Drunkenness

Prophets and Sibyls
A. Jonah
B. Jeremiah
C. Libyan Sibyl
D. Persian Sibyl
E. Daniel
F. Ezekiel
G. Cumaean Sibyl
H. Erythraean Sibyl
I. Isaiah
K. Joel
L. Delphic Sibyl
M. Zachariah

Tondi
i. Abraham's Sacrifice of Isaac
ii. Assumption of Elijah
iii. Death of Absalom
iv. (unfinished; perhaps Eliseus Healing Naaman
of Leprosy)
v. Alexander the Great before the High Priest
vi. Death of Nicanor
vii. The Punishment of Heliodorus
viii. Mattathias Destroys an Idol in Modein
ix. Razi's Suicide
x. The Fall of Antiochus Epiphanes

Second Phase, June or September 1511–October 1512

Pendentives
a. The Punishment of Haman
b. The Brazen Serpent
c. David and Goliath
d. Judith and Holofernes

Ancestors of Christ
1. Abraham, Isaac, Jacob, Judah (destroyed)
2. Phares, Esron, Aram (destroyed)
3. Aminadab
4. Naason
5. Salmon, Booz, Obeth
6. Jesse, David, Solomon
7. Roboam, Abias
8. Asa, Josaphat, Joram
9. Osias, Joatham, Achaz
10. Ezechias, Manasses, Amon
11. Josiah, Jechonias, Sealthiel
12. Zorobabel, Abiud, Eliachim
13. Azor, Sadoch
14. Achim, Eliud
15. Eleazar, Matthan
16. Jacob, Joseph

series of Christ's forebears are given such a prominent visual role when they are never mentioned by name in the accompanying inscriptions.

In the past, early Christian and medieval wall paintings in Roman basilicas, especially those in Old Saint Peter's (fig. 17) and Saint Paul's, were mentioned as models for Michelangelo. For instance, in the array of images in the two basilicas—known to us today only through drawings—the scene of the creation of Adam and Eve and the division of light between sun and moon occupied prominent places. Closer in time to Michelangelo were Lorenzo Ghiberti's so-called *Gates of Paradise* for the Florentine baptistery (so named presumably by Michelangelo because of their beauty but also because as a site of baptism, every baptistery opens the path to heaven), Jacopo della Quercia's

Fig. 17. Domenico Tasselli (?) (Italian, active 1605).
Drawing of the northern wall of the nave of Old Saint Peter's, pen-and-ink drawing, early seventeenth century.
Vatican City, Biblioteca Apostolica Vaticana.

marble reliefs on the main portal of San Petronio in Bologna, and the prophets and sibyls on the bronze tomb of Sixtus IV. For the obscure Bible scenes in the bronze medallions, Michelangelo consulted the woodcuts in an Italian Bible first published in Venice in 1490, named the Malermi Bible after its translator.[22] Other figures—especially the *ignudi*—are responses to ancient statuary such as the Belvedere Torso.

However, another type of ancient monument was perhaps the most decisive influence on Michelangelo's formal organization of the ceiling: the triumphal arch. This may at first seem somewhat surprising, since an arch is an entirely different kind of structure. The segmented attic story of Michelangelo's ceiling fresco that serves as a backdrop for the figures, the combination of various kinds of images (rectangular picture fields, tondi, individual figures) and to a certain extent the construction of the images (especially in the tondi), as well as the various levels of reality—all these features can be found in Roman triumphal arches (fig. 18).[23] Moreover, motifs from triumphal arches played a large role in real ecclesiastical architecture around 1500. It is tempting to ascribe the choice of this ancient model to the patron who commissioned the work, for Julius II's positive obsession with triumphal celebrations is well documented. Concrete examples are the temporary arches erected to celebrate the pope's entrance into the reconquered Bologna in 1507 and his return to Rome, both events staged as triumphs of the Church and the pontifex. This obsession is also evident in panegyrics on the pope that repeatedly employ triumphal metaphors. In the dedication of his guide to Rome, for instance, Albertini praises the pope as a new Julius Caesar who has made the triumph of the cross into a triumph of the church militant and then adds him to the list of ancient conquerors. It is in this context that the ceiling frescoes of the Sistine evoke a succession of triumphal arches—or rather, through these formal references, the entire space is transformed into a triumphal monument.

Yet nothing we have said up to now should give the impression that the design and significance of the ceiling paintings have essentially been explained—for the opposite is the case. Even to Michelangelo's contemporaries,

Fig. 18. The Arch of Constantine in Rome.
From Giovanni Antonio Dosio and Giovanni Battista de' Cavalieri, *Vrbis Romae Aedificiorvm
Illustrivmqvae Svpersvnt Reliqviae* (Rome, 1569), pl. 30.
Heidelberg, Universitätsbibliothek Heidelberg.

the frescoes must have seemed in every respect highly unusual and in need
of explanation. Even the basic concept of painting the ceiling not with orna-
ments or figures but with scenic depictions (from Genesis) was surprising. The
general opinion was that there were no known precedents for such a thing in
Italy. Scholars have speculated that while he was still a cardinal in France in the
1480s, Julius II could have seen the Romanesque ceiling paintings of Saint-
Savin-sur-Gartempe. Another example, from the borders of Italy, is the little
Holy Trinity church in Hrastovlje in Istria (Slovenia), whose interior includes
twelve picture fields on the ceiling with the story of Creation.[24] But neither of
these examples from what were obscure locations from a Roman point of view

is likely to have played a role in the decorations of the Sistine Chapel. There is, however, a Genesis cycle among the mosaics in the narthex of San Marco in Venice. If Michelangelo and his contemporaries were able to estimate the age of these mosaics very roughly as "from the early days of the Church," then that would be another way of referencing the beginnings of the institution.

This connection is supported by a chapel space lying directly outside the gates of Rome. The decorations of the little Oratorio della Santissima Annunziata in Cori were donated primarily by Spanish cardinals between about 1412 and 1450. The oratorio has a surprising number of points of contact with the Sistine. The ogival ceiling vaulting is painted with a cycle of frescoes from the Old Testament, stretching from the creation of Adam to the meeting of Moses and Aaron. The longitudinal walls are painted with a cycle of Moses and one of Christ. And on the entrance wall there is a *Last Judgment* (see pl. 13). This choice of themes still seems to hark back to the pictorial tradition of the basilicas of Old Saint Peter and Saint Paul. Cori thus proves to be an important link between medieval cycles and the Sistine Chapel.[25]

Confusion about the design—from the disposition of the picture fields to individual motifs in the pictures—continued. Even with the most detailed knowledge of the Bible and a willingness to discover in some of Michelangelo's picture fields scenes that had seldom, if ever, been depicted before, people were still unable to put the nine central scenes into a logical chronological order. Indeed, rather than being arranged chronologically, the ceiling is organized in three self-enclosed groups of three scenes each: three pictures of the creation of the world; three of the creation, fall, and expulsion from paradise of the first human couple; and finally, three of the story of Noah. Within each group of three, the scenes requiring the most space occupy the larger fields. Thus the Flood is placed in the middle between the smaller secondary scenes of the sacrifice and drunkenness of Noah, although the Flood comes first in the biblical narrative. The four scenes in the three picture fields devoted to the creation of the world begin with the separation of light from darkness. The separation of heaven from earth (assuming that is what the fresco depicts)

follows chronologically in the Bible, but here it was put into the third field, also a smaller one. The larger middle field shows God the Father creating the sun and the moon and—as if in passing—probably also the plants (which were actually created before the heavenly bodies). The creation of the animals is entirely absent. If we take a look at the title page of the Malermi Bible with its extremely compact illustration of the canonical first six days of Creation, it seems clear that Michelangelo could have accommodated the first five days in the three picture fields at his disposal, and done so quite legibly. Also notable is the effort of will and apparent physical exertion it costs Michelangelo's God the Father to complete the work that, according to the Bible, was the result of his word alone. Lastly, the floating, foreshortened figure of God the Father seen from below in the last picture field to be painted on the Sistine ceiling, directly above the high altar, went against every visual expectation.

The nine scenes from Genesis, however, also conform to a subdivision into two realms that precisely corresponds to the original division of the space by the chancel screen. Above the sanctuary, the first five scenes—up to and including *The Creation of Eve*—all show God the Father; humankind is living and acting in the earthly paradise. Beginning at the chancel screen, on the other hand, the progenitors are expelled, and the Creation is answered by the destruction of the Flood and the promise of a second, new beginning.

Michelangelo's contemporaries were already beginning to respond to and criticize his unusual depictions. When, from 1517 to 1519, Raphael and his studio painted the loggias of the Vatican and included, among other things, four picture fields showing the Creation, he had obviously made an intensive study of Michelangelo's scenes. But Raphael's clearly identifiable events take place in the correct chronological order and without showing God the Father from behind or below. Immediately thereafter, in 1520, the painter Guillaume de Marcillat, who had also worked in the Vatican, received a commission to paint the ceiling fields of the Arezzo Cathedral—the first large-scale religious ceiling frescoes between Rome and Florence since the Sistine Chapel. Michelangelo's model dominates Marcillat's paintings, except that God the Father, creator of the world, is again

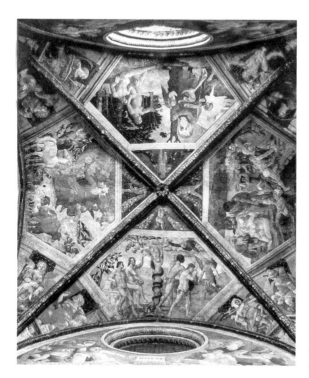

Fig. 19. Guillaume de Marcillat (French, 1467–1529).
Ceiling frescoes in the first bay: Creation of the Sun and Moon and of Earth, Water, and the Animals; the Creation of Eve; the Fall and Expulsion; and the Flood, 1520–22.
Arezzo, Arezzo Cathedral.

a majestic figure enthroned in heaven (fig. 19). The same is true of a copper engraving by Ambrogio Brambilla from about 1588–90, where Michelangelo's Creation scenes are also normalized (fig. 20).[26] Perhaps the most direct criticism is supplied by Michelangelo's biographer Paolo Giovio. The author, himself a bishop, stubbornly refuses to acknowledge God the Creator on the ceiling as such and praises only the artistic quality of the frescoes: "Among the most outstanding representations of men to be seen in the middle of the vault is the picture of an old man flying in the sky. He is delineated with so much symmetry that for our misled eyes he seems to be continually turning and changing his position when one views him from various parts of the chapel."[27]

Fig. 20. Ambrogio Brambilla (Italian, active ca. 1579–99), after Giacomo Vivio dell'Aquila (Italian modeler, active 1588–90), after Michelangelo (Italian, 1475–1564). *Il giudizio universale* (The universal judgment), 1588–90, engraving, 190 x 170 cm. Vatican City, Biblioteca Apostolica Vaticana.

Versions of Genesis

The checkered history of the plan for the ceiling frescoes shows that the Genesis theme was not regarded as the only possible logical extension of the quattrocento decorations. Instead, the initial plan to have the twelve Apostles would have emphasized the transition from Christ to the Church and the popes. It has also been rightly pointed out that Michelangelo's early plans for the ceiling, with its rows of small polygonal picture fields, had structural similarities to medieval genealogical trees and graphic depictions of the succession of ages, like those that play a prominent role in Joachim of Fiore's historical visions.

The succession of events in the history of salvation is also central to the completed ceiling pictures, in which the look back to the beginning of the world and the time *ante legem* (before the law) is always balanced by the look forward to the hope of future salvation. The transcendent order of the divine work of creation and the dignity of man—the latter a central theme not just for the humanists but also in the sermons preached before the pope—seem to be announced by the countless half-nude, idealized human bodies spread like a net over the entire ceiling and culminating in the creation of Adam and Eve and the *ignudi*. Man in the image of God (Genesis 1:26–27) is mirrored in the "beauty of the body of the first man," as one can read under the miniature on the title page of a translation of Philo Judaeus's treatise *The Creation of Woman* dedicated to Sixtus IV.[28] The dignity of man, however, also results from the love of Christ, whose sacrificial death was supposed to cancel original sin. On the ceiling, Christ is always implicitly present as the goal of the history of salvation. His life is depicted on the longitudinal walls, the genealogy in the lunettes ascends toward him, the prophets and the sibyls point to him, and with him, God's promise to man after the Flood is fulfilled. The two pendentives above the altar with the crucifixion of Haman and Nehushtan (the Brazen Serpent) are typological references to Christ's sacrificial death and the Eucharist. Rome and the pope have the primary responsibility for realizing the dignity of man—at least that is how Giles of Viterbo formulated it with reference to Julius II.[29]

In the case of the two corresponding spandrels on the entrance wall, the scene of David conquering Goliath must also be understood primarily as a Christological reference. Judith and Holofernes, however, obviously refer typologically to Mary. And the Renaissance also had a Mariological interpretation of especially Esther's role in the punishment of Haman and the rescue of the Jews in the Persian Empire: "Thou art called the door to heaven, salvation of the world."[30] In the intense discussions and interpretations of the Immaculate Conception, in which Sixtus IV had taken a decisive part, many references to the Mother of God were also discovered in the six days of Creation. For in order to be conceived without sin and be a completely pure vessel for the Son of God,

Mary had to be envisioned in the divine plan of salvation from the beginning of time. In the fresco *The Creation of Adam,* God the Father is presumably placing his left arm around that same Mary. Her nakedness and intense gaze at Adam may make us uncomfortable today, but they reflect with theological accuracy her central place in the plan of salvation from the beginning. In a demonstrative gesture that is one of the most precisely planned details of the entire ceiling, God touches the shoulder of a boy with the hand of the arm he has placed around Mary. One cannot but interpret that boy as the "new Adam" and Son of God. Thus the composition is a clear visual demonstration that the creation of Adam, body and soul, already includes the knowledge of the role Christ will later play.

The ceiling's central picture field then displays Eve as she humbly prays to God while being created from Adam's rib. The scene refers typologically to the birth of the Church from the wound in Christ's side. Another miniature from the aforementioned treatise by Philo Judaeus impressively depicts precisely this connection (fig. 21), as does the contemporaneous relief of the creation of Eve (dated around 1471–77) by Giovanni Damata for the tomb of Paul II, Sixtus's predecessor, in Saint Peter's. The idea is that Mary occupies the middle position, for in her place in the history of salvation, she reflects Eve on the one hand and points ahead to the Church on the other. It is the Church alone that administers the means of salvation and regains access to heaven for sinful humanity at the End of Days. This was summarized by the later canonized archbishop Antoninus in 1455 in a speech before the freshly chosen pope Calixtus III. In it, Antoninus spoke of a "great vision of the House of the Lord, firmly grounded and built on firm Roman stone [*petram*]," the "Church, that is nothing else but this House of the Lord and the door to heaven, . . . paradise."[31] That is why the birth of Eve could also be prominently depicted above the gate to the heavenly Jerusalem, as it is on the left wing of the *Last Judgment* triptych of Hans Memling that was commissioned by the Medici and originally intended for a church in Fiesole (see pl. 17).

The entire Sistine Chapel, under the patronage of the Assumption, is dedicated to the hope for a path to heaven. In contemporary interpretation, Mary as she appeared in Perugino's altarpiece was the door to heaven and the queen of

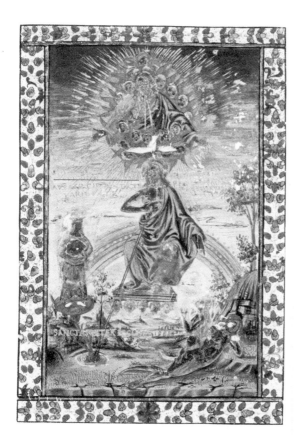

Fig. 21. *Creation of Eve and the Church.* Miniature from Sixtus IV's copy of Philo Judaeus, *Liber de creatione mulieris,* between 1471 and 1484, Vat. lat. 183, fol. [IIIv]. Vatican City, Biblioteca Apostolica Vaticana.

the kingdom of heaven. Michelangelo had already illustrated the symbolism of Mary as the ladder to heaven in his early relief *Madonna of the Stairs.* And now he brought all these ideas together on the ceiling in the figure of the prophet Jonah, centrally located directly above the altar, where the earlier cycles of Moses and Christ as well as the series of canonized popes begin.[32] Jonah, who spent three days in the belly of the whale before being disgorged, prefigures Christ's Resurrection but also the Immaculate Conception. In Michelangelo's

depiction, Jonah leads the eye of the beholder to the next picture field, seeming to be involved in a disputation with the floating figure of God the Father on the first day of Creation. This is the only figure of God on the ceiling who is seen in perspective from below, which serves to visually emphasize his connection to Jonah by putting the observer in an angle of view similar to Jonah's.

Next to this scene is one of the two narrow openings out to the "real sky"; here Michelangelo seems to integrate a recollection of Piermatteo d'Amelia's earlier starry firmament. God's throne above the heavens and his "holy temple" also play a central role for Jonah. In the belly of the whale, he hopes to see God again (Jonah 2:3–7): "For thou hadst cast me into the deep, in the midst of the seas . . . yet I will look again toward thy holy temple . . . yet hast thou brought up my life from corruption, O Lord my God . . . and my prayer came in unto thee, into thine holy temple." The excited gesture of the just-rescued prophet and his gaze toward the ceiling cannot be directed at God the Father alone. The entire array of fictive architecture is for Jonah (and thus for the actual observer) a vision of God's *templum sanctum* (holy temple). From this perspective it also becomes clearer why among all the prophets it is Zachariah who was chosen to be opposite Jonah on the entrance wall. Indeed, around 1500 Zachariah could also be regarded as the "prophet of the reestablishment of the Temple."[33] The theme of a visionary view of God's temple is thus announced both at the entrance and above the altar: for Zachariah it was an inner result of his reading and for Jonah, a highly emotional outward event.

In this context, the twenty figures of nude young men that encircle the entire ceiling with a gigantic oak-leaf garland can be best understood as wingless angels, as they would also subsequently appear in *The Last Judgment*. On the ceiling they celebrate the incipient new Golden Age ushered in by Julius II and the approach of the earthly Church to the future city of God. Alternatively, the *ignudi* can be interpreted as distinguished souls in the city of heaven (and a preview of a "new race" in the sense used by Virgil in his fourth *Eclogue* [line 7]). In any event, it is striking that below the *ignudi* are fictive marble statues of putti—both boys and girls—and next to them bronze nudes seemingly

imprisoned in the architecture. Possibly, Michelangelo is alluding here to the redemption of the soul after death in the various stages of limbo and purgatory.

The visual ascent to heaven along the middle axis of the altar wall and ceiling can be reversed and understood as a reaching down and passing on of legitimacy. After all, in Matthew 16:16–19, a passage of central importance for the self-image of the papacy, Jesus addresses Peter as "Barjona," the son of Jonah:

> And Simon Peter answered and said, Thou art the Christ, the Son of the living God. And Jesus answered and said unto him, Blessed art thou, Simon Barjona: for flesh and blood hath not revealed it unto thee, but my Father which is in heaven. And I say also unto thee, That thou art Peter, and upon this rock I will build my church; and the gates of hell shall not prevail against it. And I will give unto thee the keys of the kingdom of heaven: and whatsoever thou shalt bind on earth shall be bound in heaven: and whatsoever thou shalt loose on earth shall be loosed in heaven.

On the chapel's altar wall, this succession is made manifest with God the Father, Jonah, Christ, Peter as the beginning of the line of popes, and finally Peter on Perugino's altarpiece, laying the keys onto the shoulders of Sixtus IV.

Accordingly, the row of images down the center of the ceiling ends with three scenes of Noah, since he in particular could be interpreted as a prefigura-tion of the popes and especially of Julius II. The captain of the ark was the first to steer the ship of the elect, as did the popes who followed him with the ship of the Church. Frequent recourse to this ship metaphor was particularly prevalent in early sixteenth-century Rome.[34] Just as the drunken Noah was mocked by one of his own sons and yet was the only one who knew how to make a correct offering to God, the papacy in the present was suffering attacks and derision from heretics and schismatics. Both Annius of Viterbo, Pope Alexander VI's personal chaplain, and the Augustinian cardinal Giles of Viterbo went even further in their attempts to make connections between pagan and Old Testa-ment history. Following medieval legends, they saw in Noah and in Janus, the

mythological founder of the Etruscan people and religion, one and the same person. The Janiculum Hill in Rome had once been sacred to Janus, while one of its foothills, the Vatican Hill, was the location of the grave of Saint Peter and the seat of the Church and the popes. This topographical coincidence alone was enough to make clear that in the plan of salvation, Christianity followed the religion of Noah-Janus. And just as in his time, Noah renewed the covenant with God, now the pontificate of Julius II rang in a new Golden Age.

In addition to these connections that have been worked out in the schol-arship on the chapel, there is another aspect that must be emphasized. Julius was not celebrated merely for triumphantly restoring the Church's claim to authority in both spiritual and worldly affairs, reconquering Bologna, crushing schismatic movements, and so on. The discovery of the New World and the subjugation of all non-European empires—a hope raised by a series of colonial victories in 1507, primarily of the Portuguese in Asia—inspired the idea that under Julius's leadership the entire world would become Christian. That was the basic message of a sermon Giles of Viterbo delivered in 1507, and that hope was also described at length by Francesco Albertini in the dedication to Julius in his guide to Rome of 1510.[35] Even the reconquest of Jerusalem and Constan-tinople seemed imminent. The result of Ham's mocking of Noah, to be seen in the final picture on the Sistine ceiling, was that from Noah's three sons—Ham, Shem, and Japhet—originated the three separate races of humankind after the Flood. This separation laid the ground for the appearance of heresy in the world. With Julius, an era seemed to begin in which this division would be reversed, and Christianity would be the sole religion again. The Church's earthly struggle seemed almost at an end.

The ascension to heaven and the transition from the earthly *ecclesia militans* to the heavenly *ecclesia triumphans* appears to have been from the beginning the basic concept for the arrangement of the Sistine ceiling with its stringing together of elements of ancient triumphal arches. It was clear to every contemporary that this transition—the threshold between the here and the hereafter—marked the entrance portal to the heavenly city, with Peter

functioning as its watchman. How people around 1500 imagined this transcen-
dental threshold situation was described by the Florentine poet Ugolino Verino
in the epic *Carlias,* his most famous work. From about 1465 or 1466 until 1506
at the latest, Verino labored over one draft after another without ever com-
pleting a final version. The epic was intended to be dedicated to Charles VIII
of France, but the king did not esteem it. *Carlias* describes the deeds of Charles
VIII's predecessor Charlemagne, especially his battles against the unbelievers,
and it also recounts an imaginary visit to the hereafter. According to Verino, at
the highest point in heaven rise the towering, golden roofs of God's residence.
Porticoes open the way to a not very clearly described entrance hall leading to
a locked bronze portal. A golden dome is embellished with figures that surpass
all human artistry. In addition, there is an arch (at the beginning of the entrance
hall or around the portal?) that is decorated with gold, precious stones, and
an extensive program of images showing the story of Creation. Above the base
on the left side, pictures we are to think of as painted reliefs begin with God
the Father and the new choirs of angels. The paintings that follow show the fall
of Lucifer and the rebellious angels and the first days of Creation. At the apex
of the arch is a painting of the sky with shining stars. Then come the creation
of Adam and Eve, the temptation by the serpent, the fall of man, the expulsion
from paradise, and the first labors of our primal parents. In a later passage,
Verino adds that the entrance to the heavenly city is controlled by Peter, the
"doorkeeper of the heavenly fortress," with his two keys.[36] Beyond the entrance,
John the Baptist points the way to Christ's royal household with Mary and
the saints. Verino's fantastic arch seems to have made use of ideas from the
mosaics in the narthex of San Marco in Venice that was also regarded as a tri-
umphal monument and a reflection of paradise (until the seventeenth century,
the narthex also included a scene with Peter before the door of heaven). At the
same time, Verino was inspired by Jacopo della Quercia's portal to San Petronio
in Bologna with its reliefs of the creation story (1425–38).

We are adducing Verino's poem not as a direct inspiration for Michelan-
gelo's ceiling pictures but rather as evidence of a widespread conception that

the entrance to the heavenly Jerusalem included a vaulted narthex, triumphal architecture, images of the events at the world's beginning that would then be superseded by God's return and the city of heaven, and Peter at the portal with the keys. Thus the Sistine ceiling visualized what had also and already been aurally articulated in a motet sung in the chapel on the Feast of Saint Peter, 29 June 1507: "O keybearer of the kingdom of heaven and prince of Apostles, / Deign to pray to pious Jesus Christ our Lord on our behalf / ... so that the prince of all princes may award us entrance into the heavenly paradise after death, the athlete [of virtue], most powerful Peter; / ... [Christ] committed the reins of heaven and earth to Peter / So that he might loose the chains of those in bondage. / By the merit of our Shepherd and saving prayer, / Eternal Shepherd, free us from the debt of our sins."[37] We will mention only in passing a later idea to depict the fall of Lucifer and the rebellious angels on the entrance wall of the Sistine, facing *The Last Judgment* on the altar wall.[38]

When the pope—as Christ's deputy on earth, endowed with Peter's power over the keys—and his retinue entered the Sistine Chapel (which the fifteenth century had already thought of as standing in a "paradise") to celebrate Mass, and especially when Julius II strongly encouraged the hope that the entire world would be re-Christianized so that his pontificate could be regarded as the dawning of a new Golden Age, then the earthly *ecclesia militans* in the Sistine came as close to the heavenly *ecclesia triumphans* as was humanly possible before the actual Judgment Day. For his part, Michelangelo designed the newfangled fictive architecture of the chapel, with its troop of young men (whether angels or worthy souls) and their oak-leaf garland, as an artistic vision of the walls of the heavenly Jerusalem. Despite any confusion caused by the novelty of its images, in this symbolic environment contemporaries could experience the Sistine Chapel as the triumphal entrance hall to the future city of God, and the pope could again be celebrated in the fullness of his power as earthly keeper of the keys and gatekeeper of heaven, the representative of Peter and the *vicarius Christi* (vicar of Christ).

NOTES

1. Andrea Guarna, *Simia,* ed. Bruno Pellegrino (Salerno: Palladio, 2001).
2. Guarna, *Simia,* 64–65 (on Julius in heaven), 120–45 (the dialogue with Bramante).
3. See, for example, the editions from the Biblioteca Vaticana, Cod. Reg. Lat. 1882, fol. 2r; and from the Bibliothèque Sainte-Geneviève (Paris), ms. 218, fol. 2r.
4. Paola Barocchi and Renzo Ristori, eds., *Il carteggio di Michelangelo,* vol. 1 (Florence: Sansoni, 1965), 16 (no. X).
5. On Michelangelo's finances, see Rab Hatfield, *The Wealth of Michelangelo* (Rome: Edizioni di Storia & Letteratura, 2002), esp. 23–30 and 123–25.
6. On Michelangelo's relationship with Bramante, see Charles Robertson, "Bramante, Michelangelo, and the Sistine Ceiling," *Journal of the Warburg and Courtauld Institutes* 49 (1986): 91–105.
7. Benvenuto Cellini, *Due trattati uno intorno alle otto principali arti dell'oreficeria: L'altro in materia dell'Arte della Scultura* [1568], ed. Carlo Milanesi (Florence: L. Monnier, 1857), 83–84.
8. See Michelangelo's *ricordo* on the beginning of work in 1508 in Tolnay, *Michelangelo II,* 216 (no. 3), who also compiles most of the other sources on the ceiling.
9. Inv. 18722 F r, Uffizi, Florence.
10. The passages from Paris de Grassis's *Diarium* were first published in Eugène Müntz, "Une

rivalité d'artistes au XVI siècle: Michel-Ange et Raphael a la cour de Rome," *Gazette des Beaux-Arts,* ser. 2, 25 (1882): 281–87 and 385–400, here 385–86.
11. See Barocchi and Ristori, *Il carteggio,* for Michelangelo's letters on the pope's debts (1:107–8 [nos. LXXV and LXXVI]) and for Michelangelo's retrospective report from the end of December 1523 (3:7–9 [no. DXCIV]).
12. The note of 14–15 August in Paris de Grassis's *Diarium* about the "picturas novas . . . noviter detectas" is quoted from Tolnay, *Michelangelo II,* 235 (no. 52). Cf. also the reports of the Mantuan ambassador in John Shearman, *Raphael in Early Modern Sources (1483–1602)* (New Haven: Yale University Press, 2003), 1:148 and 1:160–61.
13. Barocchi and Ristori, *Il carteggio,* 3:7–9, here p. 9 (no. DXCIV).
14. Barocchi and Ristori, *Il carteggio,* 1:137 (no. CIV).
15. Johannes Wilde, "The Decoration of the Sistine Chapel," in *Proceedings of the British Academy* 44 (1958): 61–81.
16. The various kinds of plaster were analyzed by Nazzareno Gabrielli and Fabio Morresi, "Ricerche tecnico-scientifiche sugli affreschi di Michelangelo," in *Michelangelo e la Sistina: La tecnica, il restauro, il mito,* ed. Fabrizio Mancinelli, exh. cat. (Rome: Palombi, 1990), 115–21.
17. Barocchi and Ristori, *Il carteggio,* 1:137 (no. CIV).
18. Paolo Giovio, *Michaelis*

Angeli Vita [1527], in Paola Barocchi, ed., *Scritti d'arte del Cinquecento,* vol. 1 (Milan: Ricciardi, 1971), 10–13. English translation in Paolo Giovio, *Michaelis Angeli vita (um 1527),* ed. and trans. Charles Davis, *FONTES* 12 (2008): 15, https://doi.org/10.11588/artdok.00000579.
19. For the original quote and on the conception of the ceiling as described in 1523, see Barocchi and Ristori, *Il carteggio,* 3:8 (no. DXCIV), and a second version, 3:11 (no. DXCV). For descriptions of these events in later biographies of Michelangelo, see Ascanio Condivi, *The Life of Michelangelo,* trans. Alice Sedgwick Wohl, ed. Hellmut Wohl (Baton Rouge: Louisiana State University Press, 1976); Giorgio Vasari, *Lives of the Painters, Sculptors, and Architects,* ed. Gaston du C. De Vere and David Ekserdjian (New York: Knopf, 1996); and Frank Zöllner, *Michelangelos Fresken in der Sixtinischen Kapelle: Gesehen von Giorgio Vasari und Ascanio Condivi* (Freiburg im Breisgau: Rombach, 2002).
20. The surviving drawings are in the following locations: British Museum, inv. 1859-6-567 and inv. 1887-5-2-118 v; the Detroit Institute of Arts 27.2. r; and Archivio Buonarroti, XIII, 175v.
21. For the phases of Michelangelo's ceiling design, see Kathleen Weil-Garris Brandt, "Michelangelo's Early Projects for the Sistine Ceiling: Their Practical

and Artistic Consequences," in *Michelangelo's Drawings,* ed. Craig Hugh Smyth (Washington, DC: National Gallery of Art, 1992), 57–87; and Christoph L. Frommel, "Michelangelo e il sistema architettonico della volta della Cappella Sistina," in *Michelangelo: La Cappella Sistina.* Vol. 3, *Atti del convegno internazionale di studi. Roma, marzo 1990,* ed. Kathleen Weil-Garris Brandt (Novara: Istituto Geografico De Agostini, 1994), 135–39. Another sketch was discovered only recently: Adriano Marinazzo, "Ipotesi su un disegno michelangiolesco del foglio XIII, 175v, dell'Archivio Buonarroti," *Commentari d'arte* 18 (2012 [2013]): 52–53, 108–10, and 118. See also an important analysis of the formal structure of the ceiling in Wiebke Fastenrath, *"Finto e favoloso": Dekorationssysteme des 16. Jahrhunderts in Florenz und Rom* (Hildesheim: Olms, 1995).
22. On the significance of the Malermi Bible in the editions of 1490 and 1493, see Rab Hatfield, *Trust in God: The Sources of Michelangelo's Frescoes on the Sistine Ceiling* (Florence: Syracuse University, 1991).
23. On Michelangelo's quotations of ancient triumphal architecture, see Sven Sandström, *Levels of Unreality: Studies in Structure and Construction in Italian Mural Painting during the Renaissance* (Uppsala, Sweden: Almqvist & Wiksell, 1963); Loren Partridge, *Michelangelo:*

The Sistine Chapel Ceiling, Rome (New York: Braziller, 1996); and Georg Daltrop, "'Clipei non enarrabile textum': Die 'Medaglioni finti di metallo' an der Decke der Sixtinischen Kapelle als Element antiker Triumphalkunst," *Pegasus: Berliner Beiträge zum Nachleben der Antike* 13 (2011): 9–28. Michelangelo was also thought to paint in an ancient style comparable to the heroic epics of Homer and Virgil. See Andrea Fulvio, *Antiquitates Vrbis* (Rome: Marcello Silber, 1527), fol. XXVIr: "Since the fiery spirit of Julius II burned for everything outstanding, he also had the Sistine basilica . . . adorned with sacred heroic paintings [*sacra pictura heroica*] very similar to ancient painting and never seen again down to the present day." See John Shearman, *Only Connect . . . : Art and the Spectator in the Italian Renaissance* (Princeton: Princeton University Press, 1992), 209–12. On Julius II and the iconography of triumph, see Massimo Rospocher, *Il papa guerriero: Giulio II nello spazio pubblico europeo* (Bologna: Il Mulino, 2015).

24. John Shearman, "Il mecenatismo di Giulio II e Leone X," in *Arte, committenza, ed economia a Roma e nelle corti del Rinascimento (1420–1530)*, ed. Arnold Esch and Christoph L. Frommel (Torino: Einaudi, 1995), 213–42. I owe the reference to Hrastovlje to Chiara Franceschini.

25. On the quattrocento frescoes in Cori, see Pio F. Pistilli and Stefano Petrocchi, *L'oratorio della SS. Annunziata a Cori: L'architettura e gli affreschi* (Latina: Sinergis, 2003), 5–21; Pio F. Pistilli and Stefano Petrocchi, "El oratorio y los frescos de *La Anunciación* de Cori: Un antiguo caso de patrocinio castellano en el agro romano," *Archivo español de arte* 77 (2004): 35–57; and Clemente Cimmaruconi, Pio F. Pistilli, and Gabriele Quaranta, eds., *La castiglia in marittima: L'Oratorio dell'Annunziata nella Cori del Quattrocento* (Pescara: Edizioni ZIP, 2014). On the Cappella del Crocefisso, see Sandro Santolini, "La committenza Mattei in S. Oliva: Gli affreschi con le Storie dell'Antico e del Nuovo Testamento nella cappella del SS. Crocefisso," in *Il complesso monumentale di S. Oliva a Cori*, ed. Domenico Palombi and Pio F. Pistilli (Tolentino: Biblioteca Egidiana, 2008), 183–93.

26. Tom Henry, "Arezzo's Sistine Ceiling: Guillaume de Marcillat and the Frescoes in the Cathedral at Arezzo," *Mitteilungen des Kunsthistorischen Institutes in Florenz* 39 (1995): 209–57. On Giacomo Vivio dell'Aquila's "rilievo di cera" and Brambilla's etching, see Mancinelli, *Michelangelo e la Sistina*, 261–62 (cat. 161).

27. Giovio, *Vita*, 1:11.

28. Philo Judaeus, *The Creation of Woman*, trans. Lilio Tifernate, Vat. lat. 183,

fol. IIIv, Biblioteca Apostolica Vaticana, Vatican City. See Stefania Tarquini, *Simbologia del potere: Codici di dedica al pontefice nel Quattrocento* (Rome: Roma nel Rinascimento, 2001), 104.

29. John O'Malley, "Man's Dignity, God's Love, and the Destiny of Rome: A Text of Giles of Viterbo," *Viator* 3 (1972): 389–416.

30. On Esther and Haman, see Bernardino de' Busti's *Officium de Immaculata Conceptione*, approved under Sixtus IV, quoted from Kim E. Butler, "The Immaculate Body in the Sistine Ceiling," *Art History* 32 (2009): 270.

31. Antoninus's speech in Odoricus Raynaldus, *Annales Ecclesiastici ab Anno quo desinit Card. Caes. Baronius M.C.XCVII usque ad Annum M.D.XXXIII*, vol. 18 (Cologne: Apud Ioannem Wilhelmvm Friessem, 1694), 436 (1455, no. 21).

32. The figure of Jonah has been comprehensively analyzed by Matthias Winner, "Giona: Il linguaggio del corpo," in *La Cappella Sistina: La volta restaurata; Il trionfo del colore*, ed. Pierluigi De Vecchi (Novara: Istituto Geografico De Agostini, 1992), 110–93; and Michael Rohlmann, *Michelangelos "Jonas": Zum Programm der Sixtinischen Kapelle* (Weimar: VDG, 1995).

33. For Zachariah as "profeta dell'edificazione del tempio," see Savonarola's thirty-third feast-day sermon of 1495, quoted in Kraus, *Geschichte der*

christlichen Kunst, 2:361–62.

34. On Noah and the letter of 1451, see Maurizio Calvesi, "Significati del ciclo quattrocentesco nella Sistina," in *Sisto IV: Le arti a Roma nel primo Rinascimento*, ed. Fabio Benzi (Rome: Edizione dell'Associazione Culturale Shakespeare, 2000), 337; on the symbolism of the ship, see Michael Eichberger, "Die Navicella vor S. Maria in Domnica auf dem Caelius," *Römisches Jahrbuch der Bibliotheca Hertziana* 30 (1995): 307–14.

35. John W. O'Malley, "Fulfillment of the Christian Golden Age under Pope Julius II: Text of a Discourse of Giles of Viterbo, 1507," in *Traditio* 25 (1969): 265–338. Francesco Albertini, *Opusculum de mirabilibus novae & veteris urbis Romae* (Rome: Mazochius, 1510), Epistola: "Quid nunc restat nisi ipsos infideles ac perfidos maumethanos persequi: vt ad veram fidem conuertantur? Laetetur inquam tua Beatitudo / te[m]pore cui[us] Portugall. Rex nouas insulas & barbaras natio[n]es ad fidem Christi conuertit. [. . .] Qua propter Beatissime pater Iuli deprecor / vt alter iulius i[n]uictissim[us] in tertio triumpho cuius scriptum erat: Veni. Vidi. Vici. Eadem verba in triumpho Crucis christi decantare valeat Sanctitas tua." (What now remains except to persecute the infidel and faithless Muslims so that they convert to the true

faith? Your Beatitude
would surely rejoice at
the time when the king
of Portugal converted the
newly discovered islands
and barbarous nations to
the faith of Christ. [. . .]
Wherefore, most blessed
Father Julius, I pray that
like that other most invin-
cible Julius, in whose third
triumph it was written: "I
came, I saw, I conquered,"
your Holiness may be
able to utter the same
words in the triumph of
Christ's cross.) Translation
from the Latin by Ivana
Bičak. For medieval and
early modern notions of
the generations of Noah
or the Table of Nations,
see Horst Wenzel, "Noah
und seine Söhne oder die
Neueinteilung der Welt
nach der Sintflut," in *Das
Buch der Bücher-gelesen*,
ed. Steffen Martus and
Andrea Polaschegg (Bern:
Lang, 2006), 53–84.
36. Verino, *Carlias*, 282–84
and 291 (VIII, lines 234–
302 and 550–73); see
also an early text version,
46–49. By comparison,
Ugolino's earlier poem
Paradisus is still unspecific
in its description of the
heavenly vision; see the
manuscript in the Biblio-
teca Medicea Laurenziana,
Florence, Laur. 39, 40, and
the edition *Vgolini Verini
Poetae Florentini Poemata
Ex Manuscriptis Illvstriss.
Et Clariss. Viri Antonii
Magliabechi Serenissimi
Magni Etrvriae Dvcis
Bibliothecarii, Nunc primùm
edita a Nicolao Bartholini
Bargensi* (Lyon: Ex Officina
Huguetana, 1679). For
other visions of Paradise,

see Zaccaria Ferreri,
*Lugdunense somnium de
divi leonis decimi pontificis
maximi ad summum pon-
tificatum divina promotione*
(Lyon: n.p., 1513); cf. John
Shearman, *Raphael's
Cartoons in the Collection of
Her Majesty the Queen and
the Tapestries for the Sistine
Chapel* (London: Phaidon,
1972), 1–2; and Antonino
Lenio di Parabita, *Oronte
gigante* [1531], ed. Mario
Marti (Lecce: Milella,
1985), 334 (III, 5, vv.
305–11).
37. Motet quoted from
Ingrid D. Rowland,
*The Culture of the High
Renaissance: Ancients and
Moderns in Sixteenth-
Century Rome* (Cambridge:
Cambridge University
Press, 1998), 169–70.
38. Vasari, *Le vite*, 6:67.

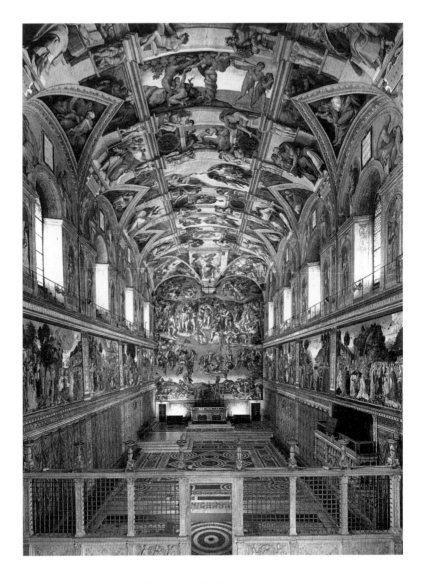

Plate 1. Sistine Chapel, general view looking toward the altar.

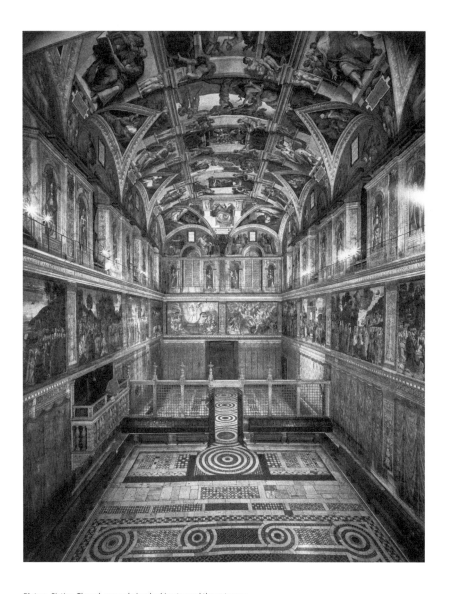

Plate 2. Sistine Chapel, general view looking toward the entrance.

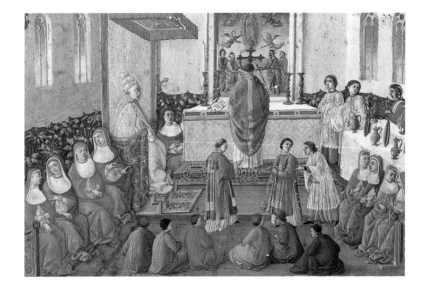

Plate 3. Giuliano Amedei (Italian, before 1446–96).
Pope Sixtus IV in the *capella magna,* fifteenth century, manuscript miniature, 10.8 x 16.3 cm.
Chantilly, Musée Condé.

Plate 4. Perugino (Italian, ca. 1450–1523).
The Delivery of the Keys, 1482, fresco.
Vatican City, Sistine Chapel.

Plate 5. Sandro Botticelli (Italian, 1444/45–1510).
The Punishment of Korah, Dathan, and Abiram, 1482, fresco.
Vatican City, Sistine Chapel.

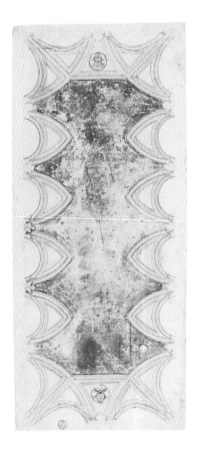

Plates 6, 7. Piermatteo d'Amelia (Italian, ca. 1450–1508).
Recto and verso of a (contractual?) drawing for the ceiling of the Sistine Chapel, 1481, stylus, traces of black chalk, pen, and colored pigments on paper, 39.2 x 17.5 cm.
Florence, Uffizi, Gabinetto dei Disegni e delle Stampe.

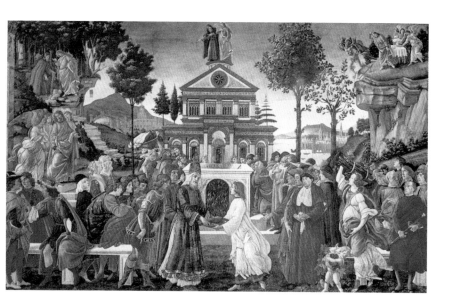

Plate 8. Sandro Botticelli (Italian, 1444/45–1510).
Temptation of Christ, 1481–82, fresco.
Vatican City, Sistine Chapel.

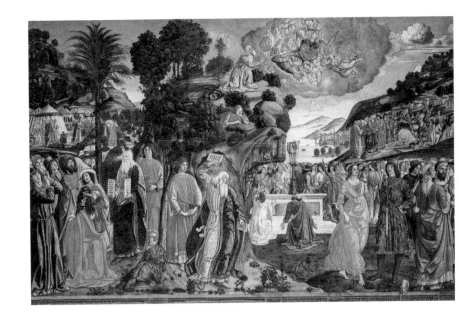

Plate 9. Cosimo Rosselli (Italian, 1439–1507).
Descent from Mount Sinai, 1481–82, fresco.
Vatican City, Sistine Chapel.

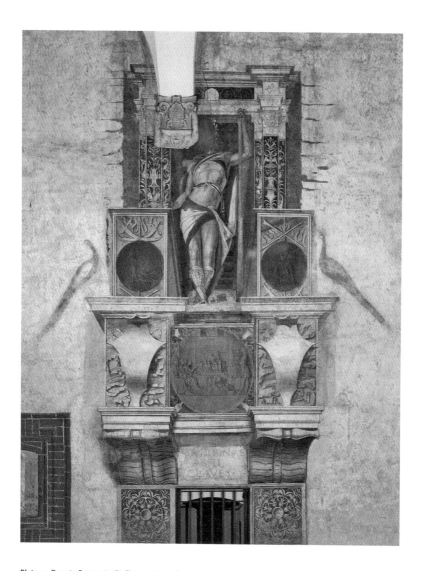

Plate 10. Donato Bramante (Italian, 1444–1514).
Argus, ca. 1490–93, fresco.
Milan, Castello Sforzesco, Sala del Tesoro.

86

Plate 11a. Michelangelo (Italian, 1475–1564).
Ceiling frescoes of the Sistine Chapel, 1508–12.
Vatican City, Sistine Chapel.

Plate 11b. Michelangelo (Italian, 1475–1564).
Ceiling frescoes of the Sistine Chapel, 1508–12.
Vatican City, Sistine Chapel.

Plate 12. Diagram showing the distribution of the three types of plaster on the ceiling, according to Nazzareno Gabrielli and Fabio Morresi.
From Fabrizio Mancinelli, ed., *Michelangelo e la Sistina: La tecnica, il restauro, il mito*, exh. cat. (Rome: Palombi, 1990), 121.

Plate 13. *The Last Judgment.*
Ca. 1420, fresco on entrance wall.
Cori, Oratorio della Santissima Annunziata.

Plate 14. *Saint Peter in Front of Heaven's Gate.*
Ca. 1420, fresco on south wall.
Cori, Oratorio della Santissima Annunziata.

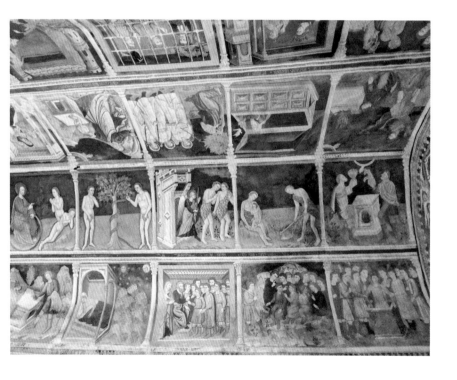

Plate 15. Scenes from Genesis.
Ca. 1420, fresco in vault.
Cori, Oratorio della Santissima Annunziata.

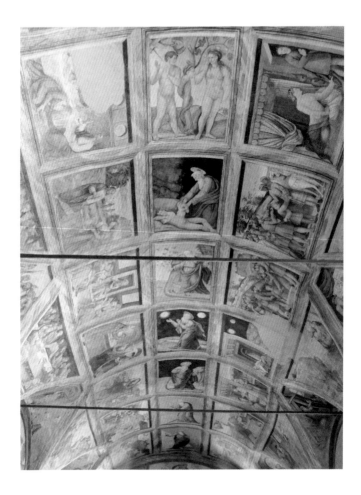

Plate 16. Scenes from Genesis.
1533/34, fresco in vault.
Cori, Sant'Oliva complex, Cappella del Santissimo Crocefisso.

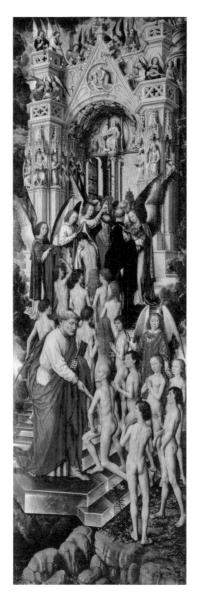

Plate 17. Hans Memling (Netherlandish, ca. 1430–94). Left panel of *Last Judgment* triptych with Peter at the door of heaven, between 1467 and 1471, oil on wood, 223 x 72 cm. Gdansk, National Museum.

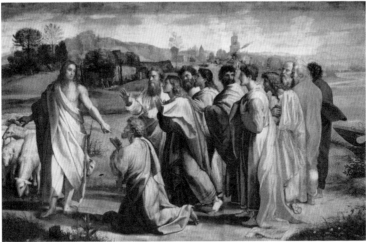

Plate 18. Raphael (Italian, 1483–1520).
Drawing for *Christ's Charge to Peter*, ca. 1515, pen,
brush, and wash, with white heightening over black
chalk on gray washed paper, 22.1 x 35.4 cm.
Paris, Musée du Louvre.

Plate 19. Raphael (Italian, 1483–1520).
Cartoon for *Christ's Charge to Peter*, 1515–16, gouache
on paper mounted onto canvas, 340 x 530 cm.
London, Victoria and Albert Museum.

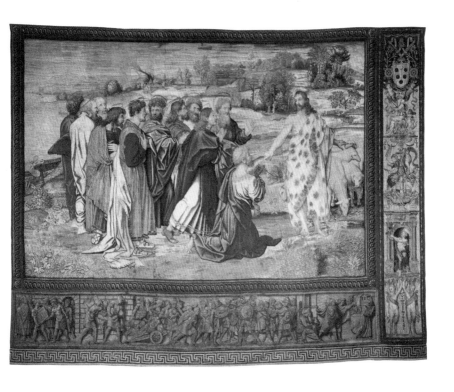

Plate 20. Pieter van Aelst the younger (Flemish, active early through mid-16th century),
after a cartoon by Raphael (Italian, 1483–1520).
Christ's Charge to Peter, 1516–17, tapestry, 484 x 633 cm.
Vatican City, Vatican Museums.

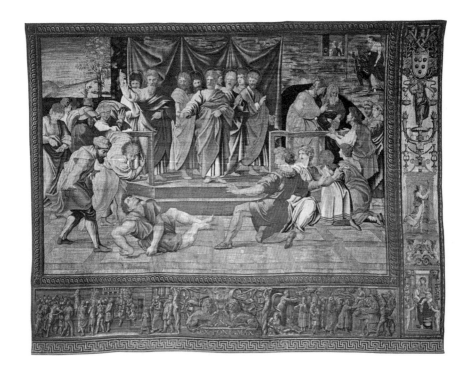

Plate 21. Pieter van Aelst the younger (Flemish, active early through mid-16th century), after a cartoon by Raphael (Italian, 1483–1520).
The Death of Ananias, 1519–21, tapestry, 488 x 631 cm.
Vatican City, Vatican Museums.

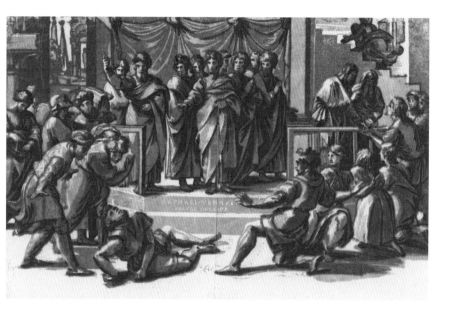

Plate 22. Ugo da Carpi (Italian, active 1502–32), after a cartoon by Raphael (Italian, 1483–1520).
The Death of Ananias, ca. 1518, chiaroscuro woodcut from four blocks, 24 x 37 cm.
London, Victoria and Albert Museum.

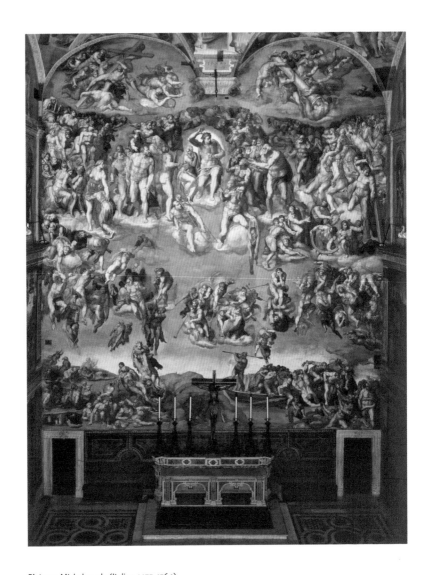

Plate 23. Michelangelo (Italian, 1475–1564).
The Last Judgment, 1536–41, fresco.
Vatican City, Sistine Chapel.

Plate 24. Michelangelo (Italian, 1475–1564).
Preparatory study for *The Last Judgment*, 1535, black chalk, retouched later in pen, 42 x 29.7 cm.
Florence, Casa Buonarroti (Inv. 65F recto).

Plate 25. Attributed to Emilio di Pier Matteo Orfini da Foligno (Italian, active 1461–92).
Medal of the consistory of Paul II, 1466/67, struck gold, diam.: 7.8 cm.
Vienna, Kunsthistorisches Museum.

Plate 26. Luca Signorelli (Italian, ca. 1441 or 1450–1523).
Coronation of the Elect in the Earthly Paradise, 1500–1502, fresco.
Orvieto, Orvieto Cathedral, Cappella Brizio.

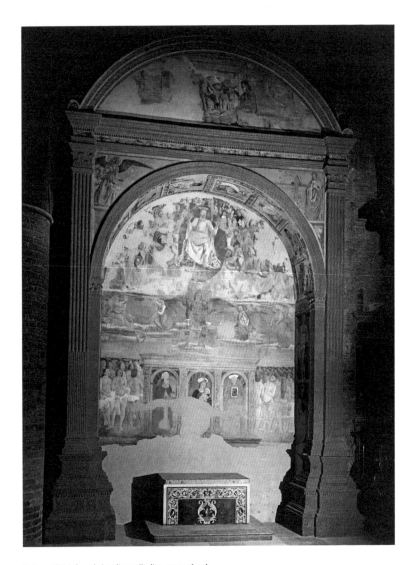

Plate 27. Cristoforo da Lendinara (Italian, ca. 1426–91).
Frescoes with fake altarpiece and *Last Judgment*, 1470/80.
Modena, Duomo, Cappella Bellincini.

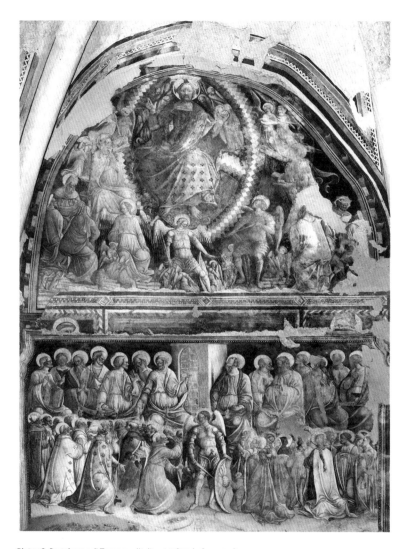

Plate 28. Bartolomeo di Tommaso (Italian, 1408/11–before 1454).
Christ the Judge (above) and Saint Peter at the door of heaven (below), ca. 1450,
fresco on altar wall.
Terni, San Francesco, Cappella Paradisi.

Plate 29. Mark Tansey (American, 1949–).
Triumph over Mastery II, 1987, oil on canvas, 249 x 173 cm.
Private collection.

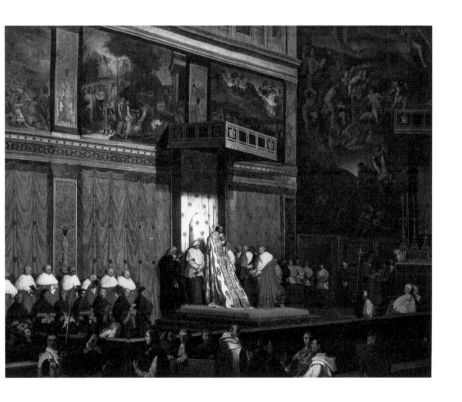

Plate 30. Jean-Auguste-Dominique Ingres (French, 1780–1867).
Pope Pius VII in the Sistine Chapel, 1812–14, oil on canvas, 98 x 117 cm.
Washington, D.C., National Gallery of Art.

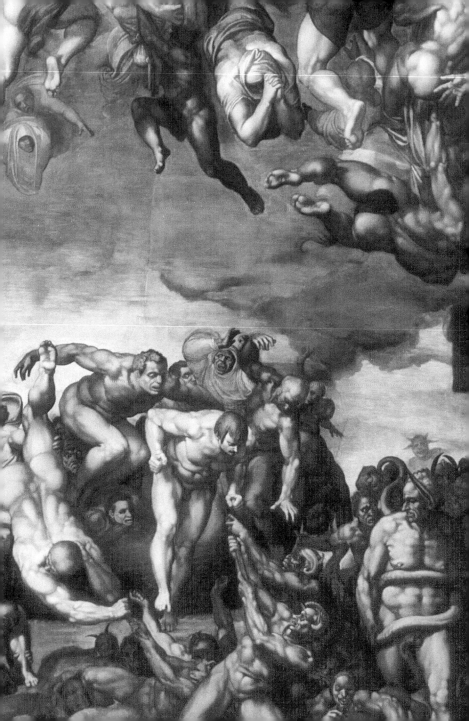

TABERNACLE, SOLOMON'S TEMPLE, AND THE HEAVENLY JERUSALEM: RAPHAEL'S TAPESTRIES AND LEO X

Great hopes were riding on the election of Giovanni de' Medici as Pope Leo X on 11 March 1513. The thirty-seven-year-old was declared the next best thing to a reincarnation of the Savior himself. His choice of the name Leo, with its references to Christology, cosmology, and the history of the Church, reinforced the hope placed on him. People expected peace in Italy and the rest of the Christian world, the restoration of the dignity and unity of the Church, and the final repulse of the "Turkish danger," as well as prosperity and patronage for the arts in the Medici family tradition.[1] And at first, Leo's pontificate was promising, despite the dawning of the Reformation shortly after his election. However, the new pope had run up such huge debts by his early death on 1 December 1521 that even the tapestries after Raphael's designs, which Leo had donated to the Sistine Chapel, were impounded to cover the costs of his burial and of the conclave to elect his successor.

Of the two most important artists working for Leo's predecessor, it was Michelangelo whom Leo sent to Florence to design the facade of San Lorenzo, the Medici family's church, as well as the burial site for recently deceased family members in the New Sacristy. Michelangelo planned both projects as grandiose architectonic settings for an unprecedented number of monumental sculptures. Years later, he had utterly failed to realize the facade that had been conceived as a "mirror of all Italy" and had only partially completed the New Sacristy. The failure resulted from the gigantic dimensions of Michelangelo's plan as well as the mythic conception of himself as a solitary artist-hero, which led him to forgo the adequate team of assistants necessary for such enormous undertakings. Raphael, on the other hand, thanks precisely to his excellently trained assistants,

succeeded in covering the walls of the Vatican Palace with extensive series of frescoes in the years of Leo's pontificate: the remaining halls of the *stanze* (rooms) with events from the history of the Church, a decoration already begun under Julius II; the loggias with an Old Testament cycle and a New Testament cycle; the Sala dei Pappagalli; the Sala dei Paramenti; and the Sala di Costantino. (For the latter, Raphael had at least supplied the designs before his death in 1520.)

But what must have been Raphael's two most costly commissions for the Vatican are today no longer to be seen in their original locations. He supplied the cartoons depicting the story of the apostles Peter and Paul for ten Sistine Chapel tapestries and, immediately thereafter, the designs for six tapestries with putti and Medici *imprese* for the Sala di Costantino. These two interconnected commissions exemplify how tapestries constituted one of the most precious materials in which the Middle Ages and the early modern period presented images in both worldly and sacred environments. Tapestries were a sign of extraordinary grandeur, power, and wealth easily understood in profane contexts while also being vital to religious worship. In his biography of Nicholas V, Giannozzo Manetti writes,

> [The pope] provided wonderfully and to the highest degree for church ceremonies and with the greatest attention and unbelievable care. So that these [ceremonies] would excite the greatest possible admiration of Christian nations and be taken up with special reverence, he beautified them with things that are usually called paraments, namely, with tapestries, wall hangings, textiles, vessels of silver and gold, as well as with liturgical vestments woven of silk and gold thread and decorated with a great number of large and small pearls.[2]

To be sure, the mobile character of tapestries, with multiple possibilities for deployment at various events, created problems. In his 1464 draft for a reform of the Roman Curia, for example, Pius II needed to emphasize that with the exception of female saints, women could not be depicted on picture tapestries

in the Curia. Furthermore, of those tapestries with female saints, only ones showing "decent stories" that would spur their beholders to virtue were allowed. This admonition suggests what sort of tapestries had been customary until then (especially ones from Burgundy and the Netherlands, one assumes) and how they had engaged the eyes and imaginations of churchmen.

In any event, the popes' inventory of tapestries seems to have been quite substantial by the fourteenth century.[3] The walls of the original *capella magna* had in the past been decorated with tapestries on particular occasions (see pl. 3). In the new Sistine Chapel, there were hooks above the trompe l'oeil tapestries so that real tapestries could be hung over them. We have no record of the original appearance of the latter or whether a more or less unified series was already available. Tapestries were also hung in some places in Saint Peter's, and Nicholas V (r. 1447–55) had ordered a cycle from the life of Saint Peter from Jacquet d'Arras, a weaver active in Siena. In an inventory from the time of Leo X, there were eighteen tapestries attributed to this Jacquet— enough to have decorated the walls of the Sistine, at any rate.

With his commission for Raphael to design new tapestries for the Sistine Chapel with scenes from the history of the Apostles, Leo thus stood in a long tradition of papal endowments of wall hangings, a tradition reaching back into the early Middle Ages and including in particular his predecessors Leo III and Leo IV. At the same time, if Leo wanted to ensure an everlasting memorial to his pontificate in the Sistine Chapel, only the lowest register of the walls remained as yet undecorated with figures. His choice of an expensive medium and of Michelangelo's rival Raphael, who was not yet represented in the Sistine, clearly shows Leo's determination to compete with his two prede-cessors from the Della Rovere family. And the works resulting from Raphael's designs indeed represented a revolution in the art of picture tapestries.

Stories of the Apostles | According to a famous aphorism often attributed to Aby Warburg, "God is in the details." For art histori-ans, there is hardly another work to which it applies

so well as to Raphael's tapestries. Two payment orders, from 15 June 1515 and 20 December 1516, suggest that Raphael was commissioned at the latest by the beginning of 1515 to supply designs for the tapestries that would be woven in Brussels. However, the orders say nothing about the number or themes of the works. The cartoons, which were developed in numerous drawings (see pl. 18), had to be the same size as the tapestries and include all the details of composition and color, with no further explanation being necessary for the specialized weavers in the distant Netherlands. Seven cartoons for the Sistine tapestries survive and are now exhibited in the Victoria and Albert Museum in London (see pl. 19). The templates were probably sent in several batches to the master weaver Pieter van Aelst, who had successfully carried out orders for the pope before. As early as 30 or 31 July 1517, the cardinal of Aragon visited Aelst's workshop and was able to admire the first completed tapestry of the sixteen said to be planned (see pl. 20). The cardinal's secretary Antonio de Beatis described the scene in his diary and put into circulation the rumor of an unheard-of price:

> Pope Leo is having 16 tapestries made [in Brussels], chiefly in silk and gold. They are said to be for the chapel of Sixtus in the apostolic palace in Rome. Each piece costs 2,000 gold ducats. We went to the place where they were being made and saw a completed piece showing Christ's delivery of the keys to St. Peter, which is very beautiful. Judging from this one, the Cardinal gave it as his opinion that they will be among the finest in Christendom.[4]

Two years later, on 26 December 1519, the first seven tapestries were hung in the Sistine Chapel. Three others—*The Death of Ananias, Saint Paul in Prison,* and *Saint Paul Preaching in Athens*—were delivered between then and Leo's death in 1521. All ten of these tapestries are now in the Vatican Museums. On three of them, the original borders with the Medici coat of arms and *imprese* are still attached. Two detached borders survive that may also belong to the cycle.

The decision to depict the lives of the two Princes of the Apostles on oppo-site walls of the Sistine is again based on the model of the images decorating Roman basilicas (fig. 22; see fig. 17). Raphael depicted four scenes from the life of Peter: *The Miraculous Draught of Fishes* (Luke 5:1–10 and John 21:1–14), *Christ's Charge to Peter ("Feed My Sheep")* (Matthew 16:16–19 and John 21:15–17), *The Healing of the Lame Man* (Acts 3: 1–8), and *The Death of Ananias* (Acts 5:1–5). The Saint Paul cycle begins with *The Stoning of Saint Stephen* (Acts 7:54–60), at which Saul was present as a young man. And this Saul became Paul through the fall from his horse on the road to Damascus (*The Conversion of Saint Paul,* Acts 9:1–7). There follow four more scenes from the life of the second Prince of the Apostles: *The Conversion of the Proconsul* (Acts 13:6–12), *The Sacrifice at Lystra* (Acts 14:8–18), *Saint Paul in Prison* (Acts 16:23–26)—smaller than the others at 130 centimeters wide—and *Saint Paul Preaching in Athens* (Acts 17:16–34).

All the tapestries have a fictive bronze frieze along their bottom edge, and this arrangement of a large field for the event and a narrow frieze may have been influenced by a work of seventy years earlier: Filarete's bronze door for the main portal of Old Saint Peter's. While the friezes under the scenes of Saint Paul show more events from the history of the Apostles, those under the scenes of Saint Peter have as their theme decisive moments in the life of Giovanni de' Medici before his election as pope, beginning with his arrival in Rome after his elevation to cardinal and his admission to the College of Cardinals. As an excep-tion, the second scene from Giovanni de' Medici's life is located on a tapestry from the Saint Paul cycle: *The Stoning of Saint Stephen.* It is an open question whether the tapestry cycle as we have it is to be regarded as incomplete (per-haps because of the death of Raphael followed quickly by that of his patron, or because of Leo's financial troubles) or as finished. In either case, scenes of such central importance to Saint Peter's Cathedral as the martyrdom and burial of the two Princes of the Apostles are missing, and the life of Leo breaks off with the Medicis' triumphal return to the reconquered Florence in 1512.

In 1972, John Shearman published a detailed reconstruction of the order in which the tapestries were intended to be hung.[5] Shearman's reconstruction

places the scenes of Saint Peter beneath the frescoes of the life of Christ (to the right of the altar) and the more numerous scenes of Saint Paul beneath the frescoes of the life of Moses (to the left of the altar). However, one small but important detail, discovered during the 1999 restoration of the chapel and brought to my attention by Arnold Nesselrath, contradicts Shearman's thesis. Under the bench that runs along the walls of the Sistine Chapel, a marble band decorated with oak leaves and acorns (the coat of arms of the Della Rovere popes) continues beyond the point at which the old chancel screen was located. Thus, the marble band must have been installed under Julius II, the last Della Rovere pope, and the chancel screen repositioned before 1513, not in the 1550s or 1560s as conjectured earlier. This means that Raphael's tapestry designs were conceived for the division of the space that still exists today. In that case, the narrower tapestry of *Saint Paul in Prison* would have fit precisely in the space between the *cantoria* and the repositioned chancel screen, on the wall to the right of the altar. Therefore the stories of the two apostles were located exactly opposite to what Shearman thought (see fig. 22).[6]

 With their differing sizes, the two tapestries on either side of the altar serve to confirm this order: on the left hung *The Miraculous Draught of Fishes,* whose 512-centimeter width would have completely covered the space inside the altar then in place. The tapestry to the right of the altar, *The Stoning of Saint Stephen,* was only 450 centimeters wide and a good 60 centimeters shorter than its counterpart because on this side there was a narrow door into the chapel's sacristy that was obviously not meant to be completely covered up. To summarize this order of hanging: the tapestries of Saint Paul and his mission to the heathen are paired with the life of Christ in the frescoes above them, while those of Saint Peter and his mission to the Jews are paired with the life of Moses, as was customary in the exegetical tradition. Moreover, the tapestries of Saint Peter, the first pope, would have appropriately framed the seat of the pope to the left of the altar. For the fictive bronze frieze with the life of Giovanni de' Medici, however, the resulting placement entailed a somewhat more complicated but convincingly logical reading. On the altar wall, Medici's

Fig. 22. The envisaged order of the tapestries designed by Raphael.

Peter Cycle
a. The Miraculous Draught of Fishes (492 x 512 cm, with a border)
b. Christ's Charge to Peter ("Feed My Sheep") (484 x 632 cm, with a border)
c. The Healing of the Lame Man (500 x 566 cm)
d. The Death of Ananias (490 x 631 cm)

Paul Cycle
A. The Stoning of Saint Stephen (370 x 450 cm)
B. The Conversion of Saint Paul (465 x 530 cm)
C. The Conversion of the Proconsul (damaged; 220 x 579 cm)
D. The Sacrifice at Lystra (482 x 571 cm)
E. Saint Paul in Prison (478 x 130 cm)
F. Saint Paul Preaching in Athens (494 x 535 cm, with a border)

[**F1.** It is possible that this tapestry was hung inside the chancel screen in the blank space at the end of the Peter Cycle.]

i. Altar
ii. Seat of the pope
iii. Original position of the chancel screen
iv. Since 1513, new position of the chancel screen
v. *Cantoria*

narrative ran from left to right and included the tapestry *The Stoning of Saint Stephen*. Then its continuation jumped to Saint Peter's wall, while across the way, on Saint Paul's wall, the secondary events of the history of the Apostles were presented.

From this reconstruction of the order in which the tapestries were hung, an uneven distribution emerges. On Saint Peter's side, there would have been room for another tapestry inside the chancel screen, while on the opposite wall, *Saint Paul Preaching in Athens* would be located outside the screen. However, it is possible that contrary to the original plan, in the end the ten available tapestries were hung so that all the walls within the chancel were covered. A justification for placing *Saint Paul Preaching in Athens* as the last scene of the Saint Peter cycle—on the left-hand wall and inside the chancel screen (in field F1 in fig. 22)—could have been that Saint Paul was already present and next to Saint Peter in *The Death of Ananias*.

Even if the stories of the Apostles were supposed to have been continued, the series of completed scenes is instructive as is. To the right of the altar, the depiction of Saint Stephen, one of the two protomartyrs of the Church, complements Peter's assignment to "fish for men" on the left side of the altar, since Stephen risked his life to bear witness to the faith. Moreover, during his time as a deacon in Rome, Stephen had performed the same function as Giovanni de' Medici when he was a cardinal deacon. And the presence of Saul/Paul in the lower right-hand corner of this tapestry provides the transition to the longitudinal wall. There, the choice of scenes again yields connections with the Saint Peter series on the opposite wall. The conversion of Saul to Paul and the announcement of Paul's missionary assignment to come correspond to Christ's charge to Peter, "Feed my sheep" (see pl. 20). Sudden injury as a punishment (*The conversion of the Proconsul* and Paul's temporary blinding of the sorcerer Elymas) corresponds to recovery as a reward (Peter's healing of the lame man). The third pair of tapestries is connected first rather formally by the theme of death: a man is punished in the person of Ananias (see pl. 21), and in the city of Lystra, an animal is sacrificed. Both

deaths resulted from disastrous miscalculations: Ananias thought his posses-
sions were more important than the word of God, and the inhabitants of Lystra
thought the Apostles were gods.

The tapestries' program reaches its climax in the three scenes of Saint
Peter on the longitudinal wall. Previous visualizations of the life of the Prince of
the Apostles—to be found not just in Rome but also, for example, in San Piero
a Grado near Pisa and in the Cappella Brancacci in Florence—include the epi-
sodes of the tribute money, Peter's sermon, and his subsequent performance of
baptism, but not the charge to "Feed my sheep." In the Sistine, however, Christ
charges Peter with the office of leading the Church directly beside the seat
where the pope sits. Once again, the keys in the hand of the kneeling apostle
symbolize the power bestowed upon him to bind and to loose (see pl. 20). And
it is precisely this double power that the two tapestries continuing the series
on the other side of the pope's seat illustrate: the *Healing of the Lame Man* as a
symbol for the redemption or releasing from sin and the *Death of Ananias* as a
symbol for the passing of earthly judgment.

The Symbolism of
Architecture and Decor

Whenever the ten tapestries hung in the Sistine
Chapel, they lent the interior an increased aura of
maiestas pontificia, supplemented the images of
historic religious events with scenes from the lives of the two previously absent
Princes of the Apostles, and added Leo's name to a long tradition of papal
donations. They also reinforced the symbolic connections to the past and future
history of salvation.

Renaissance viewers in general seem to have associated tapestries with
paradise—especially when the tapestries incorporated gold thread, as in the
Sistine, and when they were combined with liturgical music and lighting.[7] With
the tapestries installed beneath the fresco cycle of the life of Moses, it would
have been natural to associate them with Moses's decoration of the tabernacle
that housed the Ark of the Covenant. The tabernacle's walls were covered with
"ten curtains of fine twined linen . . . with cherubims of cunning work" in two

groups of five "coupled one unto another" (Exodus 26:1 and 36:10). In the Old Testament, the tabernacle provided the model for Solomon's Temple and both were interpreted as prefigurations of paradise. Both had the same floor plan— and that is another connection to the Sistine Chapel. In the temple, as in the chapel, the ratio of length to width is 3:1 and of length to height, 2:1. It is possible that the dimensions of the Sistine were in fact an attempt to reconstruct the historical dimensions of the temple. Furthermore, both Solomon's Temple and the chapel were divided into a holy of holies and an exterior area. Additional linkages were made by Nicholas V's biographer Manetti, who reported that the pope planned to have a "huge forecourt" built for the *capella maxima* like the one in front of Solomon's Temple, as well as the second Temple in Jerusalem. (Manetti praised Nicholas's building projects as even more important than the architect of the temple.) A few hundred yards away, an inscription was added to one of the two spiral columns in Old Saint Peter's in 1438 stating that they were from the Temple in Jerusalem, and Raphael's tapestry *The Healing of the Lame Man* also evokes the temple by including those columns. And finally, there were originally seven candleholders along the chancel screen. They harkened back to the seven-armed menorah in the temple and harkened forward to the seven golden candlesticks of the Apocalypse (Revelation 1:20) while also holding the seven candles required during a papal mass. Under Sixtus IV, the Arch of Titus on the Forum had been sufficiently unearthed to reveal its relief of the trans- fer of spoils from the Temple in Jerusalem to Rome. In his translation of Philo Judaeus's *Life of Moses,* the humanist Lilio Tifernates immediately interpreted this relief as referring to the pope: "The [seven-armed] candelabrum represents the covenant with God that was transferred to Your Holiness." Sixtus IV in fact appears to have presented himself as a new Solomon and temple builder, and Julius II refers to him as such in a papal bull of 19 February 1513.[8] In the Sistine itself, Sixtus's association with Solomon was made explicit by the golden inscription on the triumphal arch in Perugino's *The Delivery of the Keys:* "Sixtus IV—Thou, who takest second place [to Salomon] in riches, but surpasseth [him] in religion, hath consecrated this gigantic Salomonic temple" (see pl. 4).

Except for this inscription, none of the other connections mentioned above are compelling. Some scholars have pointed to the fact that the dimensions of the Sistine—at least in length and width—were predetermined by the old *capella maior* of the Vatican Palace. And it is the new Saint Peter's rather than the Sistine that corresponds to the temple, as both Manetti and Aegidius of Viterbo emphasized at the time. Besides, in the end every church contains symbolic references to the tabernacle and the temple. In his *Rationale divinorum officiorum,* written before 1286, Durandus of Mende declares, "Our 'material church' [that is, the building itself] has adopted its form from both, i.e., the Tabernacle and the Temple . . . The material church . . . refers to the [spiritual] church, which is built of 'living stones' [i.e., the believers] in heaven."[9] Chronologically closer, Juan de Torquemada (d. 1468) discusses all these symbols for the Church in his *Summa de ecclesia* and then proceeds to an even more extensive argument in favor of the pope's absolute *plenitudo potestatis* (fullness of power).[10] In any case, the long tradition and general comprehension of these references do not preclude their special effectiveness in the Sistine Chapel, where typology and the history of salvation, *ecclesia militans* and the future city of God play such a central role.

However, one aspect of the chapel seems at first sight to contradict the semantics elaborated above, and that is its distinctly fortress-like exterior. In the chapel's first decades, its high and mostly blank walls crowned by crenellations towered above all the other buildings of the Vatican (fig. 23). Precisely in the years discussed here, however, an idea was being promoted of the *ecclesia militans,* the militant Church on earth, as a tower-like fortress against which all enemies of the faith must fail. One example is the title of the popular polemic *Fortalitium fidei* (Citadel of faith) by the Spanish Dominican Alfonso de Spina, in print since about 1464–70, that expounded upon numerous questions relevant to the Sistine Chapel. Moreover, in fifteenth-century Italy, both the earthly Church and the heavenly city (or at least the construction of the city's portal) were usually described as crenellated, tower-like structures, so that even the exterior of the Sistine Chapel could be thought of as an earthly version of the entrance hall of paradise.

Fig. 23. Maerten van Heemskerck (Dutch, 1498–1574).
Demolition of Old Saint Peter's showing the newly constructed choir and transept on the left and behind it, the
Sistine Chapel in the center, between 1532 and 1535–36, pen and ink.
Berlin, Staatliche Museen zu Berlin, Kupferstichkabinett.

Antipodes

Starting with Raphael's arrival in Rome in late 1508, the art commissioned by the Vatican can be described as a great, continuing competition between him and Michelangelo. Donato Bramante seems to have energetically promoted his countryman from Urbino, which led to a deterioration in Bramante's relations with Michelangelo. Unmistakably, Raphael modified his painting style once he had a chance to see Michelangelo's frescoes on the Sistine ceiling. Vasari wove that change into one of his stories about artists that had great influence on subsequent opinion. In his biography of Michelangelo, Vasari claims that Bramante tried to have the second half of the ceiling assigned to Raphael. In his biography of Raphael, he wrote that when Michelangelo was in Florence,

Bramante had the key to the chapel and let his friend Raphael see Michel-
angelo's works so that Raphael could profit from his methods. . . . Looking
at Michelangelo's figures brought [Raphael] to the point of giving his
own work a more imposing size and more dignity. Michelangelo, however,
when he later saw Raphael's works, thought—and not without justifica-
tion—that Bramante had caused him this injury to earn fame and profit
for Raphael.[11]

At the same time, Michelangelo likely felt pressure from Raphael as well.
One can at least speculate that Michelangelo—quite contrary to his usual
habit—finished his ceiling frescoes so quickly and efficiently because a mere
few hundred yards away, Raphael himself was finishing a new marvel and
model for painters: the Stanza della Segnatura, the papal reception room also
completed in 1512. A diplomatic report of early July 1512 indicates that the two
sets of frescoes were immediately compared to each other; Alfonso d'Este was
permitted a special viewing of the almost complete Sistine ceiling from the scaf-
folding and stood admiring it so long that in the meantime, his entourage went
to look at Raphael's new frescoes as well.[12] If Raphael was praised for his narra-
tive ability and gracefulness, Michelangelo's crowning achievements were his
representations of the human body and the deeply moving effect they had on
viewers. While Raphael employed a large workshop of assistants who realized
and reused the master's designs and cartoons with great skill and economy,
Michelangelo tried to give the impression that he painted everything himself,
without any help, in heroic physical exertion, and every time in a completely
new way. If Raphael presented himself as a perfect courtier, Michelangelo did
everything possible to appear a melancholy loner.

With respect to reproductions, Raphael was far ahead of his rival Michel-
angelo. Sometime between 1508 and 1510, the Bolognese engraver Marcantonio
Raimondi produced three engravings of figures from Michelangelo's Florentine
cartoon for the *Battle of Cascina,* but these rather clumsy reproductions do not
seem to have particularly impressed the master. Probably for the first time

in the history of graphic art, the signature on one of the three prints makes the distinction between the "inventor" (Michelangelo) and the "engraver" (Raimondi).[13] Raimondi then tried his luck again in Rome (he may not have made the third engraving after the *Battle of Cascina* until he got there). His two engravings after Michelangelo's *The Fall of Man and Banishment from the Garden* and the two good sons in *Noah's Drunkenness* may have originated as early as 1511, as copies of drawings. While these engravings also failed to bear much fruit, Raimondi made his first reproduction of a drawing of Raphael's circa 1510, and the master from Urbino recognized the potential of this new medium for promoting his fame as an artist. Thereafter, Raimondi worked almost exclusively with Raphael's images. By 1514, he was joined by two more engravers, Agostino dei Musi and Marco Dente, as well as by a sort of director of publications in order to keep up with the volume of reproductions. In this way, Raphael's cartoons for the Sistine tapestries were made known to the world almost as soon as they were finished (fig. 24).

Raphael was quite open to improvements in the technology of reproductions. In 1516, the Venetian senate granted Ugo da Carpi a franchise for producing chiaroscuro woodcuts with a method Ugo supposedly invented, but which had actually been used by Lucas Cranach and Hans Burgkmair before him. It involved printing an image using two or more blocks to achieve differing tones and levels of brightness. In 1518, Leo X granted Ugo a franchise for Rome as well, whereupon the printer seems to have immediately reproduced some of Raphael's tapestry designs using the new technique. The resulting prints dispensed with dark outlines and worked almost exclusively with varying color tones. They must have made a spectacular visual impression on contemporaries (see pl. 22).

It may be that Michelangelo mistrusted this influential "falsification" of his drawing style and insisted that his frescoes be copied individually. With Michelangelo's permission, his colleague Bastiano da Sangallo may have made copies of the scenes of the Temptation and the Expulsion from the scaffolding as early as 1509 or 1510, but perhaps not until the 1520s. Vasari describes these large-format painted reproductions, now lost. Along with other early copies of Michelangelo's work, they demonstrate that the artist had no objection in principle to such reproductions.

Fig. 24. Agostino dei Musi (Italian, ca. 1490–1536/40), after Raphael (Italian, 1483–1520).
The Death of Ananias, ca. 1516, engraving, 24.9 x 39.3 cm.
London, Victoria and Albert Museum.

But he seems not to have recognized until much later the outstanding value of
prints for spreading his reputation (and posthumous fame) across Europe. Until
the 1540s, only scattered scenes and figures from the ceiling were engraved.
But from then on, coherent series of figures began to be published, some of
which also had traces of the ceiling's fictive architectural frame (fig. 25). In 1543,
countless reproductions of the *Last Judgment* began to appear; they were partic-
ularly in demand because of the heated discussions of that painting.

 Another factor in Michelangelo's acceptance of copies may have been that
before this increased distribution of prints after his Sistine frescoes, gross errors
of attribution were possible. According to the 1536 travel diary of the Frankfurt
jurist Johannes Fichard, Raphael had obtained a clear victory in the contest
with his competitor. In Fichard's otherwise meticulously accurate description,
written in Latin, the paintings of the master from Urbino secured the fame of
the entire chapel:

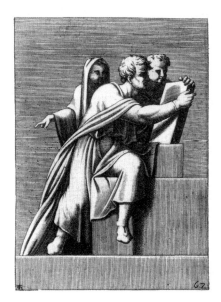

Fig. 25. Copper engraving by Adamo Scultori (Italian, ca. 1530–85), ca. 1550, after a destroyed lunette figure from Michelangelo's Sistine Chapel ceiling. Vatican City, Biblioteca Apostolica Vaticana.

The outstanding rooms in this palace are . . . the papal chapel and the library. The chapel is rectangular, of medium length. The area entered by the pope, the cardinals, and the bishops with their entourage, where they assemble and where the altar is located, is divided from the place where guests and the common people stand by a balustrade and a gilded metal screen somewhat more than three-fourths of the way down the entire length. . . . The floor of this chapel is richly decorated with different marbles, with various circular ornaments and other fine mosaics. . . . According to the judgment of all painters, this chapel is very famous on the basis of the incomparable paintings of Raphael of Urbino, although their colors now seem darker than usual, which doubtless is owing to the daily smoke. The entire chapel is painted.[14]

NOTES

1. See Götz-Rüdiger Tewes and Michael Rohlmann, eds., *Der Medici-Papst Leo X. und Frankreich: Politik, Kultur und Familienge-schichte in der europäischen Renaissance* (Tübingen: Mohr Siebeck, 2002); and Flavia Cantatore, ed., *Leone X: Finanza, mecenatismo, cultura,* 2 vols. (Rome: Roma nel Rinascimento, 2016).

2. Iannotius Manetti, *De vita ac gestis Nicolai Quinti Summi Pontificis,* 47–48.

3. On the inventory of tapestries, see Shearman, *Raphael's Cartoons,* 5–7; and Thomas Ertl, "Stoffspektakel: Zur Funktion von Kleidern und Textilien am spätmittelalterlichen Papsthof," *Quellen und Forschungen aus italienischen Archiven und Bibliotheken* 87 (2007): 166.

4. Antonio de Beatis, *Die Reise des Kardinals Luigi d'Aragona durch Deutschland, die Niederlande, Frankreich, und Oberitalien, 1517–1518, beschrieben von Antonio de Beatis,* ed. Ludwig Pastor (Freiburg im Breisgau: Herder, 1905), 65. English translation from Antonio de Beatis, *Travel Journal of Antonio de Beatis: Germany, Switzerland, the Low Countries, France and Italy, 1517–1518,* ed. J. R. Hale, trans. J. R. Hale and J. M. A. Lindon (London: The Hakluyt Society, 1979), 95.

5. Shearman, *Raphael's Cartoons,* 25.

6. On the status of the scholarship, see Shearman, *Raphael's Cartoons;* Mark Evans, Clare Browne, and Arnold Nesselrath, eds., *Raphael: Cartoons and Tapestries for the Sistine Chapel* (London: V&A, 2010); Michael Rohlmann, "Raffaels vatikanisches 'Bilderzeremoniell': Grenzüberschreitungen in

der Sixtinischen Kapelle und den Stanzen," in *Functions and Decorations: Art and Ritual at the Vatican Palace in the Middle Ages and the Renaissance,* ed. Tristan Weddigen, Sible de Blaauw, and Bram Kempers (Turnhout: Brepols, 2003), 95–113; and Lisa Pon, "Raphael's *Acts of the Apostles* Tapestries for Leo X: Sight, Sound, and Space in the Sistine Chapel," *Art Bulletin* 97, no. 4 (2015): 388–408. For an important iconographic clarification on the life of Giovanni de' Medici, see Tristan Weddigen, "Tapisseriekunst unter Leo X: Raffaels *Apostelge-schichte* für die Sixtinische Kapelle," in *Hochrenaissance im Vatikan: Kunst und Kultur im Rom der Päpste, 1503–1534,* exh. cat. (Ostfildern-Ruit: Gerd Hatje, 1999): 268–84.

7. On tapestries' associations with paradise, see Enea Silvio Piccolomini, *I Commentarii,* ed. Luigi Totaro (Milan: Adelphi, 1984), 2:1538–40 (VIII.2) and 1594–1613 (VIII.8).

8. For the quote from Tifernates, see Ms. Vat. lat.vi 82, fol. 2v–3r, Biblioteca Apostolica Vaticana, Vatican City; after Charles L. Stinger, *The Renaissance in Rome* (Bloomington: Indiana University Press, 1985), 224–26. The contents of the bull are paraphrased in Steinmann, *Die Sixtinische Kapelle,* 2:48–49.

9. Guillaume Durandus [Gulielmus Durandus], *Rationale divinorum officiorum,* vol. 1, books 1–4, ed. Anselme Davril and Timothy M. Thibodeau (Turnhout: Brepols, 1995), I.1.5–9.

10. Johannes de Turrecre-mata, *Summa de ecclesia* (Rome: Eucharius Silber, 1486), book 2, chap. 52.

11. Vasari, *Le vite,* 6:36–37.

12. The diplomatic report is in Steinmann, *Die Sixtinische Kapelle,* 2:729–30; and Shearman, *Raphael in Early Modern Sources,* 1:160–61. In English, it reads:

"His Excellency wanted very much to see the vault of the large chapel that Michelangelo was painting, and Sig. Federico arranged through Mondovi that he be asked on behalf of the pope. The duke went up to the vault and the duke stayed with Michelangelo and he could not get his fill of looking at those figures. His Excellency flattered him a great deal, saying he desired to have him paint a picture. [The duke] had someone talk to [Michelangelo] and offer him money, and [Michelangelo] promised to do it for him. Sig. Federico, seeing that His Excellency was staying up at the vault for such a long time, led his gentlemen to see the rooms of the pope and those that Raphael of Urbino was painting: after the duke came down from the vault they wanted to show him the pope's rooms and the rooms Raphael was painting, but [the duke] did not want to go, and his gentlemen said it was out of the greatest respect that he could not go in to the chamber where the pope slept."

Translation from the Italian by Sabine Eiche.

13. On the history of prints after Michelangelo and Raphael, see Alida Moltedo, ed., *La Sistina riprodotta: Gli affreschi di Michelangelo dalle stampe del Cinquecento*

alle campagne fotografiche Anderson, exh. cat. (Rome: Palombi, 1991); Madeleine C. Viljoen, "Raphael into Print: The Movement of Ideas about the Antique in Engravings by Marcantonio Raimondi and His Shop" (PhD diss., Princeton University, 2000); Bernadine Barnes, *Michelangelo's "Last Judgment": The Renaissance Response* (Berkeley: University of California Press, 1998); and Bette Talvacchia, "When Marcantonio Met Raphael," in *Renaissance Studies in Honor of Joseph Connors,* ed. Machtelt Israëls and Louis A. Waldman (Florence: Villa I Tatti, the Harvard University Center for Italian Renaissance Studies, 2013), 305–10 ; and Edward H. Wouk with David Morris, eds., *Marcantonio Raimondi, Raphael and the Image Multiplied,* exh. cat. (Manchester, England: Manchester University Press, 2016).

14. Agnese Fantozzi, ed., *Roma 1536: Le "Observationes" di Johann Fichard* (Rome: Libreria dello Stato, 2011), 132–35.

THE GATE TO ETERNITY:
MICHELANGELO'S *LAST JUDGMENT*,
CLEMENT VII, AND PAUL III

On Dante's path through the hereafter in the *Divine Comedy,* he has to be granted the boon of superhuman perception and understanding at a gradual rate—especially during his ascent to paradise—so that he can bear to behold the visionary images. Ultimately, however, the poet's *alta fantasia* (superior fantasy) fails him at the sight of God. Like Dante, Michelangelo was attracted by the possibilities and limits of representation, perception, and understanding—as evident in his *Last Judgment,* which took viewers to extreme limits (see pl. 23). With his ceiling of stars, Piermatteo d'Amelia had painted the extreme edge of the created, visible world and left what was beyond to the imagination of the observer. Michelangelo's ceiling picked up this notion and took it further in the direction of ideas, visual metaphors, and associations with the walls of the heavenly Jerusalem and the gate of heaven as its triumphant entrance. Jonah's gaze toward the ceiling, but also the various levels of reality in the picture fields, refers to the possibilities and limits of painting. With the fresco of the resurrection of the flesh and the Last Judgment, the painter went even further, daring to present a direct vision of the return of the divine judge and the incipient abolition of the earthly categories of time, space, and body.

Unlike Luca Signorelli in Orvieto, for instance, whose pictorial vision was framed by references to authoritative texts and authors, Michelangelo dispensed with any framing commentary. Such immediacy and the brilliant clarity of innumerable bodies had never been seen anywhere before. By thus radically throwing into question, unsettling, and transforming contemporary conventions of painting and seeing, Michelangelo seemed to be anticipating the experience of a categorical change in human perception and understanding at the Last

Judgment itself. Both his artistic daring and his increasingly intense religiosity in these years aimed at paradoxical effect and the superhuman expansion of consciousness necessary to foresee the visual and physical experiences of the Last Judgment in the contemplation of this fresco.

At least some contemporary reactions after the fresco was unveiled seem to go beyond mere topical remarks and ideas—they seem to wrestle with an experience similar to Dante's of exactly how to put this vision into words. "In some miraculous way, didn't God Himself create the idea for this overwhelming *Last Judgment* into your imagination . . . ? Cannot one thus rightly declare that there is a Michael [that is, the archangel] in heaven as God's messenger and another on earth [that is, Michelangelo] as the only son and sole emulator of nature?" Or, with direct reference to Dante's formulation quoted above, "[Michelangelo] has created in the holy temple of the Vatican out of your [whether God's or Michelangelo's is consciously left open] *alta fantasia* a great and overwhelming God." And one admirer speculates with reference to his own physical reaction, "I wonder if I won't be as good as paralyzed when I stand before the *Last Judgment* and in that sweet condition draw my last breath, flying up to heaven (by the grace of God) and crying 'Michelangelo, my divine fellow!'"[1]

No sooner was it completed than the *Last Judgment* became not only the most celebrated contribution to the Sistine Chapel but also the most extensively condemned painting Europe had ever seen. It goes without saying that such an artistic exploration—and even violation—of the boundaries of theological content and the traditions of Christian imagery at the center of the Catholic Church caused much confusion and elicited sharp criticism, especially in the years of the Council of Trent (1545–63).[2] Supposedly Biagio da Cesena, Paul III's master of ceremonies, remarked that the many naked figures belonged in a bathhouse and not in the most important chapel in the world.[3] Vasari reports the rumor that, as punishment for that remark, Michelangelo gave Biagio's features to Minos, who stands entwined by a serpent at the entrance to hell. The *Last Judgment*'s powerful effect ultimately provoked an iconoclastic assault on the fresco itself: Paul IV (r. 1555–59) seriously considered having it scraped off, and only Daniele da Volterra's painting

over all-too-offensive parts of the nude bodies (earning him the nickname *bra-ghettone*, "pants painter") disarmed and saved Michelangelo's second contribution to the chapel, which Vasari considered even more sublime than the ceiling.[4]

Beyond the Borders | By the mid-1520s, the Sistine Chapel was no longer in the best condition. Although the lintel of the main entrance, which had collapsed in 1522, had been repaired, the two badly damaged frescoes above it remained for decades in their ruined condition. Then, during Passion Week in 1525, a curtain used to cover the altarpiece during Lent caught fire, and Perugino's paintings must have been seriously affected. Disastrous conditions in the Curia, including internal abuses and a crisis of papal authority, must have stood in the way of a quick restoration, along with the beginning of the Reformation, wars in Italy, and finally the *sacco di Roma* in 1527, in which Charles V's unruly troops plundered the Eternal City.

The situation improved between 1530 and 1533, and in the latter year the Medici Pope Clement VII (r. 1523–34) commissioned Michelangelo to repaint the altar walls (and maybe also the entrance wall) of the Sistine with monumental frescoes. The first source to mention a specific theme speaks in February 1534 of a *resurrectione* for the altar wall.[5] Some scholars interpret this as a reference to a resurrection of Christ, so that the theme of the destroyed fresco on the entrance wall would have been transferred to the wall behind the altar. However, it seems more plausible that what was meant was the resurrection of all flesh at the Last Judgment, the theme actually carried out. Vasari reports that the fall of the rebellious angels was planned for the entrance wall. Thus the End of Days on the west wall would correspond to the Beginning of Days on the east wall, for the fall of the rebellious angels was considered a prelude to the Creation.

Like his great predecessors, Clement VII wanted to leave a monument to himself in the Sistine Chapel. And like Julius II, he was prepared to sacrifice existing frescoes for the new project: the pictures of the birth of Christ and the discovery of Moses in the bulrushes, the beginning of the series of canonized

popes above them, and Michelangelo's own lunettes under the ceiling, not completed until 1512. Still, the initial plan was to preserve Perugino's frescoed altarpiece. Michelangelo's early sketches for the design of the *Last Judgment* show a rectangle left blank for the altarpiece. Its depiction of the Assumption of Mary—the first time the gates of God's kingdom were opened for a human following Christ's Resurrection and thus an anticipation of a general resurrection—could be easily integrated.

On the basis of preparatory drawings, we can distinguish two main phases of the planning process. The first is documented by two drawings in London and New York that both apparently go back to an elaborate presentation drawing by Michelangelo. Thus these copies probably represent the design approved by Clement VII, which is characterized by the central position of the archangel Michael directly above the blank space reserved for the altarpiece. The pope venerated Michael; after all, he had survived the *sacco di Roma* in the Castel Sant'Angelo, which was dedicated to the archangel. Moreover, the militant messenger of God would have been a welcome expression of the *ecclesia militans* in those troubled times.

But Clement VII died in September 1534, before Michelangelo had even begun to prepare the surface to be frescoed. Clement's successor, Paul III Farnese (r. 1534–49), was barely installed in office before he went to great lengths to ensure that Michelangelo would continue to carry out the commission. Condivi reports an unheard-of sign of favor: the pope himself, accompanied by eight or ten cardinals, paid a visit to the artist's studio,[6] just as in ancient times Alexander the Great was said to have visited the painter Apelles. It is certain that in September 1535, with an eye to Michelangelo's work on the *Last Judgment,* Paul appointed the artist as the "chief architect, sculptor, and painter of Our Apostolic Palace."[7] The pope's decree of the following year charging Michelangelo with the work on the fresco served mainly to relieve the artist of all other commitments, especially the Julius tomb. Despite Vasari's claim that Paul had Michelangelo carry out without modification the design he had prepared for Clement, two important studies in Florence (see pl. 24) and Bayonne

attest to a second planning phase. Perugino's altarpiece was still meant to be preserved, but the relatively static figure of Michael standing in the middle was erased on the Florence drawing and replaced by a group of struggling figures, and other figures were repositioned.

Before Michelangelo began to realize a further modified design in 1536, he had the entire altar wall chiseled and prepared so that it tilted forward by about 30 centimeters. The effort involved in this unique preparation demonstrates how meticulously Michelangelo planned the innovative overall effect of his fresco. After five years of work, the *Last Judgment* was solemnly unveiled on 31 October 1541, All Hallows' Eve. This time, the master appears to have in fact painted almost all the more than three hundred, mostly nude, figures by himself, without assistants. One wonders whether in this colossal effort we can begin to discern what is obviously true for the sculptures of Michelangelo's late period: that he regarded his art as a kind of personal service to God, both physical penance and spiritual observance.

Without any frame whatsoever, Michelangelo's enormous picture occupies the entire surface of the front wall, about 226 square meters, and forcefully draws the eye toward the end of the chapel (see pl. 23). Where previously, various directional impulses had basically offset one another, the interior now possesses a single magnetic pull. At the bottom of the fresco, a narrow strip of hilly land appears whose horizon line melts into a flat, eternal sky. High above, Christ stands as Judge of the World surrounded by the heavenly hosts in two concentric circles. The herculean figures of John the Baptist (Vasari's identification of him as Adam is not convincing) and Saint Peter lead the inner circle of apostles, patriarchs, prophets, and other Old Testament figures. At their feet crouch Saint Lawrence and Saint Bartholomew, the latter holding his skin as a sign of his martyrdom: being flayed alive. (Not until 1925 was the face on the skin identified as that of Michelangelo himself.)[8] John the Baptist, Saint Peter, and the other apostles belong to the second planning phase and do not appear this way in any preliminary drawing. The apostles, at least, were already present on Perugino's altarpiece.

The altarpiece's removal seems also to be responsible for the new role and position of the Virgin. While the altarpiece had represented her as the Queen of Heaven, on Michelangelo's preliminary drawings she appears as an intercessor for humanity. Ultimately, in the completed fresco, she nestles against Christ's side and shares his aureole, almost seeming to reverse the birth of Eve from Adam's rib and—as a symbol of the Church—merge again with Christ. Thus the Mother of God epitomizes the transformation hoped for by all believers, as described by Paul in Philippians 3:20-21: "For our conversation is in heaven; from whence also we look for the Saviour, the Lord Jesus Christ: Who shall change our vile body, that it may be fashioned like unto his glorious body, according to the working whereby he is able even to subdue all things unto himself."[9] In the lunettes above them, wingless angels present the *arma Christi*, the instruments of the Passion that prove his triumph over death.

In the outer circle are more saints—Saints Andrew, Sebastian, Blaise—with some grouped together into choirs. The objects they carry help suggest their identities. One has the impression that this circle continues downward in a throng of figures that reaches the visual border of the painting and almost intrudes into the space of the actual chapel. In the middle is a group of angels who blow the trumpets of the Last Judgment and display the books with the names of the saved and the damned. To the left, wingless angels raise the saved into the heavenly realm, while on the right demons drag the damned into the depths of hell. The fact that some of the saved are hanging on to rosaries as they are pulled up has conflicting interpretations. Michelangelo may have been depicting the teaching—criticized by the Reformation—that good deeds would be counted at the Last Judgment. Or the fact that one sees only rosaries, which indicate prayer and hope in salvation, might also suggest precisely the opposite idea: that one is saved *sola gratia*, by the grace of God alone. On the strip of land to the left, the dead are rising from their graves. In the middle, we look into a subterranean cavern filled with demons and reminiscent of purgatory. To the right, the ferryman Charon herds the damned into his boat to cross the Acheron. On the other bank, the fiery entrance to hell is revealed with the figure of Minos entwined by a serpent (after Dante, *Inferno* 3.109-20 and 5.4-12).

The composition of the fresco thus responded very ingeniously to the chapel's existing decorations and liturgical requirements. Instead of concentric circles in the space around Christ, one could also describe it as having three registers: the action on the earth that corresponds to the "earthly reality" of the chapel; the zone of angels with the saved and the damned that seems to continue the quattrocento frescoes; and the area around Christ and Saint Peter that compensates for the loss of the first two canonized popes who used to occupy this space. In addition, the angels with the Cross and Pillar of the Scourging engage in a typological dialogue with the Old Testament scenes—*The Punishment of Haman* and *The Brazen Serpent*—in the spandrels above them.

A conscious decision seems to have been made to portray less important things directly above the altar, where Perugino's altarpiece had been located. This area was screened from view partly by the crucifix and candles and sometimes by temporary constructions on the altar such as one sees in the engraving from 1578 (see fig. 3). Moreover, the size of the figures in the entire fresco increases from the bottom to the top, thus mediating between the smaller-scale figures of the quattrocento frescoes and the monumental ones of the ceiling. As a result, the figures' size and the forward tilt of the wall give Christ and his immediate heavenly companions a supernatural presence that creates an unsettling tension with what the observer assumes to be their perspectival distance.

The Power of the Keys | The mixed reactions of Michelangelo's contemporaries continued to occur in the art-historical literature. Until about 1900, every discussion of the *Last Judgment* involved an aesthetic assessment, and it was impossible to have an interpretation that was—at least in its intention—a distanced, historical critique. And yet when such interpretations did begin to be published, they could not have been more at odds with each other. In 1907, the Jesuit Joseph Sauer stressed that despite the unique position of the fresco, the choice of themes and the location on the altar wall made logical sense in the context of the existing decor. Almost simultaneously, the art historian Carl Justi described the gigantic painting in

1909 as "abnormal"—and it was this judgment that had the greatest influence on subsequent opinion.[10]

These contrasts in previous scholarly research all served to emphasize Michelangelo's uniqueness. Take, for example, medieval works in Pomposa, Sant'Angelo in Formis, Torcello, Florence, and Rome; Giotto's Arena Chapel in Padua; Buffalmacco's fresco in the Camposanto in Pisa; Fra Angelico's and Fra Bartolommeo's works in Florence; and Signorelli's Cappella Brizio in the Orvieto cathedral (see pl. 26). The attempt to prove that Giovanni Sulpizio Verolano's poem on the Last Judgment of the living and the dead, *Iudicium Dei supremum de vivis et mortuis,* completed by 1506, provided a concrete textual model for Michelangelo is not very convincing.[11] Instead, I suggest a more thorough examination of a group of neglected depictions of the hereafter. While they do not explain Michelangelo's picture, they at least provide a glimpse of the context in which the work was commissioned.

In order to understand why the *Last Judgment* was placed behind the altar, one should first note that like Saint Peter's, the Sistine Chapel has an unusual orientation in that it faces west, and thus geographically, the scene of the *Last Judgment* points in the "right direction": the direction from which the arrival of the Judge of the World was expected. Also recall that the chapel of the papal palace occupies a special place in the iconography of the Last Judgment, since the pope in his role as judge also operates as the deputy of Christ. Therefore, in this particular location, the events of the Last Judgment possessed a specific admonitory significance, not just a general warning as in the decor of other churches and chapels. A late fourteenth-century miniature probably made by Niccolò da Bologna for a manuscript of the *Decretum Gratiani* clearly demonstrates how the Last Judgment, with its raising of the elect and damnation of sinful, could be seen as parallel to the pope's power of the keys and power to judge.[12] The same connection is established by a medal that Paul II had struck, probably by Emilio di Pier Matteo Orfini da Foligno, around 1466/67 to commemorate the excommunication of the king of Bohemia: one side shows Christ as judge at the Last Judgment, the other the pope in the public consistory (see pl. 25).[13]

Most important, however, having the *Last Judgment* on the altar wall of the Sistine is by no means unique to the Sistine Chapel. In the 1470s, for instance, the Bellincini family had Cristoforo da Lendinara and his studio decorate their chapel in the Modena cathedral with frescoes (see pl. 27).[14] Just as had once been the case in the Sistine, one finds here a fictive altar retable with Mary and the saints. On the wall surrounding them, the Last Judgment is occurring. Here, Christ with the heavenly hosts, the archangel Michael accompanied by trumpet players, and resurrected humanity are distributed in three registers loosely separated by bands of clouds. Also comparable is a series of eight prophets on the inner side of the chapel's flat framing arch. Another instance of a Last Judgment on an altar wall is a 1446 scene in the church of San Giorgio di Campochiesa in Piedmont.

More examples can be found in locations less remote from a Roman point of view: between Florence and Rome itself. They share the additional peculiarity that the Last Judgment and scenes in the hereafter occupy not just one wall but the entire interior. This is the case for the Cappella Strozzi in Santa Maria Novella in Florence from the 1350s, where the presence of the Judge on the altar wall is accompanied by heaven and hell on the side walls. Tellingly, Orcagna's altarpiece shows Christ bestowing the keys on Saint Peter. The decorations of the Cappella Paradisi in San Francesco in Terni, about fifty miles from Rome, were painted by Bartolomeo di Tommaso around 1450.[15] In this specific case, the family name of the chapel's aristocratic patrons, the Paradisi, suggested the theme of the hereafter. The altar wall is divided into two registers (see pl. 28). Above, Christ the Judge is enthroned, and below him we see the gate of heaven. With his golden key and assisted by the archangel Michael and his fellow apostles and saints, Saint Peter watches over the entrance to the kingdom of heaven. As in the Cappella Strozzi, the contiguous walls to the right and left again depict hell and paradise. Signorelli's frescoes in the Cappella Brizio in Orvieto, which present the last stages of the history of salvation in particular detail, also have Christ the Judge on the altar wall. And finally, there is the former Oratorio di San Pietro Martire in Rieti. Although the frescoes by Bartolomeo di Cristoforo Torresani and Lorenzo Torresani were not painted until 1552 to 1554, they represent an early

reception of Michelangelo's work, expanded by the addition of heaven and hell under the influence of Signorelli's frescoes in Orvieto.[16]

Thus Michelangelo's *Last Judgment* dominates the interior of the Sistine for reasons other than its innovative shattering of the picture frame. Indeed, on the basis of preceding artistic tradition, contemporary observers would have been to some extent prepared for the fact that with a Last Judgment behind the altar, the entire interior would have the locations of the hereafter as its theme. Saint Augustine's Civitas Dei could be represented as a well-ordered community of believers. That was complemented by a tradition, widespread in northern and central Italy, of visualizing a heavenly city with walls, a gate, and sometimes a central tower, but above all with Saint Peter as the doorkeeper. As in the Cappella Paradisi, Peter stands with Michael at the gate of heaven in San Fiorenzo in Bastia Mondovi (Piedmont), painted circa 1466 to 1472. In Santa Maria in Piano (in the Abruzzian town of Loreto Aprutino), Saint Peter also allows the righteous to pass through a tower-like gate into the kingdom of heaven. Next to him are depicted Abraham and the two patriarchs in whose bosom the righteous awaited the return of Christ (see Luke 16:19–31 and Matthew 8:11). Similar scenes at the entrance to heaven are found in fourteenth- and fifteenth-century murals in the Santa Maria del Casale (Brindisi), Santo Stefano (Spoleto), and Santissima Annunziata (Sant'Agata dei Goti near Benevento).[17]

While here I cannot follow further the prehistory of these visual motifs, it will suffice to mention the mosaics on triumphal arches in Rome on which abbreviated versions of the heavenly Jerusalem always appear beneath Christ the ruler of the world; the mosaics in the Florentine Baptistery with their gates of heaven; the entrance wall of Santa Maria della Pomposa—also painted in the thirteenth century—where the four corners of the picture field are occupied by hell at the lower right, the three patriarchs at the lower left, the heavenly city at the upper left, and the instruments of the Passion at the upper right; and the 1483 frescoes by Tommaso and Matteo Biazaci in San Bernardino in Albenga. However, perhaps the most striking example of the significance of Saint Peter as the doorkeeper of the kingdom of heaven is again the chapel in Cori, near

Rome (see pl. 13). Its entrance wall shows a Last Judgment with Christ between Mary and John the Baptist, beneath them the instruments next to an empty altar as in the vision in the Revelation of Saint John, and next to the empty altar the resurrection, hell, and the round dance of the inhabitants of heaven. Since this densely packed surface lacked enough room to prominently feature one indispensable element, one field was reserved from the Moses cycle on an adjoining wall in order to portray the stairway to the door of heaven with Saint Peter standing watch before it.

Given this background, two things become clear. First, for Michelangelo and his two papal patrons, it was a quite obvious choice to paint a Last Judgment on the altar wall of an interior whose existing decorations were so closely associated with the triumphal forecourt of heaven. And second, for contemporary viewers, the completed fresco of the end of days must have connected the existing decorations even more strongly to ideas of the hereafter, logically leading all strands of salvation history to their final culmination. The fictive architecture, crowned by prophets, sibyls, and *ignudi,* suggested the walls of the heavenly Jerusalem. We have outlined above an escalation of the visual ideas in the Sistine, with its decorations becoming more and more daring and the limits of what could be represented expanding and being transcended at the same time. In keeping with that development, the image of the city of God that humanity's limited imagination was deemed capable of grasping—an image of walls and buildings—seems in the *Last Judgment* to be succeeded by an assembly of the elect beyond space and time, an assembly with no further need for architectural metaphor.

Now we can also understand the unprecedented pose of Saint Peter on the Sistine's altar wall. He is giving the keys back to Christ, or at least offering to do so. For the first time in iconographic tradition, we see depicted a sort of reversal of the *traditio clavium*—the bestowing of the keys—that was seen in the earlier imagery of the chapel: in Perugino's fresco from the Christ cycle, in Raphael's tapestries, and possibly a third time at the beginning of the series of popes above the altarpiece. With the Last Judgment and the definitive separation of the saved and the damned, there is no more need for Christ's deputy on earth

or for a gatekeeper to the heavenly Jerusalem. At that moment, purgatory also loses its function. In the depictions of the Mass of Saint Gregory that had been very popular since the late fifteenth century, purgatory is still full to bursting with the souls Saint Gregory was "praying free" by celebrating Mass at the altar, but in Michelangelo's purgatory above the altar, only a few demons remain.

Nevertheless, these basic ideas were complicated and—at least for some observers—made highly questionable by Michelangelo's composition. It is hinted at by his own self-portrait on the flayed skin of Saint Bartholomew. First, this concealed portrait-signature follows the not-unusual double impulse of pride in his own work alongside personal humility and hope for redemption, as in Job 19:26: "And though after my skin worms destroy this body, yet in my flesh shall I see God." But in view of the drooping skin, for Michelangelo the resurrection of the flesh cannot have taken place yet; his skin is still a mere attribute of a saint. Does the artist doubt his own resurrection? Does his *alta fantasia* forsake him in his own case? Is he incapable of measuring up to the greatness of his vision? At the same time, the archangel Michael, Michelangelo's personal patron saint, is missing from the fresco or at least cannot be conclusively identified, despite the fact that he plays one of the leading roles in the iconographic tradition of the Last Judgment. Contemporary panegyrics often compared the artist with the archangel. Is Michelangelo hoping that it will occur to an observer that he can't find Saint Michael on the altar wall because the archangel has anticipated the work of the Supreme Judge by beginning to weigh souls (Michelangelo's?) right there in the chapel, in Rome, on earth?[18]

Attempts to interpret the Sistine as a preview and symbol of the heavenly Jerusalem to come, in circulation since its decoration first began, reach their apex with the *Last Judgment*. In Michelangelo's vision, the kingdom of heaven descends to earth directly over this chapel, or rather, into the center of the earthly *ecclesia militans* and onto the tomb of Saint Peter. But the *Last Judgment* also marks the completion of the popes' efforts to demonstrate their power on earth—and thus the power of Peter and Christ as well. The axis from Mary via Christ and Peter to Jonah and God the Father would then be temporally

extended one last time to the return to earth of the God of Eternity. That he will take back the keys from Peter and thus declare his actions and those of his successors to have been right legitimizes the fullness of the papacy's power on earth as forcefully as possible *sub specie aeternitatis* (for eternity). But the deeply disconcerting aspects of the fresco are that Michelangelo delivered this message through heroic, nude figures—most of whom are not identified and some not even clearly differentiated into good and evil—and that an artist asserted the claim that his powerful vision could anticipate and interpret this final event of the history of salvation.

To be sure, the reform of the conclave under Gregory XV in 1621 and 1622 and the first papal election to take place after Gregory's death in the following year seem to indicate that by that point at the latest, the reception of the fresco had moderated. For the first time, the election was moved from the Cappella Paolina to the Sistine, where it still takes place today. The main reason for the move seems to have been the new oath the cardinals had to swear out loud at the altar. It certified before "Christ the Lord, who will be my judge" that they were voting for the right person according to God's will. To swear this oath, there was clearly no better and more symbolic place than the altar below Michelangelo's Christ the Judge.[19]

Picture Programs and Artistic Freedom in the Renaissance

In the biographies of Michelangelo by Vasari and Condivi, the artist's *Last Judgment* is mentioned solely as a demonstration of the power of artistic imagination, freedom, and perfection. Thus Condivi writes,

[Pope Clement] . . . resolved to have [Michelangelo] paint the Day of the Last Judgment, with the idea that the variety and magnitude of the subject ought to afford the scope for this man to demonstrate his powers and how much they could achieve. . . . Because it had been Pope Clement's idea and begun in his time, Michelangelo did not put Paul's coat of arms in this work, although the pope had besought him to. So great was Pope

Paul's love and respect for Michelangelo that, even though he desired this, he nevertheless did not want ever to displease him. In this work Michelangelo expressed all that the art of painting can do with the human figure, leaving out no attitude or gesture whatsoever.

Vasari sums it up by writing that Clement commissioned Michelangelo with the *Last Judgment* "to demonstrate with this picture, what the art of painting . . . could accomplish."[20]

Both authors, one of them an artist himself and the other Michelangelo's faithful mouthpiece, pursue at least two aims with these assertions. On the one hand, the assertions are addressed to contemporary theologians who desired to strictly regulate the visual arts in the wake of the Counter-Reformation and particularly criticized Michelangelo's *Last Judgment* for its violations of theme and decorum. On the other hand, they present Michelangelo as the high point of a development that measured the intellectual and social status of artists and their productions by the extent to which they invented their own subjects.

For it was not manual execution that would raise painting and sculpture into the rank of liberated arts but only intellectual conception. Indeed, Leon Battista Alberti, writing in 1435, had praised the inventions of the ancient painter Apelles. Lorenzo Ghiberti was proud of the fact that he was permitted to execute *Gates of Paradise* "according to his invention."[21] And when, in 1501, Isabella d'Este wanted a mythological painting by Giovanni Bellini at any price, she granted him the right to choose the theme he thought best.[22] We can also interpret Marcantonio Raimondi's prints after Raphael's designs to be partly in this tradition: they increased Raphael's fame by disseminating his visual inventions. Michelangelo, thus, functions as the consummator of this tradition of Renaissance artists explicitly claiming the free invention of their works; at the same time, he claims to be a Dante specialist and a painter-theologian and visionary by God's grace.

The reality was certainly more complicated. For instance, if we look at the surviving contract for Fra Bartolommeo's 1498 *Last Judgment* in Florence, we see that the main persons to be depicted and the textual basis for the painting are

clearly laid out. That was also the case for Ghiberti's *Gates of Paradise*. In the Vatican in 1516, Raphael asked Cardinal Bibbiena for the "text of the stories" for the frescoes that he was to paint in the cardinal's bath. Of course, such profane decoration cannot be compared to a religious theme without major reservations, but it shows that it was a matter of course even for a "superstar" like Raphael to work according to instructions like these at the papal court.[23] And this is the way we should also imagine the genesis of all the images in the Sistine Chapel. Whoever was pope at the time had the honor of being the author of the entire conception—as was claimed in 1477 in the first known poem on Sixtus IV's renovation of the Sistine Chapel.[24] The papal cue, possibly prompted by members of his entourage, would then be elaborated by them and passed on to the artists either orally or in writing. The entire process from first idea to finished work would not have been simply a succession of directives, however. The artists' latitude in carrying out a commission was considerable; they alone were capable of envisioning and then realizing the formal possibilities. Still, regular dialogue was important. Michelangelo's initial designs for the Sistine ceiling, for instance, created opportunities for new, larger picture fields that required renewed consultations with the responsible authorities. Their suggestions could then supply the impetus for new visual ideas. That said, Michelangelo's imaginative power and interpretive accomplishments in the decoration of the ceiling and the *Last Judgment* remain enormous even if one accepts the very likely scenario that in the center of the Christian world, an artist was not allowed to paint whatever he liked, without direction or oversight.

This is all the more so in view of the basic structure of picture programs in the Renaissance. The contemporary name for these was *invenzioni*—inventions. The inventions could be texts so brilliant that they could be read with pleasure even without the artwork they described. That was what Alberti claimed early on, and Pope Leo X is said to have had the program for the 1514 celebration of the Feast of Saint John the Baptist in Florence sent to him. But the inventions could also be so complicated or ambivalent that there was urgent need for an explanation of what was depicted; evidence survives that this was true for the

pictures for a Florentine tournament of 1471 and for the 1539 carnival wagons in Rome. In any case, none of these *invenzioni* corresponded to our modern concept of a program that describes the precise spatial distribution of images, their relation to one another, and how they should be (visually) interpreted. Instead, Renaissance programs merely named the themes to be depicted.[25] In the decades around 1500, the conversations between artists and their advisers about how these texts were to be translated into visual images are largely beyond our ken. We can be certain, however, that Michelangelo, Raphael, and even the painters of the quattrocento played a decisive role in them.

At any rate, the process of decorating the Sistine Chapel described in this book as a continual visual reflection on the history of salvation, the office of the pope, the *ecclesia militans* and *ecclesia triumphans,* paradise and the heavenly Jerusalem—and on what painting was able to accomplish—could not have been merely the systematic realization of a single, predetermined program. Yet each new visual element took up aspects of the existing decor, thought them out further, and partially modified them or made them more precise. This is the process that can be followed in the Sistine Chapel over six decades, as in no other place in Renaissance Italy. In their competitive engagement with the other visual elements of the chapel—and the entire Vatican—it is this continuity that motivated especially Michelangelo and Raphael to develop their new visual languages, blazing a trail for European art of the following centuries.

NOTES

1. The first two quotes on the Last Judgment are by Niccolò Martelli, letter to Michelangelo, 4 December 1541, in Barocchi and Ristori, Il carteggio, 4:119, and the third is by Antonfrancesco Doni, letter to Michelangelo, 12 January 1543, in Barocchi and Ristori, Il carteggio, 4:160–63.
2. On the intimate relationship between praise and criticism of the Last Judgment, see Melinda Schlitt,

"Painting, Criticism, and Michelangelo's Last Judgment in the Age of the Counter-Reformation," in Michelangelo's "Last Judgment," ed. Marcia B. Hall (Cambridge: Cambridge University Press, 2005), 113-49.
3. On the maestro di ceremonie Biagio da Cesena, see Norman E. Land, "A Concise History of the Tale of Michelangelo and Biagio da Cesena," Source: Notes in the History of Art 32, no. 4 (2013): 15-19.

4. On 21 January 1564, a congregazione convoked by Pius IV in Rome decided that those figures in Michelangelo's Last Judgment that showed "obscene things" should be painted over. The Council of Trent did not discuss Michelangelo's frescoes, as was long asserted, but referred only in general to the edict about the images: "The paintings in the Sistine Chapel are to be covered, and in other churches effaced, if anything

obscene or evidently false is shown, according to the second decree in session 25 under Pius (it was the ninth session for Pius, as he presided over sessions 17-25)." Translation from the Latin by Ivana Bičak. Latin original text cited in Peter Lukehart, "Painting Virtuously: The Counter-Reform and the Reform of Artists' Education in Rome between Guild and Academy," in The Sensuous in the Counter-Reformation Church, ed. Marcia B.

Hall and Tracy E. Cooper (Cambridge: Cambridge University Press, 2013), 161–86.

5. A report for the duke of Mantua from 2 March 1534 mentions an earlier letter of 20 February with this information; see Charles de Tolnay, *Michelangelo V: The Final Period* (Princeton, N.J.: Princeton University Press, 1960), 19 and 99–100 (no. 5), who argues that a *Resurrection of Christ* was planned.

6. Condivi, *The Life of Michelangelo,* 77; the original version is in Condivi, *Vita di Michelagnolo Buonarroti raccolta per Ascanio Condivi da la Ripa Transone (Rom 1553),* pt. 1, ed. Charles Davis, *FONTES* 34 (2009): 38 (35r), https://doi.org/10.11588/artdok.00000714.

7. Steinmann, *Die Sixtinische Kapelle,* 2:742–44; the pope's decree mentioned in the next sentence also here, 2:748–52.

8. On Michelangelo's concealed self-portraits, see Bernadine A. Barnes, "Skin, Bones, and Dust: Self-Portraits in Michelangelo's *Last Judgment,*" *Sixteenth Century Journal* 35, no. 4 (2004): 969–86; Rudolf Preimesberger, "'Und in meinem Fleisch werde ich meinen Gott schauen': Biblische Regenerationsgedanken in Michelangelos 'Bartholomäus' der Cappella Sistina (Hiob)," in *Das Buch der Bücher—gelesen,* ed. Steffen Martus and Andrea Polaschegg (Bern: Lang, 2006), 101–17; and Victor I. Stoichita, "La pelle di Michelangelo," *Humanistica* 3, no. 1 (2008): 77–86.

9. On the significance of Philippians 3:20–21, see Giovanni Careri, *La torpeur des Ancêtres: Juifs*

et chrétiens dans la chapelle *Sixtine* (Paris: Éditions de l'École des Hautes Études en Sciences Sociales, 2013).

10. Kraus, *Geschichte der christlichen Kunst,* 2:541–42; and Carl Justi, *Michelangelo: Neue Beiträge zur Erklärung seiner Werke* (Berlin: Grote, 1909), 310–11.

11. Marco Bussagli, "Michelangelo e Sulpizio Verolano: La fonte letteraria del Giudizio Universale," in *Il Rinascimento a Roma: Nel segno di Michelangelo e Raffaello,* ed. Maria G. Bernardini and Marco Bussagli (Milan: Electa, 2011), 88–93.

12. Inv. 4215, Kupferstichkabinett, Berlin.

13. On the medal, see Louis Waldman, "A Medal of Paul II after a Design by Fouquet," *The Medal* 21 (1992): 3–15; and Anne Leader, "Michelangelo's *Last Judgment:* The Culmination of Papal Propaganda in the Sistine Chapel," *Studies in Iconography* 27 (2006): 115–17.

14. Daniele Benati, ed., *La Cappella Bellincini nel Duomo di Modena* (Modena: Panini, 1990).

15. Piero Adorno, "Gli affreschi della Cappella Paradisi nella Chiesa di San Francesco a Terni," *Antichità Viva* 17, no. 6 (1978): 3–18; and Aldo Cicinelli, "Appunti per uno studio della Chiesa di S. Francesco e degli affreschi attribuiti a Bartolomeo di Tommaso (sec. XV), nella Cappella Paradisi, in Terni," in *Arte sacra in Umbria e dipinti restaurati nei secoli XIII–XX* (Todi: Ediart, 1987), 25–46.

16. On these examples of portrayals of the Last Judgment, see Jérôme Baschet, *Les justices de l'au-delà: Les représentations de l'enfer en France et en Italie (XIIe–XVe*

siècle) (Rome: École française de Rome, 1993); and Anne-Sophie Molinié, *Corps ressuscitants et corps ressuscités: Les images de la résurrection des corps en Italie centrale et septentrionale du milieu du XVe au début du XVIIe siècle* (Paris: Champion, 2007).

17. On the Roman tradition of images and Sant'Agata dei Goti, see Stephan Waetzoldt, *Die Kopien des 17. Jahrhunderts nach Mosaiken und Wandmalereien in Rom* (Vienna: Schroll, 1964), 28n8 and fig. 8.

18. I thank Michael Cole for his thoughts on the archangel Michael.

19. The idea that the *Last Judgment* influenced the new formula for the cardinals' oath of office after the reform of the conclave under Gregory XV comes from Günther Wassilowsky, *Die Konklavereform Gregors XV. (1621/22): Wertekonflikte, symbolische Inszenierung und Verfahrenswandel im posttridentinischen Papsttum* (Stuttgart: A. Hiersemann, 2010).

20. For the Condivi translation, see Condivi, *The Life of Michelangelo,* 75 and 83. The Vasari quote is in Vasari, *Le vite,* 6:65.

21. Lorenzo Ghiberti, *Lorenzo Ghibertis Denkwürdigkeiten (I commentarii),* ed. Julius von Schlosser (Berlin: Bard, 1912), 1:48: "Fummi allogara l'altra porta cioè la terça porta di sancto Giouani la quale mi fu data licentia io la conducessi in quel modo ch'io credessi tornasse più perfettamente et più ornata et più riccha."

22. Leon Battista Alberti, *De pictura,* ed. Lucia Bertolini (Florence: Polistampa, 2011), lib. III, §53; and

Ghiberti, *Lorenzo Ghibertis Denkwürdigkeiten,* 1:48–49. See also Leon Battista Alberti, *Leon Battista Alberti: On Painting; A New Translation and Critical Edition,* trans. Rocco Sinisgalli (Cambridge: Cambridge University Press, 2013), 75–76. On Isabella d'Este, see Stephen Campbell, *The Cabinet of Eros: Renaissance Mythological Painting and the Studiolo of Isabella d'Este* (New Haven: Yale University Press, 2006); and Hans von der Gabelentz, *Fra Bartolomeo und die Florentiner Renaissance* (Leipzig: Hiersemann, 1922), 1:138.

23. On Raphael, see Shearman, *Raphael in Early Modern Sources,* 1:240–43 (1516/8).

24. Flemmyng, *Lucubranciunculae Tiburtinae,* 26–27. Michael Baxandall analyzes this notion of the role of the commissioner using another example; see Baxandall, "Rudolph Agricola on Patrons Efficient and Patrons Final: A Renaissance Discrimination," *Burlington Magazine* 124 (1982): 424–25.

25. On the sources for how programs of decor were developed in the Renaissance, see Charles Hope, "Artists, Patrons, and Advisers in the Italian Renaissance," in *Patronage in the Renaissance,* ed. Guy Fitch Lytle and Stephen Orgel (Princeton: Princeton University Press, 1918), 293–343; Julian Kliemann, "Dall'invenzione al programma," in *Programme et invention dans l'art de la Renaissance,* ed. Michel Hochmann et al. (Paris: Somogy Éditions d'Art, 2008), 17–26; and, for a different view, cf. Herzner, *Die Sixtinische Decke.*

EPILOGUE IN PURGATORY:
ART HISTORY AND THE MYTH OF
THE SISTINE CHAPEL

The subsequent history of the Sistine Chapel involves a
collision of extremes.[1] First of all, the chapel would continue to acquire new
decorations beyond the two replacement frescoes on the entrance wall. Since
the *Last Judgment* made it impossible to hang Raphael's tapestries beside
the altar, relegating them instead to the longitudinal walls, Paul III commis-
sioned Perino del Vaga to create a tapestry border with grotesqueries to be
placed along the lower edge of the *Last Judgment*. For unknown reasons, the
design was apparently never woven, but two almost identical drafts on canvas
have survived. At the time, a tapestry with the Coronation of Mary served
as a temporary altarpiece. (Pupils of Carlo Maratti then designed three new
tapestries in the late seventeenth century.) In 1543, Paul III had named Fran-
cesco di Bernardino d'Amaldore, a stonemason and former pigment grinder for
Michelangelo, as the overseer of all the paintings in the Sistine, the Sala Regia,
and the Cappella Paolina. Obviously, the pope was concerned about keeping the
pictures in good condition. And it was not just the two or three generations of
artists after Michelangelo who copied his frescoes as a "school for artists"—as
shown, for instance, by the painted biography of Taddeo Zuccari (fig. 26). Until
the early nineteenth century, Michelangelo's figures were a standard element
of drawing textbooks, represented by a greater or lesser number of examples
depending on whether the stock of the divine artist was rising or falling. Still in
Triumph over Mastery II (1987), the American painter Mark Tansey's reflection
on modern art and how we perceive the artistic accomplishment of past eras, a
house painter, using a roller brush, is covering up Michelangelo's *Last Judgment*
as the prime example of a masterpiece (see pl. 29).

Fig. 26. Federico Zuccaro (Italian, ca. 1541–1609). *Taddeo in the Sistine Chapel Drawing Michelangelo's "Last Judgment,"* ca. 1595, pen and brown ink, brush with brown wash, over black chalk and touches of red chalk, 41.9 x 17.7 cm. Los Angeles, J. Paul Getty Museum.

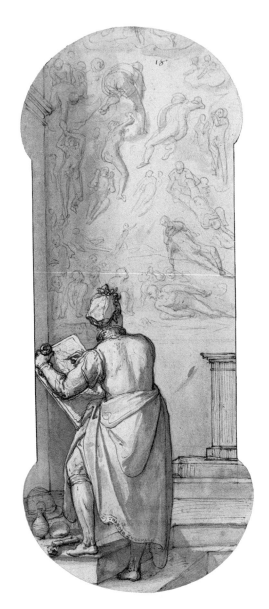

Beginning in the nineteenth century, artistic worship of Michelangelo finally began to wane. The Frenchman Jean-Auguste-Dominique Ingres, having just arrived in Rome as the winner of the Grand Prix de Rome of the French Academy, was deeply moved by his visit to the Sistine during Holy Week in 1807.

> The Sistine Chapel is reserved exclusively for services during Holy Week and the conclave. . . . Nothing is as overwhelming as the ceremony led by the pope . . . with his cardinals. . . . Finally in the evening . . . the pope descends from his seat and kneels down and a great stillness anticipates the heavenly entrance of voices performing the "Miserere." . . . There is no more light. The day declines and barely allows one to make out the terrifying painting of the "Last Judgment," whose powerful effect sinks a kind of horror into our souls.[2]

The interior view of the chapel during a Mass attended by the pope that Ingres painted somewhat later, between 1812 and 1814, cannot be understood as documentation—at the time, Pius VII was a prisoner of Napoleon in Fontainebleau Palace and, for one thing, would not have worn such white robes (see pl. 30).[3] Instead, Ingres's portrayal is a nostalgic ideal in which the art of painting plays a decisive—if not all-encompassing—role in the interest of that art. The critics of this painting, which Ingres exhibited in the Paris Salon, bemoaned the "anachronism and inversion of time" in the picture. They said the depicted Renaissance frescoes seemed more modern than the sharply outlined, disembodied, and seemingly frozen figures of Ingres.

A few decades earlier, Johann Wolfgang von Goethe's viewing of the ceiling from the gallery running along the main cornice, as he described it in *Italienische Reise* (*Italian Journey*), was still full of unqualified praise:

> On November 28 [1786], we returned to the Sistine Chapel and had them unlock the gallery, where one can see the ceiling from close up, although it is very narrow and one leans out over the iron bars with some difficulty

and apparent danger, which is why dizzy people stay behind. But it is all compensated for by the sight of the greatest of masterpieces. I am so smitten by Michelangelo that I even have no taste for nature after him, for I cannot see it with such great eyes as he does. If only there was a way to fix such images in one's soul! At least I will take back with me whatever I can acquire in the way of engravings and copies of his works.[4]

Goethe's mention of engravings and copies reminds us to what extent people's ideas and knowledge of the chapel were determined by its reproductions and the details they present and highlight. In the decades that followed the first systematic photographic documentation of the ceiling by the firm Adolphe Braun in the years 1868 to 1869 and published in 1870, *The Creation of Adam* gained the status of an icon of Western art, especially, since 1951, close-ups of God's finger touching Adam's. The focus of media attention on that image seems to have misled some people to take this detail as a kind of key and the most important scene of the entire ceiling. It remains to be seen what the new possibilities for three-dimensional views of the chapel will mean for future understanding of its interior.[5] One could say the same regarding the power of the popular books and films about Michelangelo that have disseminated the image of a solitary genius and made the Sistine exclusively a monument to the fame of the unique artist.

The purgatory of extremes last flickered up on the occasion of the restoration of the Sistine prior to the year 2000. The traditional image of the heroically dark works of Michelangelo gave way, picture field by picture field, to metallically lucid, shining color. Some critics accused the conservators of radically destroying Michelangelo's final, *a secco* layer of paint, applied after the fresco had dried, which was meant to tone down the contrasts. But comparison with Michelangelo's earlier *Doni Tondo,* as well as the ceiling's reception by other artists, has led to the majority opinion that his original intention has been restored.

In the face of these debates, but also in view of the flood of new, detailed information and brilliant new color photographs that tempt publishers to

produce large-format coffee-table books, efforts to reach an overall interpretation of the interior decor seem for now to have moved into the background. To be sure, the Sistine and especially Michelangelo as its most prominent artist have elicited so much literature that it can hardly be mastered. After the great contributions of Ernst Steinmann (1901–5), the neo-Platonic interpretation of Charles de Tolnay (1945; 1960), and John Shearman's thoughts on the ceremonial and on papal legitimacy (1972), a view gained currency that foregrounded the fractures, provocations, and supposed heresies of Michelangelo's paintings.[6] In recent years, texts about the Sistine Chapel have been more focused on the totality of the chapel's interior and its visual traditions. If this book joins those contributions, then it does so not to lessen the exceptionality of Michelangelo and his frescoes but rather to acknowledge that the history of the space and its traditions created a framework that even Michelangelo could not entirely transcend and helped establish the starting point for the real achievement of his revolutionary pictures.

Michelangelo himself remained skeptical about the value of his work. The poem in which he complained of the working conditions for the ceiling frescoes (see fig. 13) ends with the confession, "My pictures are dead. . . . I'm in the wrong place here—I'm no painter!" It is one of the lucky accidents of our existence that in this world, even a "divine" artist could be so fundamentally wrong.

NOTES

1. See the extensive description of the chapel in Agostino Taja, *Descrizione del Palazzo Apostolico Vaticano* (Rome: Pagliarini, 1750), 33–64, and the history of the decor after 1541, 64–66. On the reception of the ceiling and the *Last Judgment,* see Romeo De Maio, *Michelangelo e la Controriforma* (Bari: Laterza, 1978); Mancinelli, *Michelangelo e la Sistina;* Lieselotte Bestmann, *Die Galerie Alexanders VII. im Palazzo del Quirinale zu Rom und ihre Beziehung zum ikonographischen Programm der Decke der Sixtinischen Kapelle* (Ammersbek: Verlag an der Lottbek, 1991); and Francesco Buranelli, Anna M. De Strobel, and Giovanni Gentili, *La Sistina e Michelangelo: Storia e fortuna di un capolavoro* (Milan: Silvana, 2003). On the work of renovation in the chapel, see Mancinelli, *Michelangelo e la Sistina,* 277–98.

2. The sources for Ingres's experience and the painting in Uwe Fleckner, "Die Gegenwart einer Illusion: Jean-Auguste-Dominique Ingres malt die Sixtinische Kapelle," in *Geschichte und Ästhetik,* ed. Margit Kern, Thomas Kirchner, and Hubertus Kohle (Munich: Deutscher Kunstverlag, 2004), 313–30.

3. On the later liturgical use of the chapel, see also Peter Gillgren, "Siting Michelangelo's *Last Judgement* in a Multimedia Context: Art, Music and Ceremony in the Sistine Chapel," *Konsthistorisk tidskrift* 80, no. 2 (2011): 65–89.

4. See Johann Wolfgang von Goethe, *Werke,* vol. 11, *Autobiographische Schriften III* (Munich: Deutscher Taschenbuch, 1998), 145. On the subsequent "national appropriation" of Michelangelo in the art-historical literature in German, see Joseph Imorde, *Michelangelo Deutsch!* (Berlin: Deutscher Kunstverlag, 2009); for England, see Lene Østermark-Johansen,

Sweetness and Strength: The Reception of Michelangelo in Late Victorian England (Aldershot: Ashgate, 1998); and Georg Satzinger and Sebastian Schütze, eds., *Der Göttliche: Hommage an Michelangelo* (Munich: Hirmer, 2015).

5. See a recent three-dimensional rendering project of the Vatican Museums: http://www.vatican.va/various/cappelle/sistina_vr/index.html. On the photographic documentation of the chapel, see Moltedo, *La Sistina riprodotta,* 221–82; and Philippe Jarjat, "Michelangelo's Frescoes through the Camera's Lens: The Photographic Album and Visual Identity," in *Art and the Early Photographic Album,* ed. Stephen Bann (New Haven: Yale University Press, 2011), 151–72. The figure of Adam was already reproduced by an anonymous engraver (published by Antonio Salamanca) in the 1520s, and the entire scene with God the Father and Adam was reproduced around the middle of the sixteenth century by Gaspare Ruina. The modern focus on the fingers of the two protagonists almost touching is analyzed in Leo Steinberg, "Who's Who in Michelangelo's *Creation of Adam:* A Chronology of the Picture's Reluctant Self-Revelation," *Art Bulletin* 74, no. 4 (1992): 552–66.

6. See Steinmann, *Die Sixtinische Kapelle;* Tolnay, *Michelangelo II* and *Michelangelo V;* and Shearman, *Raphael's Cartoons.*

APPENDIX

INSCRIPTIONS FOR THE CHRIST AND MOSES CYCLES
OF THE FIFTEENTH CENTURY

(The letters correspond to those in fig. 5, pp. 10–11.)

a. Moses in the Bulrushes
Inscription lost.

A. Birth of Christ
Inscription lost.

b. Moses Leaving for Egypt
OBSERVATIO ANTIQV[A]E REGENERATIONIS A
MOISE PER CIRCONCISIONEM
(Observance of the Ancient Regeneration of Moses
by Circumcision)

B. Baptism of Christ
INSTITVTIO NOVAE REGENERATIONIS A CHRISTO
IN BAPTISMO
(Establishment of the New Rebirth through Christ in
Baptism)

c. The Trials of Moses
TEMPTATIO MOISI LEGIS SCRIPTAE LATORIS
(Temptation of Moses, Bearer of the Written Law)

C. Temptation of Christ
TEMPTATIO IESV CHRISTI LATORIS EVANGELICAE
LEGIS
(Temptation of Jesus Christ, Bearer of Evangelical Law)

d. The Crossing of the Red Sea
CONGREGATIO POPVLI A MOISE LEGEM
SCRIPTAM ACCEPTVRI
(Assembly of the People to Receive the Written Law
from Moses)

D. Vocation of the Apostles
CONGREGATIO POPVLI LEGEM EVANGELICAM
ACCEPTVRI
(Assembly of the People to Receive Evangelical Law)

e. Descent from Mount Sinai
PROMVLGATIO LEGIS SCRIPT[A]E PER MOISEM
(Proclamation of the Written Law by Moses)

E. The Sermon on the Mount
PROMVLGATIO EVANGELICAE LEGIS PER CHRISTVM
(Proclamation of Evangelical Law by Christ)

f. Punishment of Korah, Dathan, and Abiram
CONTVRBATIO MOISI LEGIS SCRIPTAE LATORIS
(Turmoil of the Soul of Moses, Bearer of the
Written Law)

F. The Delivery of the Keys
CONTVRBATIO IESV CHRISTI LEGISLATORIS
(Turmoil of the Soul of Jesus Christ, Legislator)

g. Testament and Death of Moses
REPLICATIO LEGIS SCRIPTAE A MOISE
(Repetition of the Written Law by Moses)

G. The Last Supper
REPLICATIO LEGIS EVANGELICAE A CHRISTO
(Repetition of the Evangelical Law by Christ)

h. Disputation over Moses's Body
Inscription lost.

H. Resurrection of Christ
ASCENSIO CHRISTI EVANGELICAE LEGISLATOR[IS]
(Ascension of Christ, the Evangelical Legislator)

152

SELECT BIBLIOGRAPHY

Barnes, Bernadine. *Michelangelo's "Last Judgment": The Renaissance Response.* Berkeley: University of California Press, 1998.
———. *Michelangelo in Print: Reproductions as Response in the Sixteenth Century.* Farnham: Ashgate, 2010.

Barocchi, Paola, and Renzo Ristori, eds. *Il carteggio di Michelangelo.* 5 vols. Florence: Sansoni, 1965–83.

Bartoli, Roberta. *Biagio d'Antonio.* Milan: Federico Motta, 1999.

Baschet, Jérôme. *Les justices de l'au-delà: Les représentations de l'enfer en France et en Italie (XIIe–XVe siècle).* Rome: École française de Rome, 1993.

Battisti, Eugenio. "Il significato simbolico della Cappella Sistina." *Commentari* 8 (1957): 96–104.

Benzi, Fabio, ed. *Sisto IV: Le arti a Roma nel Primo Rinascimento; Atti del convegno internazionale di studi.* Rome: Edizioni dell'Associazione Culturale Shakespeare, 2000.

Blum, Gerd. "Gesamtgeschichtliches Erzählen am Beginn der Frühen Neuzeit. Michelangelo und Vasari." In *Pendant Plus, Praktiken der Bildkombinatorik,* edited by Gerd Blum et al., 131–53. Berlin: Reimer, 2012.

Blumenthal, Arthur R., ed. *Cosimo Rosselli: Painter of the Sistine Chapel.* Winter Park, FL: Cornell Fine Arts Museum, 2001.

Boesten-Stengel, Albert. "Himmelfahrt und Höllensturz? Bilderfindung und Typengeschichte in Michelangelos 'Jüngstem Gericht.'" *Folia historiae artium* 11 (2007): 27–41.

Brandt, Kathleen Weil-Garris, ed. *Michelangelo: La Cappella Sistina.* Vol. 3, *Atti del convegno internazionale di studi. Roma, marzo 1990.* Novara: Istituto Geografico De Agostini, 1994.

Bredekamp, Horst. *Sankt Peter in Rom und das Prinzip der produktiven Zerstörung: Bau und Abbau von Bramante bis Bernini.* Berlin: Wagenbach, 2000.

Buddensieg, Tilmann. "Die Statuenstiftung Sixtus' IV. im Jahre 1471: Von den heidnischen Götzenbildern am Lateran zu den Ruhmeszeichen des römischen Volkes auf dem Kapitol." *Römisches Jahrbuch für Kunstgeschichte* 20 (1983): 33–73.

Buranelli, Francesco, Anna Maria De Strobel, and Giovanni Gentili, eds. *La Sistina e Michelangelo: Storia e fortuna di un capolavoro.* Milan: Silvana, 2003.

Butler, Kim E. "The Immaculate Body in the Sistine Ceiling." *Art History* 32 (2009): 250–89.

Cadogan, Jean K. *Domenico Ghirlandaio: Artist and Artisan.* New Haven: Yale University Press, 2000.

Calvesi, Maurizio. *La Cappella Sistina e la sua decorazione da Perugino a Michelangelo.* Rome: Lithos, 1997.

Careri, Giovanni. *La torpeur des Ancêtres: Juifs et chrétiens dans la chapelle Sixtine.* Paris: Éditions de l'École des Hautes Études en Sciences Sociales, 2013.

Ciammaruconi, Clemente, Pio Francesco Pistilli, and Gabriele Quaranta, eds. *La castiglia in marittima: L'oratorio dell'Annunziata nella cori del quattrocento.* Pescara: Edizioni ZiP, 2014.

Comito, Terry. "Renaissance Gardens and the Discovery of Paradise." *Journal of the History of Ideas* 32 (1971): 483–506.

Condivi, Asciano. *The Life of Michelangelo*. Translated by Alice Sedgwick Wohl. Edited by Hellmut Wohl. Baton Rouge: Louisiana State University Press, 1976.

Daniels, Tobias. *La congiura dei Pazzi: I documenti del conflitto fra Lorenzo de' Medici e Sisto IV; Le bolle di scomunica, la "Florentina Synodus," e la "Dissentio" insorta tra la santità del Papa e i Fiorentini*. Florence: Edifir, 2013.

De Maio, Romeo. *Michelangelo e la Controriforma*. Bari: Laterza, 1978.

Dodson, Esther Gordon. "An Augustinian Interpretation of Michelangelo's Sistine Ceiling." *Art Bulletin* 61, no. 2 (1979): 223-56 and 405-29.

Eberhardt, Hans-Joachim. "Falconetto kopiert Perugino in der Sixtinischen Kapelle." In *Kunst und Humanismus: Festschrift für Gosbert Schüßler zum 60. Geburtstag*, edited by Wolfgang Augustyn and Gosbert Schüssler, 87-103. Passau: Klinger, 2007.

Ertl, Thomas. "Stoffspektakel: Zur Funktion von Kleidern und Textilien am spätmittelalterlichen Papsthof." *Quellen und Forschungen aus italienischen Archiven und Bibliotheken* 87 (2007): 139-85.

Ettlinger, Leopold. *The Sistine Ceiling before Michelangelo: Religious Imagery and Papal Primacy*. Oxford: Clarendon, 1965.

Evans, Mark, Clare Browne, and Arnold Nesselrath, eds. *Raphael: Cartoons and Tapestries for the Sistine Chapel*. London: V&A, 2010.

Fastenrath, Wiebke. *"Finto e favoloso": Dekorationssysteme des 16. Jahrhunderts in Florenz und Rom*. Hildesheim: Olms, 1995.

Fillitz, Hermann. *Papst Clemens VII. und Michelangelo: Das Jüngste Gericht in der Sixtinischen Kapelle*. Vienna: Verlag der Österreichischen Akademie der Wissenschaften, 2005.

Firpo, Massimo, and Fabrizio Biferali. *"Navicula Petri": L'arte dei papi nel Cinquecento, 1527-1571*. Rome: Laterza, 2009.

Flemmyng, Robert. *Lucubranciunculae Tiburtinae*. Published by Vincenzo Pacifici. *Un carme biografico di Sisto IV del 1477*. Tivoli: Società Tiburtina di Storia e d'Arte, 1922.

Frommel, Christoph L. "'Capella Julia': Die Grabkapelle Papst Julius' II. in Neu-St. Peter." *Zeitschrift für Kunstgeschichte* 40 (1977): 26-62.

Gabrielli, Edith. *Cosimo Rosselli: Catalogo ragionato*. Torino: Umberto Allemandi, 2007.

Gillgren, Peter. "Siting Michelangelo's *Last Judgement* in a Multimedia Context: Art, Music and Ceremony in the Sistine Chapel." *Konsthistorisk tidskrift* 80, no. 2 (2011): 65-89.

Goffen, Rona. "Friar Sixtus IV and the Sistine Chapel." *Renaissance Quarterly* 39 (1986): 218-62.

Groner, Anton. "Zur Entstehungsgeschichte der Sixtinischen Wandfresken." *Zeitschrift für christliche Kunst* 19 (1906): 163-70, 191-202, and 227-36.

Hall, Marcia B., ed. *Michelangelo's "Last Judgment."* Cambridge: Cambridge University Press, 2005.

Hall, Marcia B., and Tracy E. Cooper, eds. *The Sensuous in the Counter-Reformation Church*. Cambridge: Cambridge University Press, 2013.

Hartt, Frederick. "Lignum Vitae in Medio Paradisi: The Stanza d'Eliodoro and the Sistine Ceiling." *Art Bulletin* 33, nos. 2/3 (1950): 115-45 and 181-218.

Hatfield, Rab. *Trust in God: The Sources of Michelangelo's Frescoes on the Sistine Ceiling*. Florence: Syracuse University, 1991.

Hemsoll, David. "The Conception and Design of Michelangelo's Sistine Chapel Ceiling: 'Wishing Just to Shed a Little Upon the Whole Rather Than Mentioning the Parts.'" In *Rethinking the High Renaissance: The Culture of the Visual Arts in Early Sixteenth-Century Rome*, edited by Jill Burke, 263-87. Farnham: Ashgate, 2012.

Henry, Tom. "Arezzo's Sistine Ceiling: Guillaume de Marcillat and the Frescoes in the Cathedral at Arezzo." *Mitteilungen des Kunsthistorischen Institutes in Florenz* 39 (1995): 209–57.

———. *The Life and Art of Luca Signorelli.* New Haven: Yale University Press, 2012.

Herzner, Volker. *Die Sixtinische Decke: Warum Michelangelo malen durfte, was er wollte.* Hildesheim: Olms, 2015.

Hochrenaissance im Vatikan: Kunst und Kultur im Rom der Päpste 1503–1534. Exh. cat. Ostfildern-Ruit: Gerd Hatje, 1999.

Howard, Peter. "Painters and the Visual Art of Preaching: The *Exemplum* of the Fifteenth-Century Frescoes in the Sistine Chapel." *I Tatti Studies* 13 (2010): 33–77.

Howe, Eunice D. *Art and Culture at the Sistine Court: Platina's "Life of Sixtus IV" and the Frescoes of the Hospital of Santo Spirito.* Vatican City: Biblioteca Apostolica Vaticana, 2005.

James, Sara Nair. *Signorelli and Fra Angelico at Orvieto: Liturgy, Poetry and a Vision of the End-Time.* Aldershot: Ashgate, 2003.

John, Robert L. *Dante und Michelangelo: Das Paradiso Terrestre und die Sixtinische Decke.* Krefeld: Scherpe, 1959.

Kecks, Ronald G. *Domenico Ghirlandaio und die Malerei der Florentiner Renaissance.* Munich: Deutscher Kunstverlag, 2000.

Kessler, Herbert L. *Old St. Peter's and Church Decoration in Medieval Italy.* Spoleto: Centro Italiano di Studi sull'Alto Medioevo, 2002.

Kliemann, Julian, and Michael Rohlmann. *Wandmalerei in Italien: Die Zeit der Hochrenaissance und des Manierismus, 1510–1600.* Munich: Hirmer, 2004.

Kraus, Franz Xaver. *Geschichte der christlichen Kunst.* Vol. 2.2, *Italienische Renaissance,* edited by Joseph Sauer. Freiburg im Breisgau: Herder, 1908.

Kuhn, Rudolf. *Michelangelo: Die Sixtinische Decke; Beitrage uber ihre Quellen und zu ihrer Auslegung.* Berlin: W. de Gruyter, 1975.

Leader, Anne. "Michelangelo's *Last Judgment:* The Culmination of Papal Propaganda in the Sistine Chapel." *Studies in Iconography* 27 (2006): 103–56.

Lewine, Carol F. *The Sistine Chapel Walls and the Roman Liturgy.* University Park: Pennsylvania State University Press, 1993.

Linke, Alexander. *Typologie in der Frühen Neuzeit: Genese und Semantik heilsgeschichtlicher Bildprogramme von der Cappella Sistina (1480) bis San Giovanni in Laterano (1650).* Berlin: Reimer, 2014.

Mancinelli, Fabrizio, ed. *Michelangelo e la Sistina: La tecnica, il restauro, il mito.* Exh. cat. Rome: Palombi, 1990.

———. *Michelangelo: La Cappella Sistina; Rapporto sul restauro degli affreschi della volta.* 2 vols. Novara: Istituto Geografico De Agostini, 1994.

———. *Michelangelo: La Cappella Sistina; Rapporto sul restauro del Giudizio Universale.* 2 vols. Novara: Istituto Geografico De Agostini, 1999.

Martelli, Cecilia. *Bartolomeo della Gatta: Pittore e miniature tra Arezzo, Roma e Umbria.* Florence: Centro Di, 2013.

Molinié, Anne-Sophie. *Corps ressuscitants et corps ressuscités: Les images de la résurrection des corps en Italie centrale et septentrionale du milieu du XVe au début du XVIIe siècle.* Paris: Champion, 2007.

Moltedo, Alida, ed. *La Sistina riprodotta: Gli affreschi di Michelangelo dalle stampe del Cinquecento alle campagne fotografiche Anderson.* Exh. cat. Rome: Palombi, 1991.

Monfasani, John. "A Description of the Sistine Chapel under Pope Sixtus IV." *Artibus et Historiae* 4, no. 7 (1983): 9–18.

Monicatti, Alessandro. *Il Palazzo Vaticano nel Medioevo.* Florence: Olschki, 2005.

Nesselrath, Arnold. "The Painters of Lorenzo the Magnificent in the Chapel of Pope Sixtus IV in Rome." In *The Fifteenth Century Frescoes in the Sistine Chapel,* edited by Francesco Buranelli and Allen Duston, 39–75. Vatican City: Musei Vaticani, 2003.

———. *La Cappella Sistina: Il Quattrocento*. Milan: F. M. Ricci, 2003.

O'Malley, Michelle. "Finding Fame: Painting and the Making of Careers in Renaissance Italy." *Renaissance Studies* 24 (2010): 9–32.

Panofsky, Erwin. *Die Sixtinische Decke*. Leipzig: E. A. Seemann, 1921.

Partridge, Loren. *Il Giudizio restaurato: La Cappella Sistina*. Novara: Istituto Geografico De Agostini, 1998.

———. *Michelangelo: The Sistine Chapel Ceiling, Rome*. New York: Braziller, 1996.

Petersohn, Jürgen. "Kirchenrecht und Primatstheologie bei der Verurteilung des Konzilsinitiators Andreas Jamometić durch Papst Sixtus IV: Die Bulle 'Grave gerimus' vom 16 Juli 1482 und Botticellis Fresko 'Bestrafung der Rotte Korah' (mit Edition des Quellentextes)." In *Proceedings of the Twelfth International Congress of Medieval Canon Law*, edited by Uta-Renate Blumenthal, Kenneth Pennington, and Atria A. Larson, 667–98. Vatican City: Biblioteca Apostolica Vaticana, 2008.

Pfeiffer, Heinrich W. *Die Sixtinische Kapelle neu entdeckt*. Stuttgart: Belser, 2007.

Pierguidi, Stefano. "'Quasi ella sia stata il centro di tutte': La 'concorrenza' dei pittori forestieri nella Roma di Sisto IV e Giulio II." *Commentari d'Arte* 15/44 (2009): 21–35.

Pistilli, Pio Francesco, and Stefano Petrocchi. "El oratorio y los frescos de *La Anunciación* de Cori: Un antiguo caso de patrocinio castellano en el agro romano." *Archivo español de arte* 77 (2004): 35–57.

Polzer, Joseph. "Michelangelo's Sistine *Last Judgement* and Buffalmacco's Murals in the Campo Santo at Pisa." *Artibus et Historiae* 35, no. 69 (2014): 53–77.

Pon, Lisa. "Raphael's *Acts of the Apostles* Tapestries for Leo X: Sight, Sound, and Space in the Sistine Chapel." *Art Bulletin* 97, no. 4 (2015): 388–408.

Rasmussen, Niels Krogh. "Maiestas pontifica: A Liturgical Reading of Etienne Dupérac's Engraving of the 'Cappella Sixtina' from 1578." *Analecta Romana Instituti Danici* 12 (1983): 109–48.

Redig de Campos, Deoclecio. "I *tituli* degli affreschi del quattrocento nella Cappella Sistina." *Pontificia Accademia Romana di Archeologia: Rendiconti* 42 (1969/70): 299–314.

Riess, Jonathan B. *The Renaissance Antichrist: Luca Signorelli's Orvieto Frescoes*. Princeton: Princeton University Press, 1995.

Robertson, Charles. "Bramante, Michelangelo, and the Sistine Ceiling." *Journal of the Warburg and Courtauld Institutes* 49 (1986): 91–105.

Rohlmann, Michael. "Kontinuität und Künstlerwettstreit in den Bildern der Sixtinischen Kapelle." *Wallraf-Richartz-Jahrbuch* 60 (1999): 163–96.

———. *Michelangelos "Jonas": Zum Programm der Sixtinischen Kapelle*. Weimar: VDG, 1995.

———. "Michelangelos 'Jüngstes Gericht' in der Sixtinischen Kapelle. Zu Themenwahl und Komposition." In *Michelangelo: Neue Beiträge; Akten des Michelangelo-Kolloquiums veranstaltet vom Kunsthistorischen Institut der Universität zu Köln im Italienischen Kulturinstitut Köln 7.–8. November 1996*, edited by Michael Rohlmann and Andreas Thielemann, 205–34. Munich: Deutscher Kunstverlag, 2000.

Roser, Hannes. *St. Peter in Rom im 15. Jahrhundert: Studien zur Architektur und skulpturalen Ausstattung*. Munich: Hirmer, 2005.

Rospocher, Massimo. *Il papa guerriero: Giulio II nello spazio pubblico europeo*. Bologna: Il Mulino, 2015.

Röttgen, Steffi. *Wandmalerei der Frührenaissance in Italien*. Vol. 2, *Die Blütezeit: 1470–1510*. Munich: Hirmer, 1997.

Rowland, Ingrid D. *The Culture of the High Renaissance: Ancients and Moderns in Sixteenth-Century Rome*. Cambridge: Cambridge University Press, 1998.

Sandström, Sven. *Levels of Unreality: Studies in Structure and Construction in Italian Mural Painting during the Renaissance.* Uppsala, Sweden: Almqvist & Wiksell, 1963.

Schimmelpfennig, Bernhard. "Die Funktion der Cappella Sistina im Zeremoniell der Renaissancepäpste." In *Collectanea II: Studien zur Geschichte der päpstlichen Kapelle: Tagungsbericht, Heidelberg, 1989,* edited by Bernhard Janz, 123–74. Vatican City: Biblioteca Apostolica Vaticana, 1994.

Schmidt, Michael. "'Papst Paul wünschte, daß er die von Clemens angeordnete Arbeit fortsetzen möge': Neues zur Genese von Michelangelos 'Jüngstem Gericht' in der Sixtinischen Kapelle unter Paul III." *Das Münster* 53 (2000): 16–29.

Shearman, John. "La costruzione della cappella e la prima decorazione al tempo di Sisto IV." In *La Cappella Sistina: I primi restauri; La scoperta del colore,* edited by Marcella Boroli, 22–87. Novara: Istituto Geografico De Agostini, 1986.

———. *Raphael in Early Modern Sources.* 2 vols. New Haven: Yale University Press, 2003.

———. *Raphael's Cartoons in the Collection of Her Majesty the Queen and the Tapestries for the Sistine Chapel.* London: Phaidon, 1972.

Die Sixtinische Kapelle. Zurich: Benziger, 1986.

Steinberg, Leo. "Who's Who in Michelangelo's *Creation of Adam:* A Chronology of the Picture's Reluctant Self-Revelation." *Art Bulletin* 74, no. 4 (1992): 552–66.

Steinmann, Ernst. *Die Sixtinische Kapelle.* 2 vols. Munich: Bruckmann, 1901–5.

Stinger, Charles L. *The Renaissance in Rome.* Bloomington: Indiana University Press, 1985.

Tanner, Marie. *Jerusalem on the Hill: Rome and the Vision of St. Peter's in the Renaissance.* London: Harvey Miller, 2010.

Testi, Maria Laura Cristiani. "Le traiettorie della visione nel sistema cosmico, nella Volta della Cappella Sistina." *Critica d'Arte* 8, nos. 47/48 (2012): 7–28.

Tolnay, Charles de. *Michelangelo II: The Sistine Ceiling.* Princeton: Princeton University Press, 1945.

———. *Michelangelo V: The Final Period.* Princeton: Princeton University Press, 1960.

Vasari, Giorgio. *Le vite de' più eccellenti pittori, scultori e architettori nelle redazione del 1550 e 1568.* Edited by Rosanna Bettarini and Paola Barocchi. 6 vols. Florence: Sansoni, 1966–87.

Verino, Ugolino. *Carlias: Ein Epos des 15. Jahrhunderts.* Edited by Nikolaus Thurn. Munich: Fink, 1995.

Wallace, William, ed. *Michelangelo: Selected Scholarship in English.* Vol. 2, *The Sistine Chapel.* New York: Garland, 1995.

Wassilowsky, Günther. *Die Konklavereform Gregors XV. (1621/22): Wertekonflikte, symbolische Inszenierung und Verfahrenswandel im posttridentinischen Papsttum.* Stuttgart: A. Hiersemann, 2010.

Westfall, Carroll W. *In This Most Perfect Paradise: Alberti, Nicolas V, and the Invention of Conscious Urban Planning in Rome, 1447–55.* University Park: Pennsylvania State University Press, 1974.

Wilde, Johannes. "The Decoration of the Sistine Chapel." *Proceedings of the British Academy* 44 (1958): 61–81.

Wind, Edgar. *The Religious Symbolism of Michelangelo.* Edited by Elizabeth Sears. Oxford: Oxford University Press, 2001.

Zapperi, Roberto. "Potere politico e cultura figurativa: La rappresentazione della nascita di Eva." In *Storia dell'Arte Italiana.* Vol. 3, *Conservazione, falso, restauro,* edited by Federico Zeri, 375–442. Torino: Giulio Einaudi, 1981.

Zöllner, Frank. *Michelangelos Fresken in der Sixtinischen Kapelle: Gesehen von Giorgio Vasari und Ascanio Condivi.* Freiburg im Breisgau: Rombach, 2002.

ACKNOWLEDGMENTS

Arnold Nesselrath and Michael Cole contributed decisively to the development of this book with their ideas and critiques. I also owe a great debt of gratitude to Matteo Burioni, Kathleen Wren Christian, Frank Fehrenbach, Chiara Franceschini, Christoph Luitpold Frommel, Philippe Morel, and Cristina Ruggero for their suggestions and help.

The original German edition would not have come into being without Stefanie Hölscher, Beate Sander, Alexandra Schumacher, and the staff at C. H. Beck.

A large thank-you to the staff at the Getty Research Institute and Getty Publications for initiating, facilitating, and producing the English edition. Finally, I could not have wished for a better translator than David Dollenmayer or for a better editor than Laura Santiago.

ILLUSTRATION CREDITS

The caption text in figs. 6–9 was translated from the Italian by Sabine Eiche.

Fig. 1. Bayerische Staatsbibliothek München, Res/4 H.ref. 510 d#Beibd.2, fol. A2 verso.
Figs. 2, 5–9, 16, 22. © Ulrich Pfisterer.
Fig. 3. From Elena De Laurentis and Emilia Anna Talamo, eds., *Codici della Cappella Sistina* (Rome: Campisano, 2010), 25.
Fig. 4. iStock.com / Banauke.
Fig. 10. From Julian Kliemann and Michael Rohlmann, *Wandmalerei in Italien: Die Zeit der Hochrenaissance und des Manierismus, 1510–1600* (Munich: Hirmer, 2004), 90, fig. 1.
Fig. 11. From Ernst Steinmann, *Die Sixtinische Kapelle* (Munich: Bruckmann, 1901), 1: pl. VII.
Fig. 12. From Eunice D. Howe, *Art and Culture at the Sistine Court: Platina's "Life of Sixtus IV" and the Frescoes of the Hospital of Santo Spirito* (Vatican City: Biblioteca Apostolica Vaticana, 2005), 247, fig. 47.
Fig. 13. From Kliemann and Rohlmann, *Wandmalerei in Italien*, 96, fig. 1.
Figs. 14, 15. Courtesy of Christoph Luitpold Frommel.
Fig. 17. From Alessandra Ghidoli, *Fragmenta picta: Affreschi e mosaici staccato del medioevo romano* (Rome: Argos, 1989), 47.
Fig. 18. University of Heidelberg Library.
Fig. 19. From Franco Paturzo and Gianni Brunacci, *Il Duomo di Arezzo: Settecento anni di storia, fede e arte* (Arezzo: Letizia, 2011), 115.
Fig. 20. From Fabrizio Mancinelli, ed., *Michelangelo e la Sistina: La tecnica, il restauro, il mito,* exh. cat. (Rome: Palombi, 1990), 262.
Fig. 21. From Biblioteca Apostolica Vaticana, as appears in Ulrich Pfisterer, *La Cappella Sistina,* trans. Giovanna Targia (Rome: Campisano Editore, 2014), fig. 31.
Fig. 23. From Elena Filippi, *Maarten van Heemskerck: Inventio urbis* (Milan: Berenice, 1990), fig. 25.
Fig. 24. Bequeathed by Rev. Alexander Dyce. © Victoria and Albert Museum, London.
Fig. 25. From Mancinelli, *Michelangelo e la Sistina,* 222.
Fig. 26. The J. Paul Getty Museum, Los Angeles.

Plate 1. From Hermann Fillitz, *Papst Clemens VII. und Michelangelo: Das Jüngste Gericht in der Sixtinischen Kapelle* (Vienna: Verlag des Österreichischen Akademie der Wissenschaften, 2005), 7.
Plate 2. From Steffi Röttgen, *Wandmalerei der Frührenaissance in Italien* (Munich: Hirmer, 1997), fig. 33.
Plate 3. Musée Condé, Chantilly, France / Bridgeman Images.
Plate 4. From Francesco Buranelli, Anna Maria De Strobel, and Giovanni Gentili, eds., *La Sistina e Michelangelo: Storia e fortuna di un capolavoro* (Milan: Silvana Editoriale, 2003), 122.
Plate 5. From Buranelli, De Strobel, and Gentili, *La Sistina e Michelangelo,* 110.
Plates 6, 7. Gabinetto Fotografico delle Gallerie degli Uffizi.
Plate 8. From Buranelli, De Strobel, and Gentili, *La Sistina e Michelangelo,* 114.
Plate 9. From Buranelli, De Strobel, and Gentili, *La Sistina e Michelangelo,* 108.
Plate 10. Franco Borsi, *Bramante* (Milan: Electa, 1989), 172.
Plates 11a–b, 23. Wikimedia. CC-BY-SA.
Plate 12. Mancinelli, *Michelangelo e la Sistina,* 121.
Plates 13–16. © Ulrich Pfisterer.
Plate 17. Erich Lessing / Art Resource.
Plate 18. From Marc Evans et al., *Raphael: Cartoons and Tapestries for the Sistine Chapel* (London: V&A, 2010), 79.
Plate 19. From Evans et al., *Raphael,* 76.
Plate 20. From Evans et al., *Raphael,* 77.
Plate 21. From Evans et al., *Raphael,* 91.
Plate 22. © Victoria and Albert Museum, London.
Plate 24. From Fillitz, *Papst Clemens VII. und Michelangelo,* 13.
Plate 25. From Giancarlo Altieri, *Summorum romanorum pontificum historia nomismatibus recensitis illustrata ab saeculo XV ad saeculum XX* (Vatican City: Biblioteca Apostolica Vaticana, 2004), 22.
Plate 26. Röttgen, *Wandmalerei der Frührenaissance,* 412, fig. 3.
Plate 27. From Orianna Baracchi et al., *La Cappella Bellincini nel Duomo di Modena* (Modena: Panini, 1990), 72.
Plate 28. Photo © Marcello Castrichini, Todi (Italy).
Plate 29. © Mark Tansey.
Plate 30. From Olivier Bonfait, *Maestà di Roma, da Napoleone all'unità d'Italia* (Milan: Electa, 2003), 276, fig. 129.

INDEX